UTAH II

UTAH II

Photography • Bill Ratcliffe Text • Stanley L. Welsh

GRAPHIC ARTS CENTER PUBLISHING COMPANY, PORTLAND, OREGON

International Standard Book Number 0-912856-65-3

Library of Congress Catalog Card Number 80-85367

Copyright©1981 by Graphic Arts Center Publishing Co.

P.O. Box 10306 • Portland, Oregon 97210 • 503/224-7777

Designer • Robert Reynolds

Typesetter • Paul O. Giesey/Adcrafters

Printer • Graphic Arts Center

Bindery • Lincoln & Allen

Printed in the United States of America

Right: The intense green of ponderosa pine and golden light of morning provide the setting for this display of sculptured stone. Fairyland Canyon, Bryce Canyon National Park.

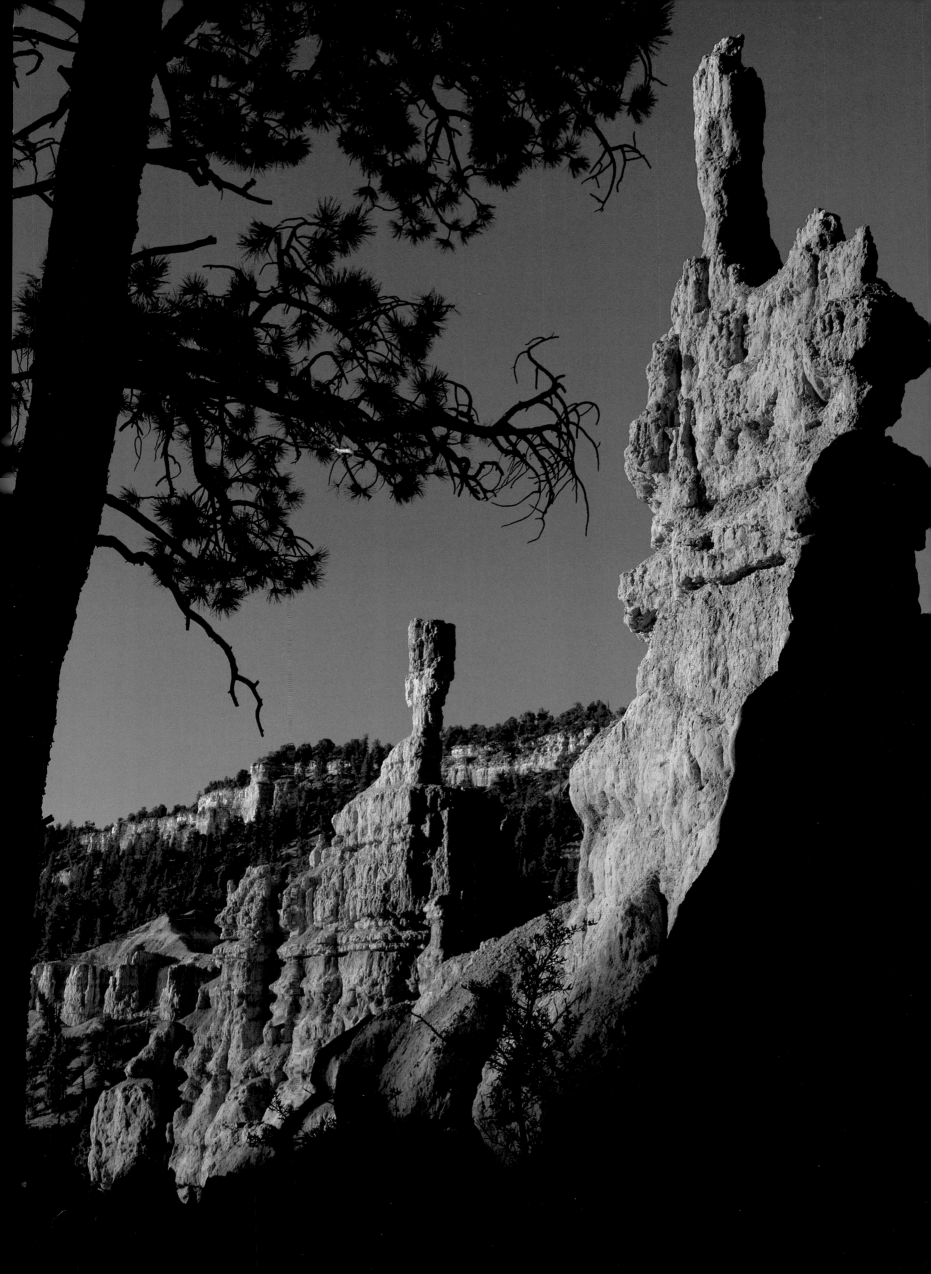

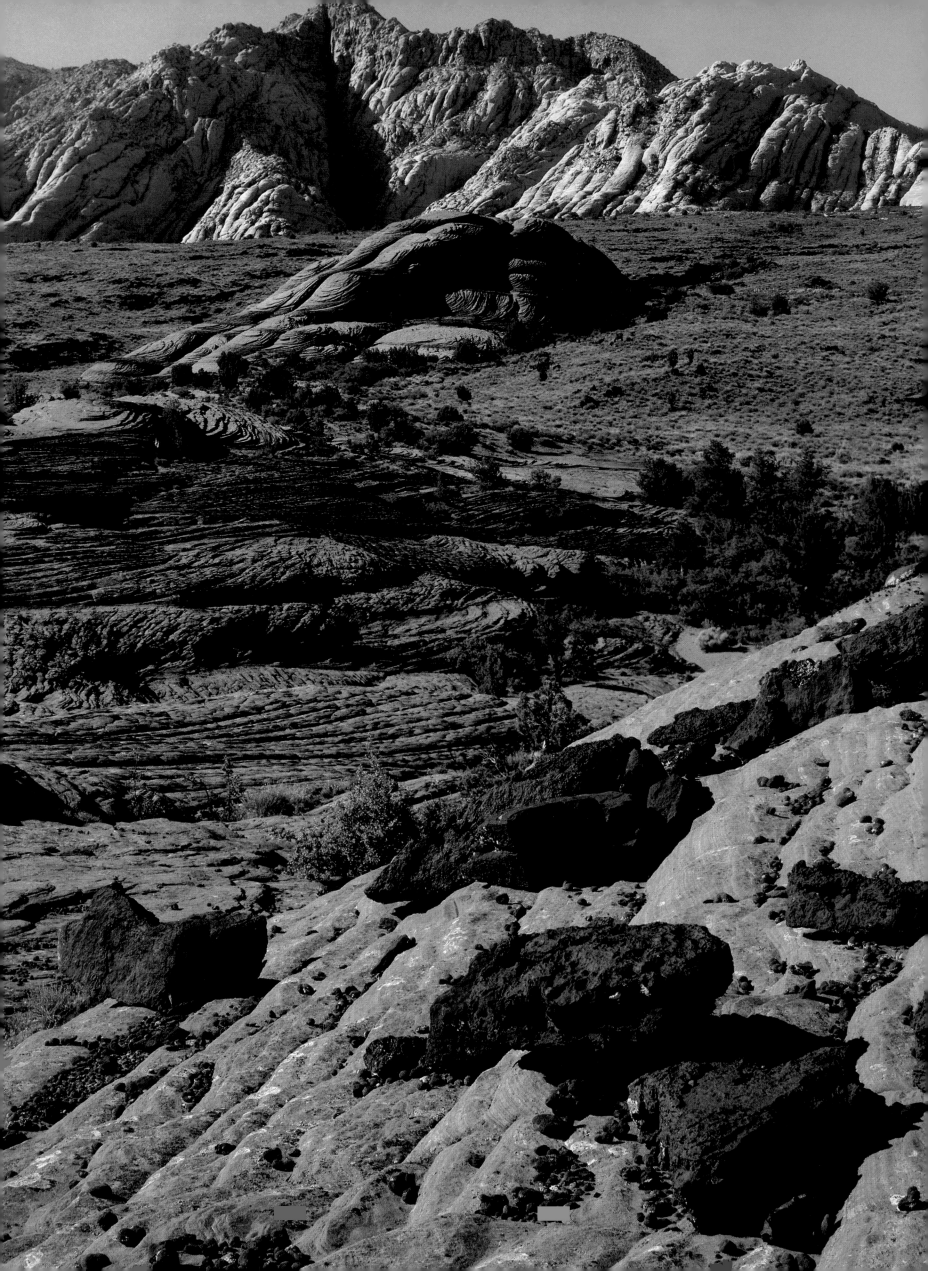

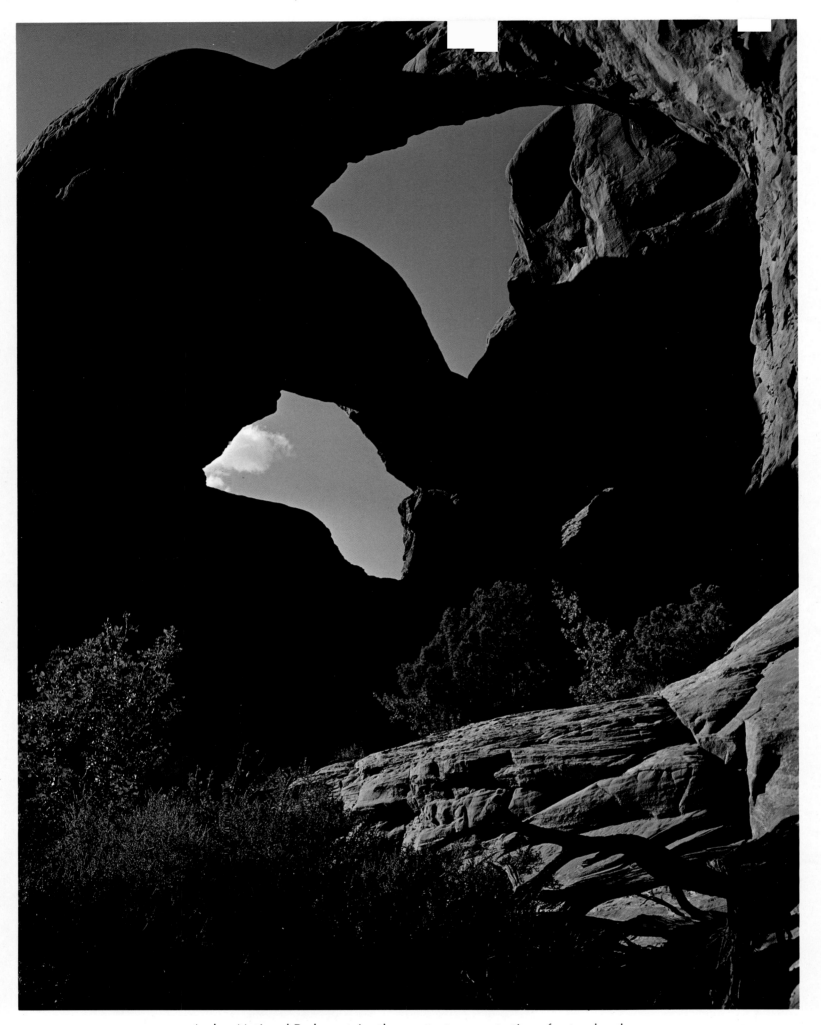

Arches National Park contains the greatest concentration of natural arches in the world. Double Arch, Arches National Park. *Left:* Navajo sandstone contrasts with black basalt boulders of a prehistoric lava flow. Snow Canyon, Washington County. *Overleaf:* Arid land of sunshine, of diurnal and annual extremes of temperature, and of brooding monoliths, Monument Valley displays its tributes to time.

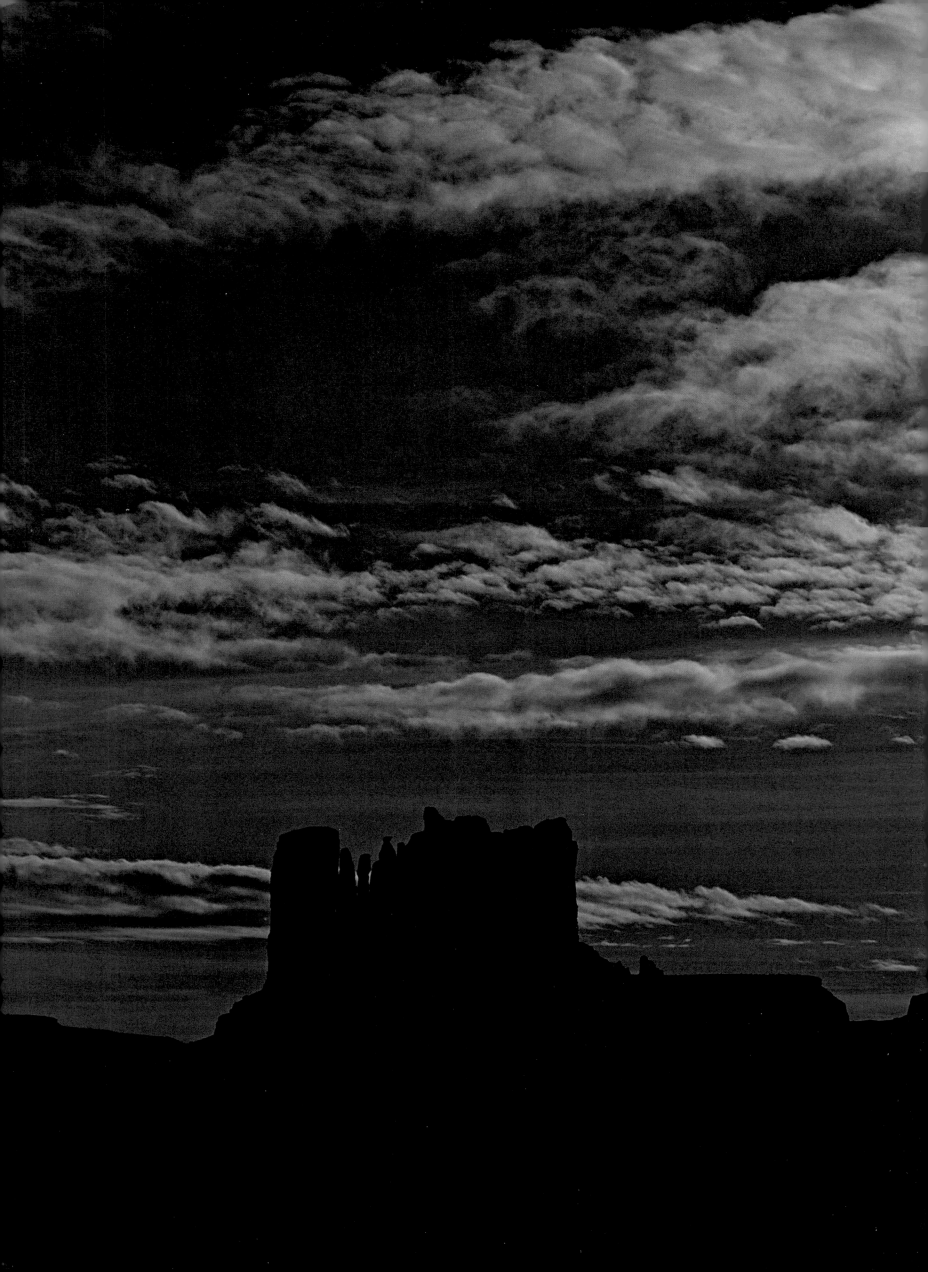

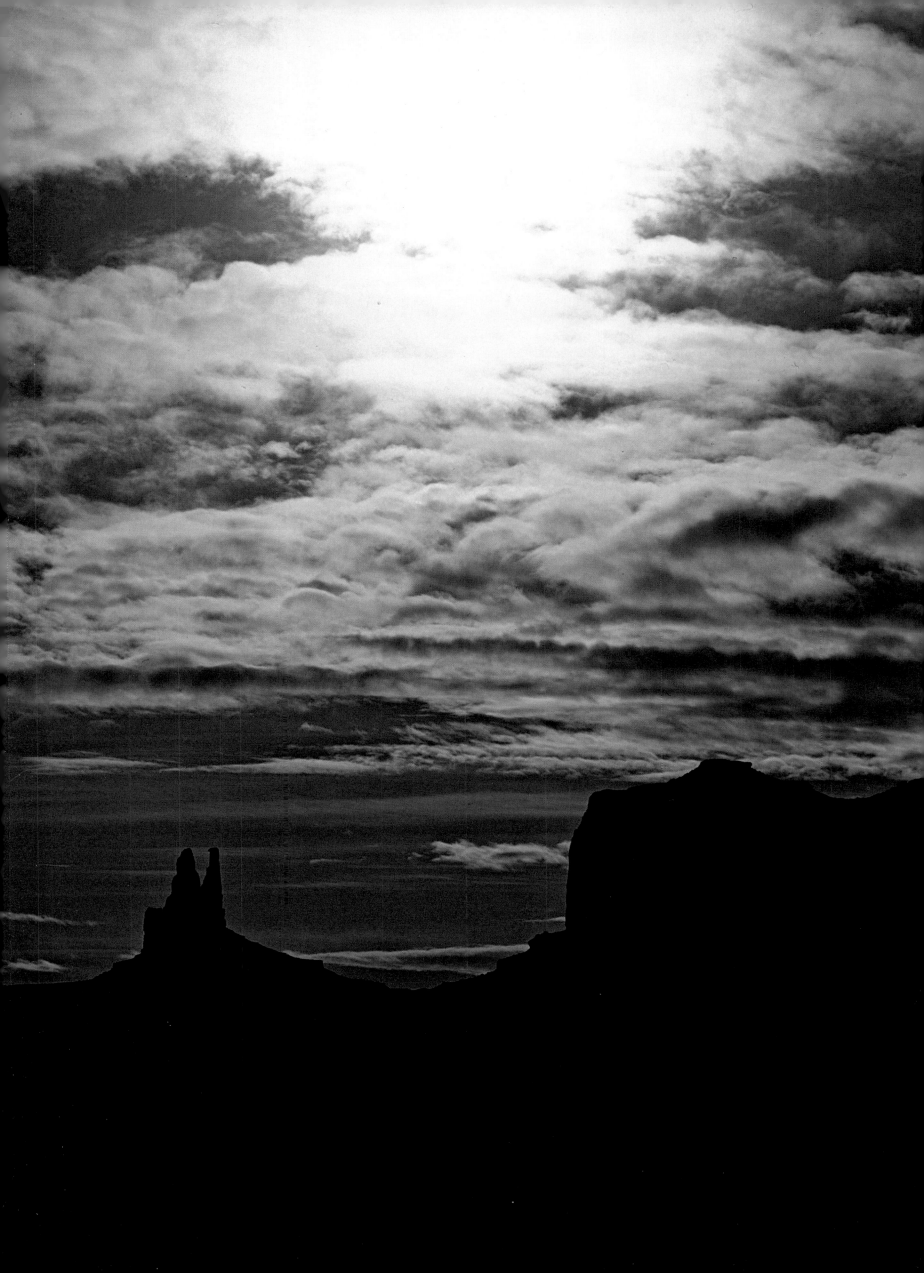

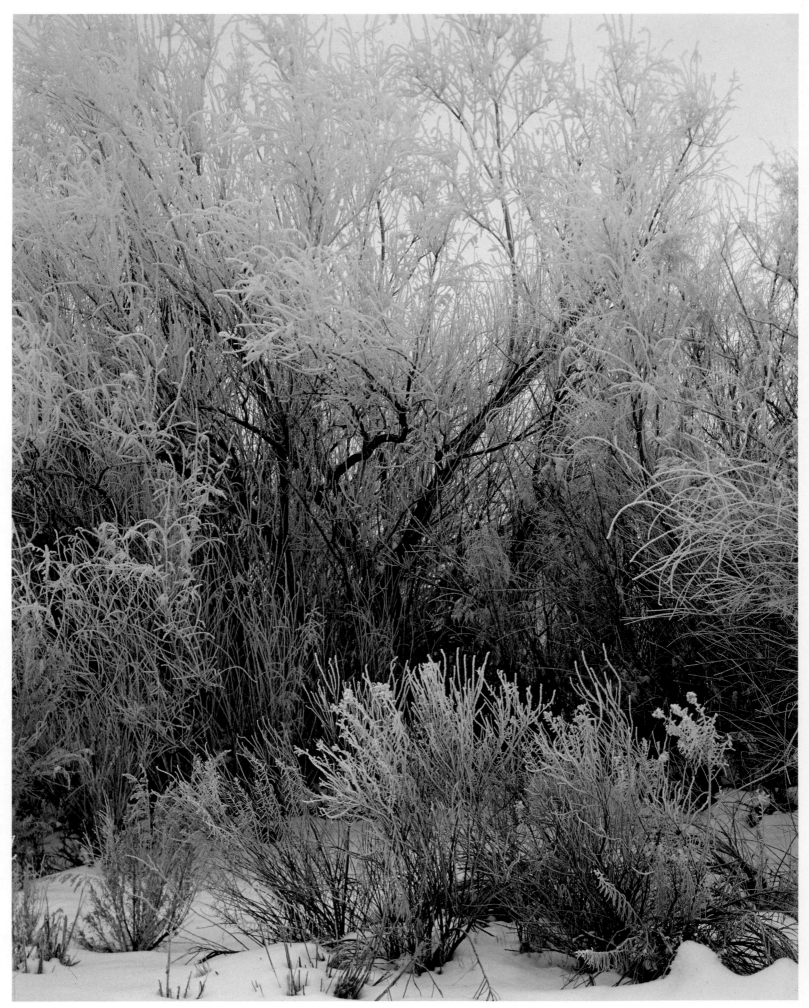

A ghost forest of tamarix and rabbitbrush in hoar frost is typical of valley bottoms along stream courses in winter. Thompson Wash, Grand County. *Right:* Ruins in coursed stone stand as reminders of another time, when Indians lived in the alcoves and grottoes, to escape the extreme heat of summer and cold of winter. San Juan County. *Overleaf:* Frescoe-like rock art by ancient inhabitants provides a view of a time contemporary man cannot perceive or comprehend. Dinosaur National Monument.

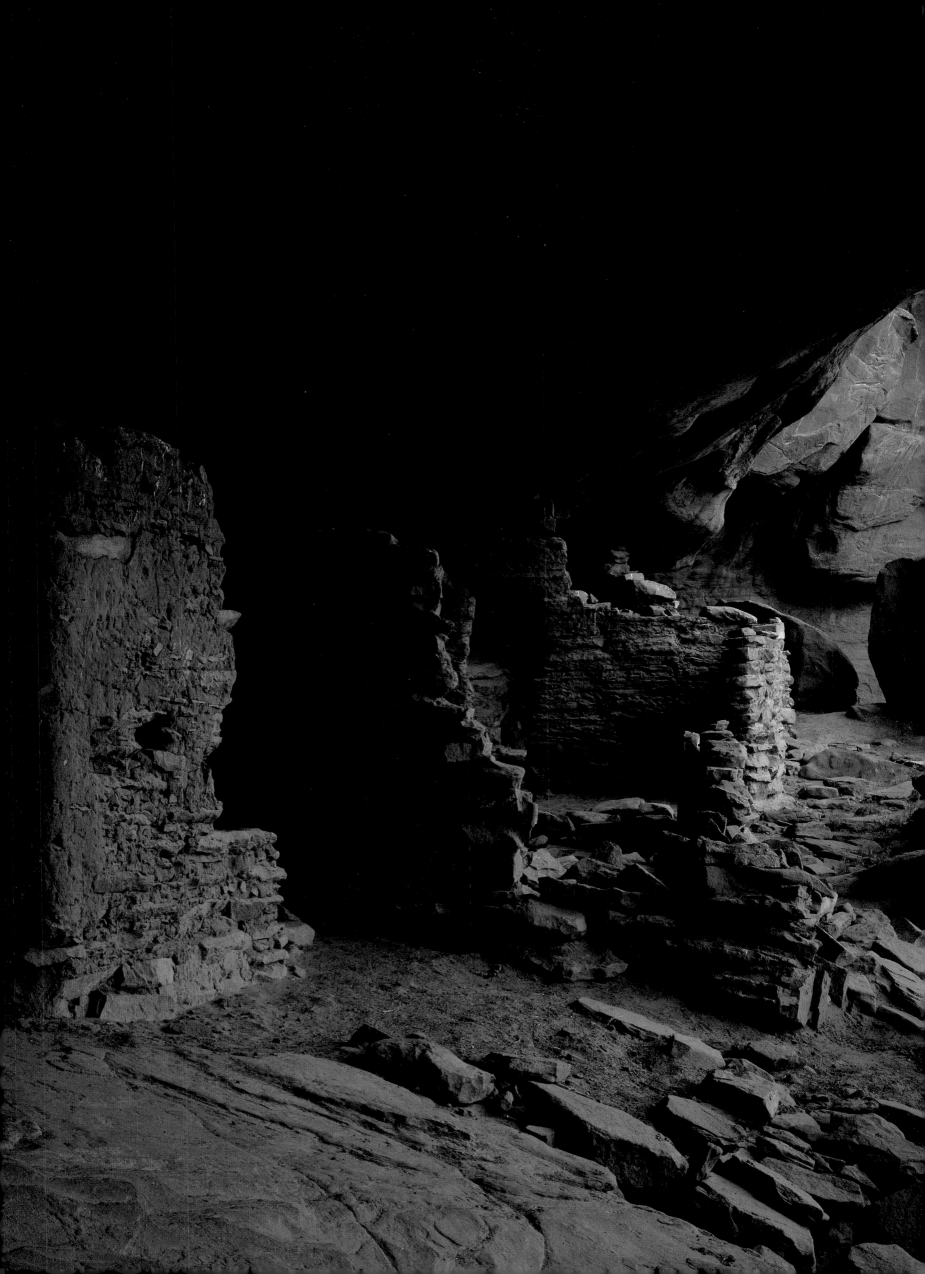

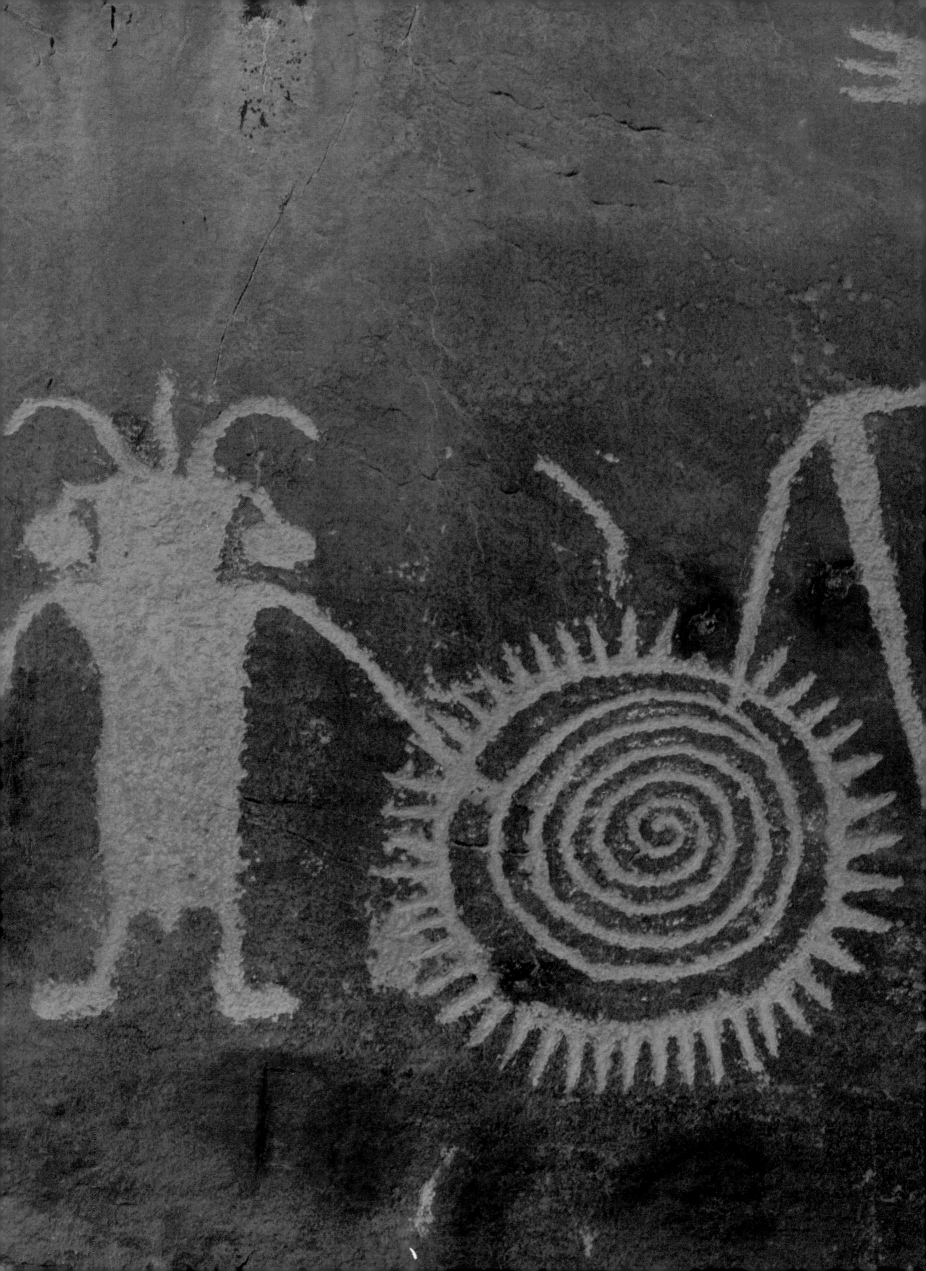

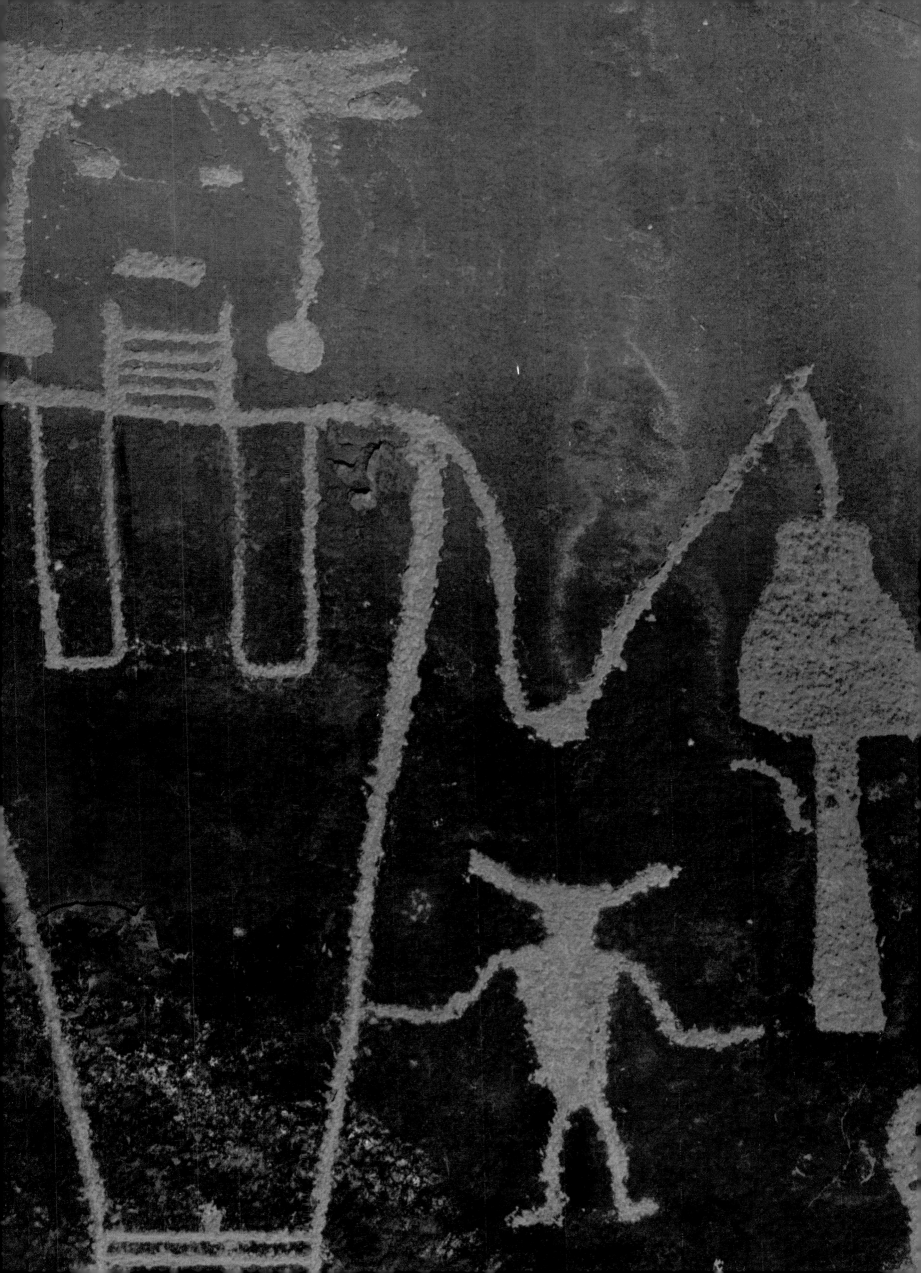

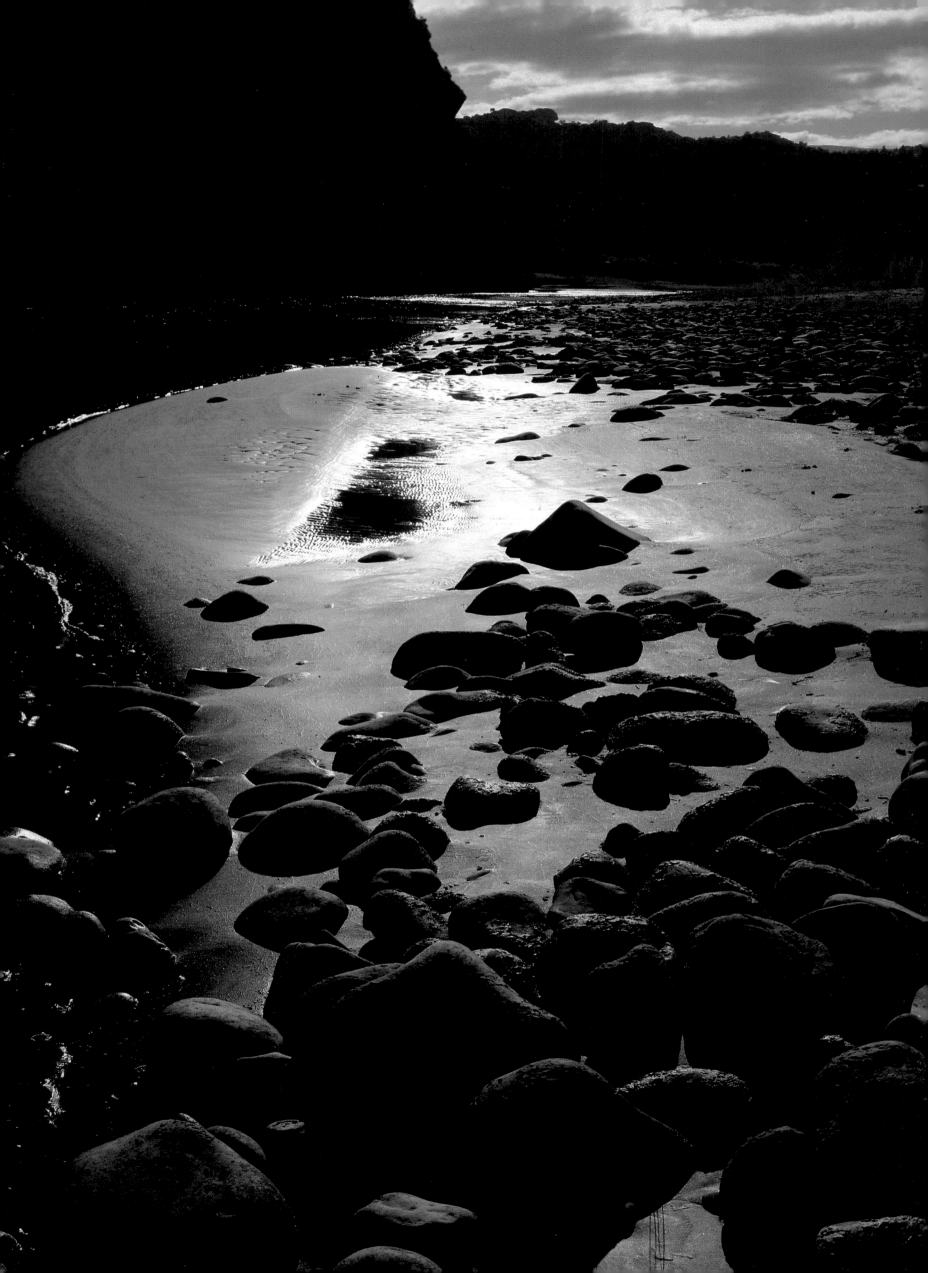

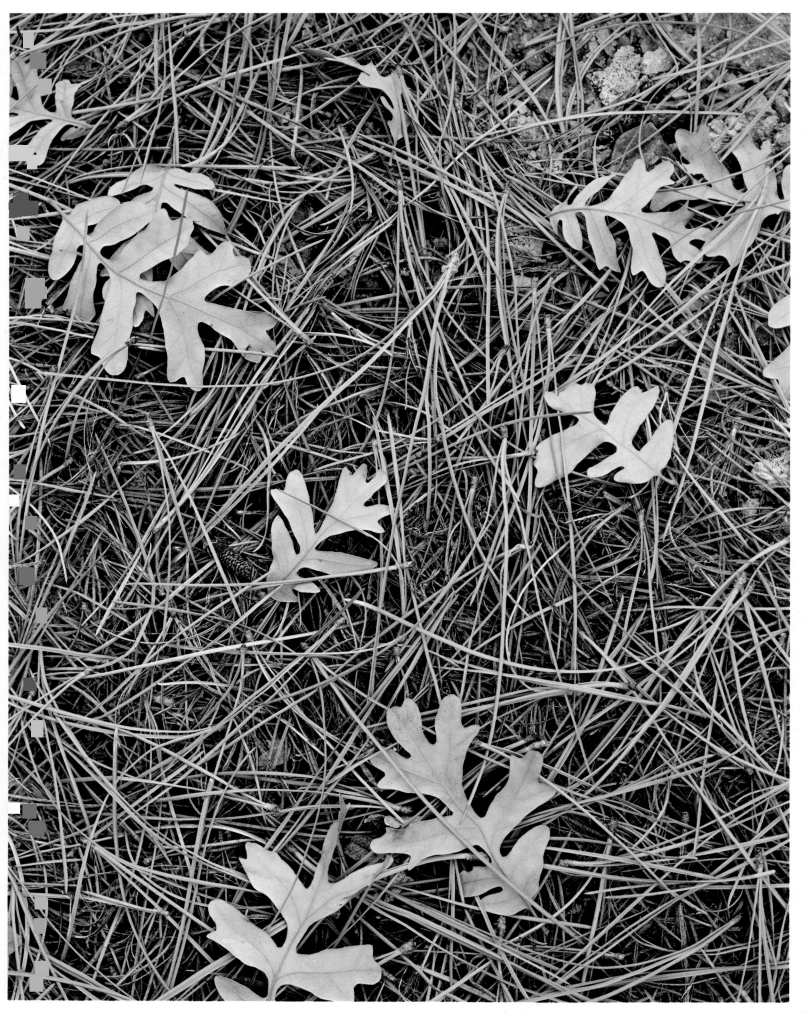

A patterned carpet of ponderosa pine needles and Gambel oak leaves
protect the soil. Pine needles fall a few at a time, with some remaining green
on branches throughout each year. Oak leaves fall in autumn, and new ones
are formed each spring. Big Rock Candy Mountain, Sevier County. *Left:*
Waters of the Green River have deposited rounded cobble and bars of mud,
both products of erosion, for countless centuries. Split Mountain Gorge,
Dinosaur National Monument.

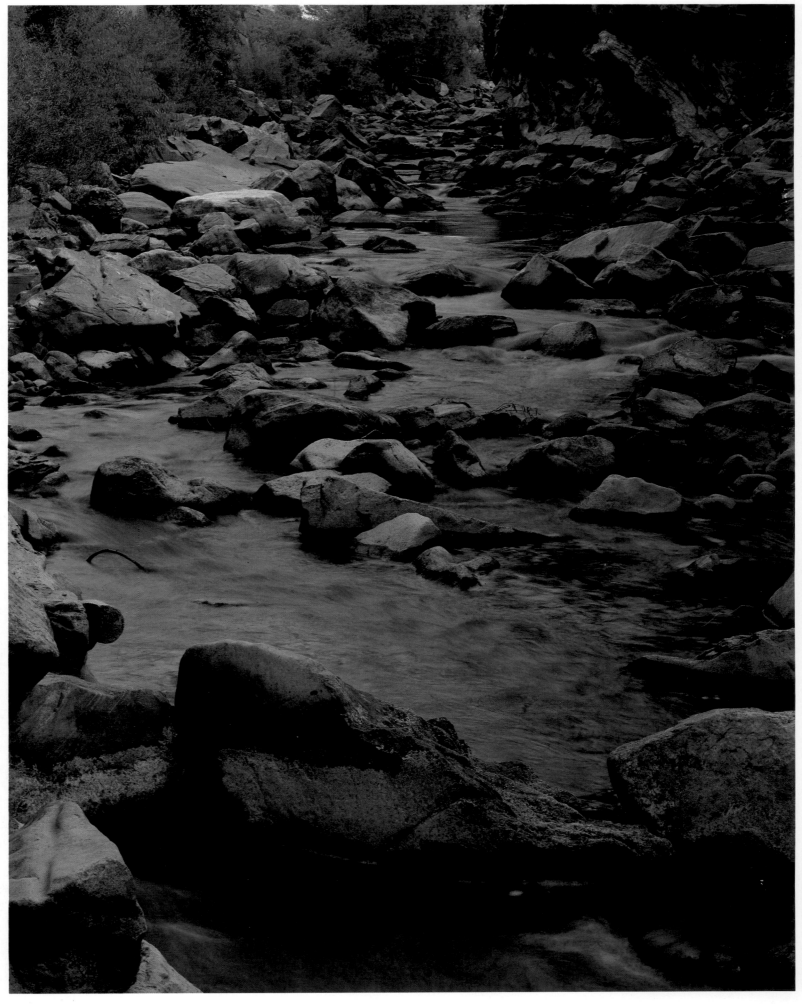

Leinhard Party road, August 6, 1846. "... we slid rapidly down into the foaming water, hitched the loose oxen again to the wagon and took it directly down the foaming riverbed, full of great boulders..." Devil's Gate, Weber Canyon.

THE PEOPLE

Arrival of the first people in Utah was unheralded and unrecorded, but that event took place sometime more than 10,000 years ago when Lake Bonneville stood deep with fresh water. Furtively they explored this vast and unknown land; quietly like animals, they searched for food and for shelter. Seeds of pickleweed and ricegrass, tender leaves and roots, rodents, insects, eggs of birds, and practically everything that could be eaten was gathered, trapped, snared, or captured. Bark of trees and shrubs, hides of animals, feathers of birds alone and in combination with strips of fur provided protection from the chill winds of winter. For millenia these peoples, distantly seen and poorly known, walked the hot lands of summer and trod the mud, frozen in times of cold, and marked the landscape white with snow with tracks alien to this region.

Wandering in search of game and of seeds, the people penetrated even the most remote regions. Alcoves, grottos, and other shallow rock shelters served to protect these hardy men, women, and children from the harshness of the climate. Survival and existence was the reward reaped by the generations who were born, reared, taught the lore necessary to exist, and died in the vastness of time before recorded history. Some shelters inhabited by early man are piled deep with accumulations of wastes discarded during the lives of those who stayed there.

At Hogup and Danger caves in western Utah, the people returned season after season for centuries, with occupancy continuing for more than 9,000 years. These early peoples belonged to what is known as the Desert Culture. Evidence of their existence is found throughout the region. Arrow and spear points, hand axes, and other implements of stone, some of excellent quality, give an indication of skill and/or a lifestyle quite alien to our own. Few were the numbers of people who could survive in this land, even by industry in gathering and a lack of fastidiousness in consideration of what could be eaten. Travel on foot did not allow the accumulation of many belongings. Peoples of the Desert Culture persisted in their wanderings following the seasons, returning to hunting and gathering grounds without significant modification of routine until about 2,000 years ago.

Late in the history of the Desert Culture, some of the people, perhaps in quest of a more efficient way to gather seeds, learned to make baskets of exquisite quality, with the warp and woof so tight as to prevent even the smallest of seeds from falling through. Artifacts of the lives of men mark changes within civilizations, much as fossils serve to indicate changes in evolution of life as recorded in geological strata. Makers of baskets, as evidenced in the antique archeological strata, were later recognized by this singular motif and were given the corresponding name of Basket Maker.

Accumulation of goods necessary for more than a meager survival tended to cause the owners to tarry in a place, but the demand for food forced the people to move onward relentlessly. Only with development of a reliable food supply could the nomadic way of life be supplanted. Adoption of agriculture based on cultivation of beans, corn, and squash, probably introduced by agricultural societies living to the south, allowed the annual migrations for food to cease.

Following the acquisition of agricultural crops and techniques, the Basket Makers were able to develop accoutrements to make sedentary life more comfortable. Houses were built. The houses underwent an evolution from pit houses made of leaning poles covered with bark and mud, only partially lowered into the ground, to sunken houses whose surfaces were level with the ground surface.

The passing generations came to revere the underground houses, because of their antique origin, and to treat them as places of religious significance. They became the kivas, or ceremonial rooms, constructed with features peculiar to their use. Living houses were made of coursed stone and were situated at ground level, and had pole roofs covered by bark and mud.

Somewhere in the process of evolution of culture and of appearance, the Basket Makers were transformed into what came to be known as the Pueblo. In the course of modification of one culture into the other, a significant development was the use of clay in the manufacture of kilned pottery. Chards of pottery provide markers within archeological strata, and record the changes in form and pattern as skills and art forms varied through the occupations.

The Basket Maker-Pueblo later became part of the Anasazi culture. Mainly that culture developed in eastern and southeastern Utah, in the redrock lands of deep canyons and mesas. The Pueblo period of the Anasazi developed from A.D. 700-1100. It flourished mainly on the mesa tops and in the canyons until around A.D. 1200, when for some unknown reason there was a movement into the alcoves formed beneath rimrock along mesa margins. During the next 100 years, the Anasazi lived in cliff houses.

Both surface and cliff dwellings occur by the thousands in southeastern Utah and adjacent Arizona, Colorado, and New Mexico. Excellent examples are present at Hovenweep and Natural Bridges national monuments. Dwellings, ceremonial kivas, and storage rooms or granaries exist in the canyons, some appearing nestlike, high in crevices or along shelves of canyon walls throughout the canyonlands.

West of the Colorado River, a second culture developed: the Fremont. That culture differed in minor ways from the Anasazi. The peoples lived in canyons along the western drainages of the Colorado River, and west into lands of the Desert Culture. Subsisting on agricultural crops of beans, corn, and squash, the Fremont peoples lived much as did the Anasazi. Crops were grown along minor drainages, with terraces constructed to trap sediment and water from periodic storms. Hunting and gathering continued to supplement the bland diet of agricultural crops. Wanderings of Anasazi and Fremont peoples are recorded in pictographs and petroglyphs on stone walls, in which art depicts animals, people, and events which still today intrigue anthropologists who study them.

Throughout the period of the Anasazi-Fremont cultures there persisted in the surrounding lands a continuation of the Desert Culture. When, at the end of the thirteenth century a cultural regression occurred among the agricultural societies, the regions occupied by them in Utah were abandoned to the nomadic bands.

The Pueblo culture persists to the present in northern Arizona and New Mexico. The Hopi, Zuni, and Tanoan tribes of those areas are connected in tribal lore with the abandoned villages to the north. Certainly the culture is similar, and the architecture and pottery connect through space and time with those dwellings abandoned near the end of the thirteenth century and later. Abandoned were the footprints

made by children whose laughter had filled the air in summer when fluffy white clouds reflected the redrock country beneath them, softly pastel on pink suffused bottoms.

Displacing the Anasazi and Fremont cultures, or possibly developing in part by assimilation, are the bands which inherited the region following abandonment. These bands subsisted by gathering and hunting in nomadic wanderings similar to that which lasted for millenia under the Desert Culture. Languages of most of the bands are related within the Shoshonian subgroup of the Uto-Aztecan linguistic family. Included within the region of what became Utah were the Northern Shoshoni, Gosiutes and other western Shoshoni, Southern Paiutes, and the Utes. Northern Shoshoni bands were located in what became northern Utah, southern Idaho, and Wyoming. Gosiutes occupied portions of northwestern Utah and northeastern Nevada. Southern Utah, southern Nevada, and northern Arizona served as home for the Southern Paiutes. The Ute occupied portions of central, eastern, and southeastern Utah and western Colorado.

Hardy and with a wisdom borne of a tradition developed during ages of living under harsh conditions, the Indians adapted to the realities of climate, food supply, and availability of water in the regions where they lived. Mostly they depended on small game and on seeds and insects. In places where water was available some of the bands planted small gardens, supplementing wild fare with vegetable crops. Walking was the means of travel until the sixteenth century when horses, introduced by Spaniards during their conquests in Central America, penetrated the area. Lands occupied by the bands within Utah are among the most harsh in North America, and the ability to derive a living from those lands is evidence of skill and wisdom of these people.

To imply that the Indian lifestyle was sublime is to obscure the fact that different bands were predatory on others, with women and children being captured and sold into slavery to neighboring groups, and that was accomplished not without bloodshed. Food supply was not dependable, and lifespan was short on the average.

Late in the history of human occupation of the region a group of Athaspacan-speaking Indians, who referred to themselves as "Dineh" (The People), arrived in the Southwest after a centuries-long migration from what is now Canada. They came to be known as Navajos. These peoples had been a nomadic hunting and gathering group, but absorbed the culture of the Pueblo societies, and later of the Spanish tradition which they contacted. Under pressure from the Utes and other Indians, the Navajos moved westward from the New Mexico region in the eighteenth and early nineteenth centuries. Much of the period of their occupation of lands in Arizona and Utah corresponds roughly with the advent of European settlers in the region. Rapid growth and spread of Navajos into what is now San Juan County is largely an occurrence of the twentieth century.

With the Spanish came the domesticated animals and cultivated plants that would forever change the lives of the Indians. Horses, sheep, and goats especially were adapted in a new pastoral life for many of the Indians. Peaches, apricots, watermelons, and other cultivated plants provided variety to the diet of corn, beans, and squash. The seeds of these introductions provide a new archeological landmark by which entry of Spanish culture can be recognized.

Excursions by Spanish explorers moving northward from New Spain brought the first contact with indigenous peoples of Utah. From that time forward, the intercourse of Indian to Indian would be supplanted by an ever-increasing exchange between Indian and diverse kinds of explorers, entrepreneurs, and settlers. And, not to be outdone by raiding and taking of slaves as practiced by the Indians, the Spanish in the seventeenth century began to raid the Utes to acquire slaves. Penetration by exploration parties awaited the latter part of the eighteenth century. The epic story of exploration outlined in the Dominguez-Escalante journal is classic in detail and description of a portion of the Southwest now within Utah.

In searching for a route from Santa Fe, New Mexico, to newly formed missions in California, the Dominguez-Escalante party traveled along a tortuous path north to Colorado where they entered Utah for the first time east of the present town of Monticello on August 16, 1776. The encounter with Utah was brief, for they returned almost at once to Colorado where they wandered for about a month through canyons and over passes before again entering the area. By September 12 they had reentered the state along Cliff Creek in the Uinta Basin.

On the 13th they came to Musket Shot Springs which they named "Las Fuentes de Santa Clara." Their fascination with water is found in the description: "two copious springs of the finest water. . . . " This is the first indication in literature of what was to become an obsession with water among all

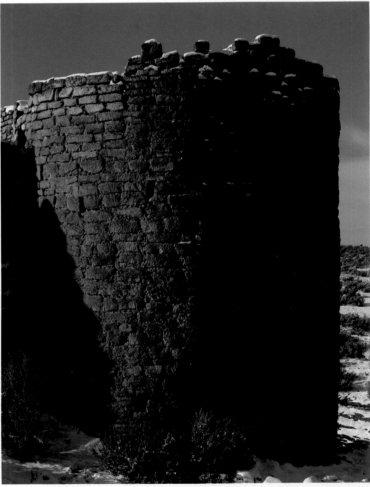

People from the Pueblo era shaped stone and mortar to build a tower and other structures, providing testimony to their skill and energy. Hovenweep National Monument.

18

future peoples to inhabit this arid region. The Dominguez-Escalante party camped along the Green River about six miles north of the present town of Jensen before moving west to Utah Valley where they arrived on September 23. After visiting the mouth of the Provo River where it enters Utah Lake, the party traveled southwesterly to present-day Washington County where they exited to Arizona.

The only other experience with Utah by this party occurred from November 3 to 8, when they traversed into the region of the state while trying to find a route through the tangled gorges of the lower portion of Glen Canyon. The land yielded little in the way of food to these travelers in this foreign land, and they ate some of their horses before leaving the state a final time.

The discoveries of the Dominguez-Escalante party were great, even though there was no attempt to consumate plans to establish outposts of the Spanish Empire or to find a route to the missions at California. More than 50 years were to pass before the Spanish trail was completed from southwestern Utah to California. In 1830 a party of Santa Fe traders led by William Wolfskill completed that final leg of the journey. Dominguez-Escalante discoveries include the Green and Duchesne Rivers, Utah Lake, Sevier River, Sevier Lake, Virgin River, and the lower end of Glen Canyon. A map based on the detailed description of the expedition was drawn by Miera y Pacheco in 1778, giving the world its first representation of this vast land.

Trade between the Spanish and the Utes followed the opening of the region by the Fathers and was to continue until the 1850s after the Mormon occupation. Trading in furs had been a mainstay of commerce among indigenous peoples and was a basis for intercourse between them and Europeans. It is surprising that the taking of furs should have long exempted the Utah area. Pelts of beaver to be made into hats brought $10 each and more in middle-western markets in the 1820s. British, French-Canadian, and American trappers and traders each mounted independent expeditions towards the intermountain region. Willam H. Ashley, in partnership with Major Andrew Henry, advertised for young men to be employed in the western fur trade. Among those responding were Jedediah S. Smith, James Bridger, John H. Weber, and Moses Harris.

By 1824 these men were deep into the western region, where they encountered Peter Skene Ogden of the Hudson's Bay Company preparing to move into lands sought by the Americans. Ogden was to play a game of economic hide-and-seek with Weber and Smith as they trapped in Cache Valley, Ogden Valley, and lower Weber Valley, where the British under Ogden and the Americans clashed. Desertion of a part of the British party led by Ogden and loss of furs, horses, and equipment was the result of the argument and show of force by the Americans who stated that the region was United States land. They were wrong; the area was jointly claimed by the British and by Mexico. The American trappers were firmly entrenched within Utah following the initial encounter with the British in 1824-25.

Etienne Provost, a Canadian operating from Taos, New Mexico, is known to have been along the Green River south of the Uinta Mountains in 1824. He followed the Duchesne River to its headwaters, crossed a divide, and came upon a river which was to bear his name (Provo), and followed it to Utah Lake. He was at the British camp on the Weber River in May 1825 when the British and American encounter took place, but he did not participate.

William Ashley was in the Uinta Basin in the 1820s, but little is known of the activities of other of the Mountain Men, as the fur trappers and traders are known, in that basin. In 1837 Antoine Robidoux, apparently based in New Mexico, built a trading post on the Uinta River near the present White Rocks. Attesting to his intent is an inscription in Westwater Canyon, a remote canyon draining south from the south rim of the Uinta Basin in present Grand County. The inscription in French states, "Antoine Robidoux. Passed here on 13 November 1837 to establish a trading post on the Green or Uinta River."

Most of the Mountain Men were transient in what is now Utah. They established temporary trading posts and provided information on the region, but most of them moved on to other endeavors as the fur supply dwindled. Some of them were still in the mountains when settlers began to trek through the region on the way to California and Oregon.

The Bartleson-Bidwell Company entered Utah along the Bear River in Cache County and followed that river into the basin of the Great Salt Lake. There they skirted the north end of that lake to Pilot Peak, now in Nevada. Soft moist saline valley bottoms, lack of water and feed for animals, and wear of the long journey proved to be too much for the travelers. With the abandonment of some wagons before they reached the springs near Pilot Peak on September 13, 1841, the party later abandoned all of its wagons and proceeded across Nevada to California mounted on horses, oxen, and mules. The route they followed through Utah was not used again by wagon trains, and the difficulty they experienced was a mere forerunner of the trial of the Donner party a few years later.

Explorer John C. Fremont entered the region, also along the Bear River in Cache Valley, in August 1843. On September 6 Fremont and his associates climbed to the summit of Little Mountain west of the present city of Ogden where they viewed Great Salt Lake. With some difficulty Fremont, ac-

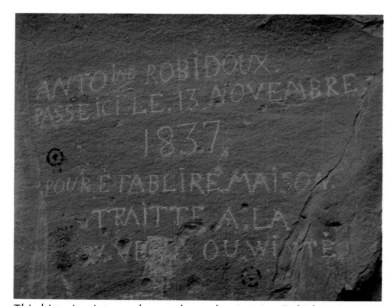

This historic pictograph was drawn by Antoine Robidoux in 1837 when he passed through a rugged canyon of the Book Cliffs on his way to the Uinta Basin where he built a trading post along the Uinta (Winte) River. Grand County.

companied by Kit Carson among others, reached an island in the lake which they named "Disappointment," because the island had neither water nor trees of any kind. The island was renamed "Fremont" by Captain Howard Stansbury in 1850. Of the white men in the region probably the first to see Great Salt Lake was James Bridger, during the trapping season of 1824-25. James Clyman and others circumnavigated the lake in 1826. Thus, Fremont was late on the scene, but was the first to determine the elevation of the lake (4,200 feet), and the first to learn that about a quarter of the water consisted of dissolved salt. Fremont moved across the vast lands of the western part of the United States as though it was a much smaller place. He crossed the Sierra Nevada range in mid-winter of 1843-44 to reach California, but by May 24, 1844, he was at Utah Lake, where he described the lake mistakenly as an arm of Great Salt Lake. He left the region on May 24 en route to the East, but was back again in 1845.

On the night of October 13, 1845, Fremont camped where Salt Lake City would be esablished in less than two years. Striking west from Salt Lake Valley, Fremont, with Kit Carson acting as an advance scout, traversed the desert regions south of Great Salt Lake to Pilot Peak, which they named. Animals died along the way, indicating the difficulty of attempting to cross this region, even for a well-provisioned and well-prepared party mainly on horseback. Arriving at Sutters Fort in California in midwinter, the Fremont party met with Lansford Hastings, giving him information of their route from

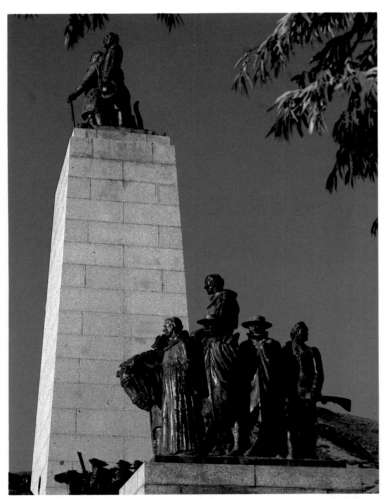

At a site not far from the "This is the place" Monument, Brigham Young uttered some version of the now famous words, "This is the right place," on July 24, 1847.

the valley of the Great Salt Lake, a shortcut which would bear Hastings' name.

Hastings rushed eastward to intercept the wagon trains traveling west along the Oregon Trail in present-day Wyoming. The Oregon Trail in Wyoming was common to travelers both to Oregon and to California. It was Hastings' proposal to aid those bound for California by providing a shortcut. The Hastings Cutoff would save more than 200 miles of travel, about 20 days by wagon, for those going to California. He retraced Fremont's route to Salt Lake Valley on horseback and arrived at Fort Bridger in Wyoming in early June via Parleys Canyon, Big Mountain, Weber River, and Echo Creek. Like other "shortcuts" the Hastings Cutoff proved to be what was later described by Lienhard, of a Swiss-German party, as "Hastings Longtripp."

Lienhard and his group had followed the Harlan-Young party down the Weber River through what came to be known as Devils Gate, where they drove teams pulling wagons, held from tipping by men at each wheel, down into the rushing water of the boulder-clogged channel because there was no other way. Beyond the mouth of the Weber Canyon, this party overtook the Harlan-Young group on August 8, 1846. The two groups traveled together or near each other during the balance of the trip in Utah. The Lienhard party seems to have been the only wagon train of the year to traverse the saline pans of western Utah without loss of livestock or wagons.

Behind them came the Donners. They arrived at Fort Bridger on July 27, where they turned westward along the route that was to lead them to a place in history unenvied by all others. Arriving along the Weber River at present-day Henefer, they were directed by a note left for them by Hastings to proceed over the divide into the Little Mountain region, where they turned west into Emigration Canyon. The route to the Valley of the Great Salt Lake, which was later followed by the Mormon migration, was essentially completed by the Donner party. Not until August 28 did they arrive at the Skull Valley campsite near the present town of Iosepa, and only then after burying one Luke Halloran at Twenty Wells (Grantsville) alongside the two-week-old grave of John Hargrave of the Harlan-Young party.

A pieced together note by Hastings was found which indicated that two days and nights of hard driving would be required to reach water. The terse description bore no resemblance to actuality. The route, clearly marked by those who preceded them, lay across low ranges, through minor sand dunes, across mudflats, and finally onto the Great Salt Lake Desert, a great wet playa. The first and second days passed, and Pilot Peak still stood sentinel-like on the distant horizon. The situation was becoming desperate, and possessions began to mark the deeply rutted path, as people abandoned their goods to lessen the weight of wagons which sunk deeper into the wet pans with each mile forward. Animals, weakened from the long walk through lands already traversed by many others, without feed, or water to drink, died along the way.

It was apparent to everyone by the beginning of the third day that the ragged march had become a race with death. That night they were still 25 miles from water at Pilot Peak, and all water in their containers had been used. Animals were finally loosened from lines and harnesses. They made their way to water at Pilot Peak, or wandered elsewhere, as many of the animals were never seen again. Men on horse-

back rode for water, which they brought back to those who could not travel, and finally most of the wagons were brought to the springs. Too late, with too little preparation, poorly advised, with worn gear and tired animals, they labored west to starvation and worse. Their sojourn through Utah had cost them time that could not be replaced. Still, members of the Donner party had built a road that would be followed in less than a year by leaders of the Mormon exodus.

The Mormon hegira actually began in 1830 in Fayette, a small farming community in western New York. The Mormon beginnings are traceable to Joseph Smith, who gained attention at Palmyra, New York, in the 1820s by announcing that he had discovered, under divine guidance, a history of the Americas inscribed on plates of gold. The story from the plates recounted the history of early peoples on the American continent, of heavenly visitations by Christ, and of difficulties and destruction of the civilization as a result of apostasy. When the Book of Mormon was published in 1830, its adherents were bound by a sense of common cause in preventing a similar fate from befalling the Church of Jesus Christ of Latter-day Saints, as they referred to themselves. The church proclaimed to have been annointed to spread the gospel to all the world, and that Christ had restored the gospel in its fullness to Joseph Smith.

The concept of one true church, one authoritative priesthood, and other proclamations caused great antipathy to the Church and its members. They moved from New York, first to Ohio, where at Kirtland, they built a temple and lived for a short time. After a period of trial and of purging, the members moved again, this time to Missouri. Lands at Independence had been designated as a New Jerusalem, a gathering place for a modern Zion. But the region was already occupied by people who resented the concept that the land was promised to members of the newly organized church. Mutually exclusive and increasing in political power, the Mormons were opposed by the people of Missouri. Conflict developed, became violent, and following bloodshed and loss of life, and, under order of extermination from Missouri Governor Lilburn W. Boggs, the Mormons were forced in 1838 to flee. The Mormons were welcomed in Illinois for humanitarian and political reasons, but by 1844 opposition had again developed. In that year Joseph Smith, prophet and president of the Church, and his brother Hyrum were shot to death while being held in jail on charges arising from destruction of a printing press belonging to dissenters.

Leadership of the Mormons fell to Brigham Young. The Mormons had planned for some time to migrate to the west where they could live and practice religion as they felt necessary. However, the beginning of the migration west was more in the form of a retreat from the magnificent city of Nauvoo, site of their great temple, center of Mormon hopes and dreams, and second-largest city in Illinois. The exodus began in February 1846, when winter conditions caused suffering and made the trip across Iowa a time of hardship and disillusionment. A temporary camp, known as Winter Quarters, was established west of the Missouri River, a few miles north of present-day Omaha. This encampment became the headquarters of the Mormon Church, and the staging point for colonization of the west. The last group of Mormons with allegiance to the body of the church then under direction of Brigham Young was driven from Nauvoo by guerrilla force in September 1846.

Outbreak of the war between the United States and Mexico coincided with the Mormon exodus from Illinois. Recruited from among the Latter-day Saints at Winter Quarters were 549 men who became the Mormon Battalion. The battalion was not organized so much to help with the war against Mexico as to conciliate the Mormons, attach them to our country, and prevent them from taking part against us, as was stated in orders from President James K. Polk. The Mormons were, in fact, about to leave the United States, because the land which served as their destination was still within the jurisdiction of Mexico. The battalion, along with wives and children, some of them also on the payroll, departed in July 1846. They marched for more than 2,000 miles in somewhat more than five months. In piecemeal fashion they were to join the Saints during their migration or after they had reached Salt Lake Valley. Some came via Pueblo, Colorado, others from California.

Led by Brigham Young, and with only a general idea of where they were bound, the advance party of 143 people, including three women, left Winter Quarters on April 5, 1847. They were joined by other Saints from Pueblo along the trail west of Fort Laramie. The original company continued to increase in numbers as it moved west. Detailed information on the Great Basin was supplied by Moses Harris, Thomas Smith, and James Bridger, Mountain Men who were encountered along the Oregon Trail in present-day Wyoming. These trappers considered Cache Valley and the

For some 1,200 miles, from Iowa City, Iowa, to the valley of the Great Salt Lake, pioneers demonstrated faith and dedication, dragging carts laden with belongings, and themselves walking, bearing hopes and dreams. Handcart Pioneer Monument, Temple Square.

areas around Utah Lake as the possible sites for successful settlements. James Bridger especially was concerned about large-scale attempts at settlement until it was demonstrated that crops could be grown. The Mormons also encountered Miles Goodyear along the Bear River in southwestern Wyoming. He assured them that vegetables were being grown at a trading post on the Weber River near present-day Ogden, but was not enthusiastic about the Mormon proposal to settle in Salt Lake Valley.

The decision to settle in the Salt Lake Valley was made some time during June 1847. Even the entrepreneur Samuel Brannan traveling east from California, who met the advance party on June 30 at the Green River crossing below present Fontinelle Dam in Wyoming, could not induce them to travel on to California. The decision had already been made, for when the wagon train arrived at the beginning of the Hastings Cutoff, they turned west away from the Oregon Trail.

Brigham Young was seriously ill with a fever that was to persist for the remainder of the trip to the valley of the Great Salt Lake. The valley was entered on July 21 by Orson Pratt and Erastus Snow, who, with an advance scouting party of 23 wagons and 42 men, had moved ahead of the main column. The wagons of the Pratt-Snow group did not reach the valley until July 22, after a few hours of cutting a new road around Donner Hill near the mouth of Emigration Canyon. On July 23 Pratt and others of the scouting party selected a site near City Creek in the north end of the valley for the first attempt at clearing and cultivation. Plowing began at once, and that

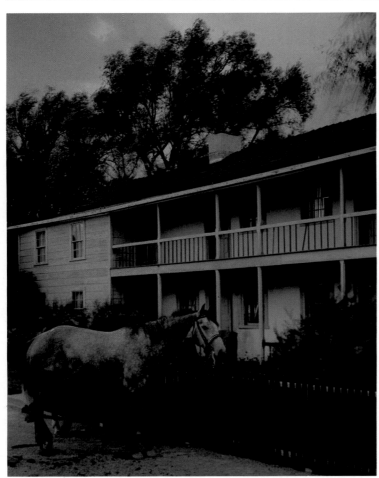

A resting place for weary travelers, Stagecoach Inn provided Overland Stage and Pony Express riders relief from travel over rough and dusty or muddy roads. Fairfield.

evening the land was dedicated in prayer as future home of the Saints.

Brigham Young and the remainder of the party entered the valley on July 24, 1847. Near the present "This is the Place" monument, Brigham Young arose from his sickbed and noted that this was the right place. That decision had been made earlier, otherwise the plowing and planting would have been premature, as would have been the dedicatory prayer. Brigham Young and other leaders remained only long enough to set the affairs of the settlement in order before beginning the return trip to Winter Quarters. By autumn of that first year, more than 1,600 people were living in Salt Lake Valley. Exploration was soon under way, and settlement in nearby valleys began almost at once. By 1857 some 100 settlements had been established.

Selection of sites for new communities was based on location of water in sufficient quantities to supplement the low rainfall of the region in growth of crops. Communities functioned on shared labor, with members contributing to such projects as building dams, irrigation canals, roads, and chapels. The fascination with water which had been experienced by members of the Dominguez-Escalante party was to become an affliction of these new inhabitants and their descendants. The agrarian life centered on ownership of shares of water. Conflict between ownership and use of water has sustained the judicial system of Utah since pioneer days. Land without water for irrigation was of less value than that with a "water right."

That settlement and occupation of the intermountain west went forward without great difficulty was not the case. Heavy rains poured from clouds in March 1848, melting the hastily prepared clay bricks of houses and pouring water in torrents through sod roofs. Planting went well that first spring in the valley, but when the fields were green and lush, giving promise of substantial harvest, the crickets came. Humpbacked, black and shiny, voracious of appetite, hopping and with long antennae sensing the air, the crickets moved through the native vegetation into fields of cultivated plants, eating all leaves and stems which they encountered.

Settlers battled the insects with all their resources and knowledge. Still the insects came, and, when the pestilence had consumed a portion of all crops, the sea gulls came. With waxy white feathers on slender wings and graceful bodies, web-footed and thick-billed, the gulls moved swiftly through the air to fields now alive with black and oily creatures. The gulls gorged themselves on crickets, flew away, and returned the next day, and the next, until the crickets had all been eaten. The settlers viewed the act of their salvation by the birds as providential, and people of Utah have revered and protected gulls since that time. Statues have been built to honor them, and the California gull has been recognized in tribute as the state bird of Utah.

Non-Mormons arrived in the valley almost at once, and dissention between them and the Mormon majority living under the benevolent theocracy led by Brigham Young began simultaneously. The region was ceded to the United States by treaty with Mexico in 1848. Brigham Young served in dual capacity as president of the Mormon Church and as territorial governor. Minor territorial officers were appointed in Washington to serve in the new territory. Anticipating more than could be expected, they found themselves at cross purposes with Brigham Young and other Mormons. Unfavorable re-

ports were written by the officers to the federal government in Washington. The announcement by the Church in 1852 that plural marriage, or polygamy, was an integral part of Mormon doctrine, made the charges more plausible.

Brigham Young had ruled the territory since his arrival there, and he continued to have the last word with regard to Mormons in the region until his death in 1877. Discussions in the halls of Congress had linked polygamy with slavery as "twin relics of barbarism." In the 1856 presidential campaign both Republicans and Democrats had denounced polygamy, and had sought ways to curb the practice and to discipline the Mormon majority. For years Congress and several U.S. presidents had been concerned with the Mormon "problem." Elected in 1856 was James Buchanan, Democrat and politician. He decided that Mormons were in a state of rebellion, that Brigham Young should be replaced as governor, and that neither could be controlled except by force. Without careful investigation of facts, and without consultation with the people in the Territory, Buchanan chose to select Alfred Cumming of Georgia as governor and ordered General William S. Harney to organize a military force to accompany the newly appointed governor to Salt Lake City.

In summer 1857 preparations were made to celebrate the first decade of colonization of the region, and to take stock of the impressive accomplishments. Freedom from overt persecution and lack of blood-letting, which had been their lot in Illinois and Missouri, along with tremendous increase in numbers and in material wealth, had allowed growth of conviction that they would never again be persecuted and driven from their homes and lands. The date July 24 had been selected as the anniversary. Brigham Young and other Church officials and numerous members had assembled at Brighton in Big Cottonwood Canyon to celebrate the occasion. Little did they realize the events that were transpiring.

A few days earlier Orin Porter Rockwell had been traveling along the Oregon Trail at Fort Laramie in eastern Wyoming, when he learned that the army was advancing on the stronghold of the Saints. Rockwell rode west as fast as horses could be run, and finally into the midst of the celebration with the alarming news. That the Saints were incensed by the information is an understatement. They prepared to defend themselves against the invasion. They were strong and secure in their mountain kingdom, and did not feel it necessary to again undergo persecution and anguish so fresh in their minds from experiences in Illinois and Missouri.

Attempts were made by friends of the Mormons to intercede in the nation's capitol, but the troops had been dispatched from Fort Leavenworth, Kansas, on May 28. Now they were far advanced along the road to Salt Lake City. Brigham Young was still territorial governor until his replacement could arrive and be installed. Seizing upon this technicality he issued a proclamation in September declaring that the militia would resist any invasion of the territory. Under a state of martial law, members of the militia, known as the Nauvoo Legion, sallied forth to meet the enemy. With orders to avoid blood-shed, the mounted militiamen made guerrilla raids against the advancing Army of the United States. They burned three supply trains, captured horses and cattle, interrupted military communications, and delayed the advance of an army of 2,500 men.

Finally the army was forced into a winter camp in southwestern Wyoming. General Harney had been replaced by Colonel Albert Sidney Johnston in September, and the hallmark of the Utah War is known as "Johnston's Army." There is little doubt that the army could have forced its way into Salt Lake Valley had they been so inclined, but prudence dictated that there should be no casualties in this conflict of pathos and comedy. The next year the valley was entered by the army following negotiations during which it was demonstrated that the supposed insurrection did not exist. Johnston's Army marched through Salt Lake Valley to a bivouac in Cedar Valley where they established Camp Floyd. The expedition was a costly blunder which ultimately benefited the Mormons when Camp Floyd was abandoned, and all military property was sold as surplus.

As the army moved towards the Mormon stronghold, a wagon train was traversing the road through the settlements in southern Utah on its way to California. Because of poor communications, because of fear due to the knowledge that an army was moving towards Utah, and because of alleged and real offenses by members of the wagon train, known as the Fancher party, a tragedy developed. Annihilated were some 120 immigrants during a four-day siege at a quiet and charming place known as Mountain Meadows. The meadows were to provide the name of the massacre that had ramifications which would reach to the heart of Mormondom and would provide a common thread in the judicial system for two decades.

John D. Lee, adopted son of Brigham Young, victim of circumstance, and unfortunate star of the ill-fated drama would be tried in federal court, have the trial dismissed, be retried and found guilty some 20 years after the fact. He was executed while sitting on the edge of his casket at the site of the massacre on March 23, 1877. Buried at Panguitch, his grave is marked with a slab of stone inscribed with the words, "You shall know the truth, and the truth shall make you free."

There were survivors of the massacre, mainly young children who were returned to relatives in Missouri and Arkansas. At least one child was reared by a Mormon family which has figured prominently in southern Utah history, and many people trace their lineage to that survivor of the tragedy.

Polygamy continued to be practiced, and to be a subject of hostility and intense feelings both in and outside the Church. Statehood for Utah continued to be denied as long as "immoral polygamy" was practiced by Mormons. Laws passed against polygamy were tested in the Supreme Court, were upheld, and provided a basis for a not-so-subtle form of harrassment and persecution by government agents. Surreptitious stalking of men who were suspected of cohabitation spread an aura of fear amongst the small percentage of the populous which practiced polygamy. Jail sentences were meted out to those found guilty. Members of the hierarchy of the Church were jailed, and others were driven underground. Church property was confiscated by the government. Finally, in 1890, Wilford Woodruff, then president of the Mormon Church, issued a manifesto declaring that polygamous marriages would no longer be allowed. Members of the Church would abide with the "law of the land."

A final application for statehood was honored, and in 1896 Utah was added to the United States in full membership. The decades following the Utah war had been marked by progress. Wagons had carried freight and mail to and from the Mormon communities since the initial establishment. The link with the established states of the Union was tenuous,

and ways of establishing faster communication and better means of transportation were sought. The mail service established in 1850 was slow and unsure at best.

The firm of Russell, Majors, and Waddell, which had made handsome profits in freighting, undertook a costly venture known as the Pony Express. A series of stations supplied with corrals, feed, and water were provided along the route from St. Joseph, Missouri, to Sacramento, California. Young men on horseback relayed the mail from station to station. Salt Lake City could expect service from Washington, D.C., in seven days and from Sacramento in four days following establishment of the Pony Express. The undertaking was an economic disaster for the founders, and persisted only from April 1860 to October 1861, when it was replaced by the overland telegraph. A romantic aura persists from the Pony Express; certainly no one was ever more alone than a young man bent low over the back of a galloping horse, at night in a driving rain, along some desert tract midway between stations. Completion of the transcontinental railroad in 1869 brought to an end the wagon trains of the overland freight. Freighting operations henceforth would be local.

Surveys of the region had been conducted since the time of Fremont in 1843. Stansbury had explored the Great Salt Lake in 1850. Fremont had returned in 1853, and Captain John W. Gunnison, also in Utah in 1853, was killed by Indians near the present town of Delta while exploring for a railroad route to the Pacific. Perhaps the most important, and certainly the most romantic, of the surveys were those of John Wesley Powell. Powell had lost an arm during the Civil War, but did

not let that loss deter him from exploits which mark his place in history. In the late 1860s Powell explored through northwestern Colorado into the Uinta Basin in Utah and in southwestern Wyoming.

With information derived from these explorations, Powell organized an expedition to explore the Green and Colorado rivers whose routes were mainly unknown. The expedition was launched at Green River, Wyoming, on May 24, 1869. The trip led Powell through or along the mouths of canyons which bear the names he gave them, Lodore, Desolation, Whirlpool, Glen, Dirty Devil, and many others. Studied was every aspect which could be observed by the party. They mapped the river, computed elevations, noted evidences of previous occupations by Indians, and recorded what they saw. Dangerous was the passage through the cliff-lined gorges where water, once calm and placid, changed to furious white-capped waves rushing at great speed over boulder-strewn and whirlpool-marked rapids.

Powell undertook a second expedition through the canyons of the Green and Colorado rivers in 1871, beginning again at Green River, Wyoming, in May and leaving the river at Lee's Ferry near the mouth of the Paria River in late October. There Powell met with John D. Lee, principal of the Mountain Meadows Massacre, secluded and safe for the moment in the vast stillness of his retreat, "Lonely Dell." Powell's second and subsequent surveys within the Colorado Plateau were funded by Congress. Values of arid lands and cooperative development of water resources, based on observations by Powell on the Mormon pattern of settlement, mapping unexplored portions, and provision of names were among the accomplishments of this remarkable man.

Colonization of Utah was to continue late into the nineteenth century. A decade after Powell first floated through the quiet waters of Glen Canyon a decision was made to colonize the San Juan region of Utah with the dual purpose of providing a mission to the Indians and of protecting that area of Utah from encroachment by non-Mormons. The area initially sought for inclusion within the state of Deseret, as the Mormons wished to call their empire, was very large indeed. Included were portions of Wyoming, Colorado, Idaho, Nevada, Arizona, and California. The size of Utah was diminished as surrounding and contiguous areas were placed within the borders of other territories and states. When modern boundaries were assumed in 1868, a portion of southeastern Utah remained unoccupied.

Called on religious missions to the San Juan region were families from among the church membership, mainly in central and southern Utah. Those selected sold their possessions and purchased teams, wagons, livestock, and other materials necessary to establish themselves in the wilderness. A shortcut route to the San Juan was chosen without benefit of knowledge of its feasibility, and like Hastings Cutoff proved to be another "Longtripp."

After a long and arduous journey, the participants arrived with wagons, goods, and livestock at a place called Hole-in-the-Rock, southeast of the newly established town of Escalante in one of the most scenic and most rugged regions of the Southwest. They arrived there in November 1879, and with passes closed by winter snows behind them, they began the task of building a road through a region they themselves had decided was impassable. Despite initial pessimism they proceeded to do what appeared to be impossible.

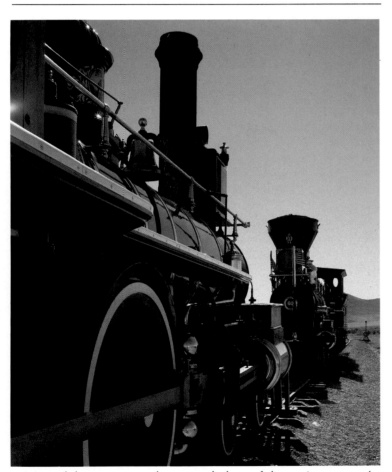

Joining of the eastern and western halves of the nation was celebrated in a "golden spike ceremony" near Promontory Point, where Union Pacific and Central Pacific tracks united on May 10, 1869.

They widened and filled the natural cleft at the Hole, and built a road down to the banks of the Colorado River in Glen Canyon.

After weeks of labor they drove the wagons to the canyon bottom. They constructed a ferry and took their wagons across. The road built to the east is over red sandstone, past monoliths, through deep sand, clay, and mud, and over hard rimrock. They traversed lands known previously only by Indians, and when they encountered an Indian at a point midway in their remarkable journey, he stood in disbelief that they had come that way. Children were born in wagons as winter winds pelted snow against the thin canvas covering. Despite all hardships they arrived finally, on April 5, 1880, at the site of their settlement. They surveyed the Bluff townsite on the north bank of the San Juan River. Participants were bound forever, as have been their descendants, by the ordeal and by the success of their cooperation.

Economics of Utah were at first entirely dependent on products of agriculture, and there was an attempt to maintain the Mormon population within a self-sufficient agrarian society, supported by industry which provided metals and other hardware. But precious metals were discovered in the mountains where magmas congealed long ago had concentrated them. Mining communities tend to be less stable than the agrarian ones, and Mormons were advised to avoid them. While avoidance was practiced to some extent, there was considerable trade with the mining communities, and many Mormons ultimately worked in the mines.

Diverse immigrants from Greece, Italy, Spain, and other countries came to the mining districts. From the mines came lead, zinc, copper, silver, and gold. Carbon County was established late in the history of Utah, and the name honors coal which is still yielded in ever-increasing measure. Metallic ores from Alta, Park City, Bingham, Firsco, Eureka, Silver Reef, and from many other towns, mostly now long abandoned, provided wealth that made millionaires and capital that built buildings, railroads, and other industry. The non-Mormon population increased in proportion and in importance in the business of the state.

Schools, colleges, universities, hospitals, libraries, and public works are the accoutrements of civilization. Utah has been and continues to be a leader in education. At first the schools were affiliated with churches, but public education was soon established. The University of Utah dates from the pioneer University of Deseret, founded in 1850. Brigham Young University was founded as an academy in Provo in 1875. Utah State University at Logan is a land-grant institution of long standing. These together with Weber State College at Ogden, College of Eastern Utah at Price, Snow College at Ephriam, College of Southern Utah at Cedar City, Dixie College at St. George, Westminster College at Salt Lake City, and technical colleges at Salt Lake City and Orem-Provo provide opportunities for training at the post-high-school level. They indicate a devotion to understanding and to the best that civilization has to offer.

Despite the attempts at self sufficiency and at maintenance of an agrarian society, the agricultural base could not support an infinite number of people. By as early as 1900, the officials of the Mormon Church were indicating that converts to Mormonism should not immigrate to Utah. The land was essentially completely occupied, at least as far as its productivity was concerned. Only about three percent of the land area could be cultivated under irrigation, due to exigencies of water supply, problems of juxtaposition of water and of arable land, or of lack of capital to develop the water resources. An additional one and a half percent or so could be cultivated using dry farming techniques. The remainder of Utah consists of lands too arid or too rugged for cultivation.

By 1880 all of the lands in the state were being grazed. Sheep populations surpassed four million head by 1900. Plant resources were severely depleted during the period of high usage. Clearly future development and growth of the economy could not depend on the agrarian base. Mining and related industries provided some release from the farms which had been adequate to support the first generations, but which had become increasingly short of being able to provide necessities as size of farms were reduced by division in inheritance following death of pioneer owners. Federal programs, especially those associated with defense, have become increasingly important in the economy of the region in the twentieth century.

Until the 1940s much of the state remained in semipristine condition, with many regions hardly impacted by humans. Only occasional use by cattle and sheep or horses left the region much as it had been prior to arrival of the pioneers. The canyonlands and areas adjacent to them, which had been explored by Powell, remained essentially unchanged until the close of the World War II. Since then there has developed an increase in activities of all kinds in the remote areas of Utah.

Exploration for uranium and for oil provided entry of

From the summit of "Silver Hill," a tram system descended carrying ore worth millions of dollars to the loading building adjacent to a spur line of the Union Pacific Railroad in Park City.

people and equipment to many of the distant and poorly known areas. Seismograph roads and caterpillar tracks mark the arid and thinly vegetated plateaus and canyon slopes. Sounds of engines running in the night, ethereal light of flaring gas from oil wells which cast shadows amongst desert shrubs, and smells of gas and oil give an indication of successful exploitation of petroleum. Giant shovels and tractors scoop gravel from ancient spits and bars, and from the terraces of ancient Lake Bonneville, at least from those deposits not already obscured by cities and towns along the eastern margin of Great Basin valleys. The high-pitched hum of diesel-electric engines, the clank of steel wheels on rails, and the drone of whistles mark the passage of trains laden with coal from black seams of eastern Utah on their way to fire furnaces of homes and industry. Sentinel-like stand the transmission towers, strung with silvery strands of aluminum across the land, humming with energy in transit from generating stations to cities and towns.

Roads, highways, and super highways form an anastomosing web through mountains and valleys. Dams block the flow of streams and rivers. Even the gigantic Green River is held in check by a dam at Flaming Gorge. The Colorado River is similarly blocked by the massive structure in concrete near the lower end of Glen Canyon in Arizona. Artificial inland seas in canyons carved by natural forces through eons of time are flooded by the lapping waters. Covered are the encampments of Powell, of other explorers and visitors, and of the peoples who used the canyons as thoroughfares in the distant past. Streamside forests, hanging gardens, and once arid canyon walls are buried by the trapped water.

Despite changes in natural features of Utah due to the increased tempo of our civilization, with its ever increasing demands for material resources and for space, the people of the United States have long recognized the beauty of the unmatched aesthetic features of Utah. Contrast of form, shape, and color results in scenes of breathless beauty. National parks and monuments have been established to preserve many of the unique areas of the state. Timpanogos Cave, Dinosaur, Cedar Breaks, Natural Bridges, Rainbow Bridge, Bryce Canyon, Zion Canyon, Canyonlands, Capitol Reef, Arches, and Hovenweep are under direction of the National Park Service.

Each of these presents a portion of the story of the earth, of the processes which molded the land, and of the events of human history that show interaction of man in this awesome region. National forests have been designated which provide timber, grazing, and recreation on a continuing basis. Other federal lands are managed by the Bureau of Land Management, Bureau of Indian Affairs, and various military services.

Still practical policies affecting land and its use have been borne of the difficulties of survival in this land of meager supplies of water and of limited opportunity to gain a living. There is opposition to establishment of additional monuments and to federal ownership of lands. Decisions made in the latter part of the twentieth century will affect not only this generation, but all future ones as well. Only those who view the wonders of Utah in the future will be able to determine whether decisions made now are the correct ones.

THE SETTING

The setting of any region is more important than the sum of all its parts. Its parts, however, determine how a place supports a civilization, the level of and nature of that support, and the quality of life that can be sustained. Utah is significantly poor in agricultural resources and short of water at the right places. But it is richly endowed with metallic ores, with energy resources, and with unmatched scenery. Structured within the setting is the potential of Utah — what it has become and what it can become.

Multifaceted like a jewel of great price, Utah is a land of mountains, plateaus, valleys, deep gorges, and sweeping vistas. Low deserts, hot and sere; high mountains, cool and lushly green; and foothills and slopes ranging between these extremes underscore the fact that diversity is a theme common to all Utah's parts.

Within Utah are portions of three main physiographic provinces, each quite different from the others. The rugged, ice and water sculpted Uinta and Wasatch mountains comprise a portion of the Rocky Mountain Province. The Basin and Range Province, with its north-south ranges and intervening broad alluvial valleys, constitutes the Great Basin portion of the state. The magnificent tablelands astride the canyonlands of the Green and Colorado rivers are within the Colorado Plateaus Province.

Elevations range vastly within the state. The boulder-clad summit of Kings Peak in the Uinta Mountains (13,514 feet) stands more than two miles above the state's lowest point at Beaverdam Wash (2,180 feet) in the arid southwestern corner of the state

From the summits and slopes of mountains, plateaus, and mesas cascades the water derived from snow, rain, and springs, supplied by sporadic storms from the prevailing westerly winds — winds which control both weather and climate. Utah's mountains bar passage of moisture-laden air that sweeps eastward from the north Pacific Ocean, or which comes from the Gulf of California, and, sweeping northward, encounters the cold air masses in great frontal storms, mainly in winter. Air masses, intercepted by mountain ranges, rise upward along western slopes of mountains. As they rise, the air expands and cools. Clouds form as a result of cooling, and rain or snow falls. On eastern slopes of mountain ranges the air descends and is compressed. Air flowing down slopes, therefore, is dry and can evaporate water from regions through which it passes. Rain shadows result from the dessicated air on eastern sides of mountain systems. The Great Basin of western Utah is arid because of the interception of moisture by the Wasatch Mountains and other high elevation areas of the state.

Summer storms differ from those of winter. These midyear disturbances are contests between great air masses associated with low pressure systems in the prevailing westerlies. Hot land surfaces heat moisture-laden air sweeping northward in summer. Warm air, unstable and rising, forms the billowy cotton-topped, black-bottomed cumulonimbus storm clouds of summer. Characteristically, storms are noted for their high intensity and short duration. During a June 1972 storm, six inches of rain fell in four hours in southern Utah. That amount almost equalled the annual average rainfall for that portion of the state. That storm was small, with adjacent areas remaining dry as they had been for more than two years.

Perennial streams, those which flow throughout the year, fluctuate with the season. Caused by melting snow, the greatest flows of water are in springtime. During the remainder of the year, the seeps and springs from groundwater provide lower stream flow. Numerous drainage channels are dry throughout most of each year, flowing only following snow melt or occasional storms.

Streams in Utah arise at high elevations where temperatures and evaporation rates are lower than in surrounding valleys. Flowing downward, the volume of the streams decreases due to evaporation. Many of the rivers and streams that arise in the mountains of the state never leave its borders. Those from the western end of the Uinta Mountains and from much of the Wasatch Range flow into the Great Basin where they terminate in Great Salt Lake. The Ogden, Weber, and Provo drainages are entirely within Utah. But the Bear River passes north into Wyoming and Idaho before reentering Utah in Cache County. Both the Bear and Provo rivers enter fresh water lakes prior to their final entry into Great Salt Lake — that sump of saline steepings of soils, strata, and wastes of human kind, a mere remnant of its precurser, fresh-water Lake Bonneville. The Jordan River, sluggish and laden with finely divided particles and dissolved minerals, flows north from Utah Lake to saline Great Salt Lake. The Jordan takes its name from the resemblance to another river by the same name which similarly joins a fresh water lake with a saline sea in the Old World. From the western side of the Colorado Plateau comes the Sevier River. It arises along the high margin of the Plateaus Province and flows through a valley trending northward and then westward before evaporating from the silts of Sevier Dry Lake, another reminder of Lake Bonneville. Long ago Sevier Lake was an arm of Lake Bonneville.

Although the drainages which flow to the Great Basin at present are destined not to reach the sea, the situation was otherwise in the past. Lake Bonneville, a large freshwater inland sea, filled the valleys in most of western Utah during recent ice ages. As the glacial period came to an end, the ice contained within the canyons and mountain systems melted at an accelerated rate making level of the lake higher. For some years the level of the lake fluctuated just below a low point along its northern rim. Then, during one spring, the level of the lake surpassed the margin; it overflowed, and in doing so, the water began to cut a channel.

Down slope ran the water with increasing velocity and increasing volume. Water stored in the lake basin swept through the newly created channel. The drainage channel, a tributary of the Portneuf River in Idaho, was widened and deepened by the escaping water. Down the valley it flowed, creating its own channel as it went. At the Portneuf River, a small meandering stream with a narrow course, the waters of Lake Bonneville unleashed their energy in a channel readjustment allowing the great flood to rush on to the Snake River. The Portneuf River now meanders along the bottom of a huge channel, almost dry except for a tiny flow.

As the initial flood subsided a constant flow of water issued from the lake. For a while the streams of the Great Basin were connected to the Snake River drainage through Lake Bonneville, and fishes moved into the basin from the Pacific Northwest. When the climate became warmer and drier, the water entering Lake Bonneville was surpassed by the amount being evaporated. Flow of water from the basin ceased. Gradually the level of the lake lowered in successive stages

marked by long periods of stabilization. At each level of stability, the pounding waves and offshore currents sculpted the shoreline, producing terraces. Also, during periods of stable water level, deltas were deposited from alluvium carried in the streams flowing into the lake. The deltas and terraces have persisted since the passing of the lake, serving to remind us of a much different past.

At present the basin of ancient Lake Bonneville is gray and sere. Desert shrubs, grasses, and low forests of pinyon pine and of juniper occupy the terraces and valley bottoms where once fishes swam and ducks dove for food. The sound of wind and of a lizard thrashing in the sand has replaced the murmur of waves. Cities built on rectangular grids mark the deltas at canyon mouths along the margin of the Great Basin. The basin of Lake Bonneville is filled with a sea of air.

In the Uinta Mountains and in higher portions of the Wasatch and other ranges, snow accumulated during the ice ages, stacked high and compressed to ice; when sufficiently thick to become plastic by pressure of this weight, the ice began to flow. Scouring, scratching, and plucking stone, the glacial ice carved a path as if it were a gigantic machine of some later period. Trees, rocks, canyon spurs, and every moveable thing was swept along by the glaciers, the longest of which reached some 29 miles in Uinta Canyon. U-shaped canyons, mountain lakes, moraines, and boulders transported in the ice give evidence of the extent and power of the glaciers.

Following the melting of the glaciers, the heads of glacial canyons provide basins wherein lakes exist. Streams drain from the well-watered highlands which receive more than 30

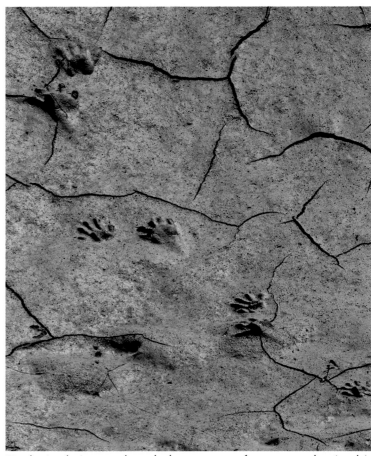

Tracks in drying mud mark the passage of a nocturnal animal in Desolation Canyon along the Green River. Uintah County.

inches of water during an average year, much of which occurs as snow that accumulates to 100 inches or more in high mountains. Down from the lakes run waters from both sides of the Uinta Mountains, the only major range to trend along an east-west axis in Utah, into streams which drain east into the Green River. That large stream arises in western Wyoming and flows south into Utah at Flaming Gorge through deep canyons entrenched into the eastern end of the Uinta Mountains. At Split Mountain, the Green River passes into the Uinta Basin where it is joined by Brush Creek, Ashley Creek, and the Duchesne River. All derive water from the Uinta Mountains or from the Wasatch Mountains and Tavaputs regions, bordering the Uinta Basin on the west and southwest.

From the east side of the Navajo Basin, in southeastern Utah, two streams enter the state. They are the Colorado and San Juan rivers. The Colorado, formerly called the Grand, joins the Green River deep in the inner gorge below the Island-in-the-Sky portion of Canyonlands National Park. The San Juan River enters Utah in the Four Corners Region of San Juan County and flows west to its confluence with the Colorado River in Glen Canyon.

From the pink limestone summits of the Markagunt and Paunsagunt plateaus, the waters of the Virgin River are gathered into the Virgin River valley. Its eastern portion is picturesque and pastoral. But westward it enters a narrow gorge, benignly named Virgin Narrows, where shadows cast by vertical walls a few feet apart allow only shafts of light to play on sandstone walls. Summer torrents can suddenly raise

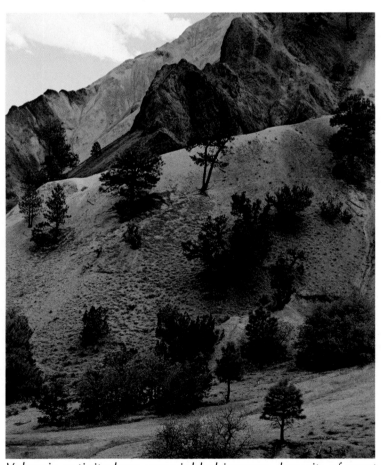

Volcanic activity long ago yielded igneous deposits of great thickness. Originally dull in color, reheating by percolating hot water produced vivid yellow, brown, and other hues. Big Rock Candy Mountain, Sevier County.

water levels by more than 50 feet, a measurement proved by driftwood lodged in crevices above that level. Towering monoliths of sandstone stand above the course of the Virgin River in Zion Canyon. Westward the stream flows placidly through the valley of the Virgin to the vicinity of St. George where it exits from the state into Arizona, finally reaching the Colorado River in southern Nevada.

Thinly disguised by the vegetative cover is the geological substructure. Strata deposited through eons of time since early in the story of the earth are exposed along the mountains, plateaus, and valleys. More than a billion years of the earth's history is recorded here. Earliest strata are exposed in the Great Basin ranges, in the core of the Uinta Mountains, and in deep canyons. Quartzites, schists, gniesses, and slates are examples of these most ancient rocks. Modified by heat and pressure these metamorphic rocks were the sandstones, shales, and lava flows of previous times.

Grays of dolomite and limestone dominate the sedimentary strata of the Great Basin ranges, but here and there are the subtly toned buffs and pinks, weathered brown, of quartzitic units. Igneous rocks, black to gray, buff, pink, and lavender to white depending on origin and composition, are exposed over large regions of the southern Great Basin and central plateaus sections. Where igneous deposits have been reheated by percolating hot water from sources deep within the earth, the chemical content has been changed, resulting in formation of strikingly rich-colored stone. Rainbow hues mark such modified rocks at Big Rock Candy Mountain and the high peaks of the Tushar Mountains which expose lemon-yellow, maroon, brown, blue-gray, and other pastels. Deposits of igneous rocks in the Tushar Mountains exceed two miles in thickness. The volcanic outflow was huge, extending more than 30 miles from the Tushar Mountain volcanic center.

Vulcanism, like sedimentary deposition, yields material which covers the pre-existing environment. Basalt and andesite flows and ashflow tuffs move over the surface of the landscape burying everything in their paths. Intrusive igneous rocks, those which solidified while still buried, modify the pre-existing strata by heating them, and by uplift, deformation, and separation. Vulcanism is most evident in the western and southwestern portions of the state. Young basalt fields are present in the Black Rock Desert, near Navajo Lake, and in the vicinity of St. George. Intrusive igneous stocks form the cores of many of the mountain ranges in the central and western mountains.

Granitic outcrops, white with dark specks of mica, occur where the overburden has been removed by erosion. Associated with the intrusive rocks are areas of mineralization, often disposed along dikes and sills, the fissures of prospectors. Gold, silver, copper, lead, zinc, and other minerals are concentrated in portions of these intrusive features. These metals are or have been exploited in the open pit copper mine at Bingham Canyon and in numerous other mining regions of the state.

Appearance of the land along the Green and Colorado rivers is dominated by massive sedimentary strata, but even there igneous activity exists. Dikes and sills, black in color and margined with thermally modified rock, stand boldly contrasted with the redrock formations in the Cathedral Valley section of Capitol Reef National Park. Massive laccolithic mountains, whose interiors are composed of gigantic sills of

granitic rock, stand islandlike above the broad valley of the Colorado River and its tributaries. The LaSal, Abajo, and Henry mountains are all laccolithic in origin. The mountains were formed by gigantic bubblelike molten masses of magma which lifted the burden of sedimentary strata, bulging the horizontal layers upwards. The magmas melted their way through the lowermost ancient strata.

Prior to complete penetration of the sedimentary layers, the magmas separated some of the strata and wedged laterally to form tapering sills of great magnitude. Cracks were filled, too, resulting in dikes which penetrated far into the surrounding rocks.

The laccolithic mountains were ultimately breached by erosion and their igneous cores exposed. One mountain of laccolithic origin, Navajo Mountain, is unbreached; its igneous core has not yet been exposed. In spite of this difference, the dome shaped outline of Navajo Mountain is similar in appearance to that of the Abajos, and less so to the LaSal and Henry mountains. In all of them there are sections of tilted sedimentary strata clinging to the margins of the mountain slopes, sculpted by water, wind, and frost.

Each of these mountain masses stand sentinel-like in the valley of the Colorado River, marking the horizon with features that makes it simple to mark one's place on the landscape. The only other evidence of vulcanism in the Colorado River portion of Utah is found in the basalt boulders. These are black and marked by holes formed by gas bubbles when the rock was still molten, which veneer the sedimentary strata in the Capitol Reef vicinity.

The canyons of the Colorado are entrenched into layers of sandstone, red to buff in color, separated by muds, silts, and shales of gray, gray-green, red, maroon, purple, and yellow. Red rock dominates the scenery, displayed in majestic vistas whose scale is beyond the realm of most human experience. The canyonlands area is one of only a small number of red-rock regions in the world. Those who reside among the red rock soon grow to feel that all geology is displayed in technicolor, but in reality most geological strata are displayed in shades of gray.

Trapped within the ancient sediments are coal, oil, tar residues, gypsum, phosphate, and salt. Preserved also are the evidences of living things: the ferns, willows, conifers, and animals which thrived during the prehistorical development of the earth. The remains of creatures which became mired in ancient streams have been preserved in the channel sands now turned to stone.

The bones of dinosaurs, amphibians, and mammals are concentrated in rock outcrops which were the deposits that entrapped the bones during the time in which the animals lived. The dinosaur quarrys at Dinosaur National Monument and at Cleveland-Lloyd near Price have yielded remains of numerous prehistoric animals. Skeletons of titanotheres mark the outcrops in the Red Wash area southeast of Jenson, and shells of giant turtles occur here and there in the Uinta Formation of the Uinta Basin. Fossilized wood is exposed in several formations, some of it preserved in such detail that its cellular structure is still evident. In some plant and animal fossils uranium has replaced carbonaceous materials, and uranium mining is often associated with such fossils.

Acting on the features of the earth are those forces of nature which work to bring equilibrium to the face of the earth. Mountains built by immense forces within the earth,

ancient sea beds elevated by similar forces, and the features of vulcanism are all treated to action of wind, water, and differential heating and cooling. For eons of time the agents of erosion have plied their trade. In endless progression mountains are modified in form as they are worn away grain by grain.

Swept away from the stone to which they have been cemented for countless ages, the fragments are carried by wind or water or by both in stepwise fashion to some basin where they become part of yet another formation. The current of air or water accompanying a single storm might wear away little of a mountain, but time is the essence of processes of weathering. Millenia pass and the accumulated effects mark the surface of the earth with gullies which become gorges and canyons; mountains become hills; mesas become buttes; and buttes become too slender to stand. They fall as if cut by an axe, the toppled stones to persist for a time before they too are removed grain by grain and are transported in the never ending cycle of degradation and of renewal.

Contemporary appearance of Utah is the result of all of the processes which have acted on its surface. Valleys in the Great Basin are filled with up to a mile or more of sediment. The mountains are lowered by the amount of valley fill which has accumulated from erosion of the mountains adjacent to the valleys. From each canyon of desert ranges extends an alluvial fan of mixed gravel, sands, clays, and boulders. The size of particle in any given location is an indication of the size of the stream of water which carried it hence. Alluvial fans tend to be joined at their margins into extensive bajadas whose lower margins adjoin playas at the valley bottoms

If the Great Basin is an area of accumulation of sediments, the Colorado drainage system is not. There thousands of cubic miles of materials have been swept away, mainly down the Colorado River to the Gulf of California. The canyons deepen by headward cutting along the bottoms of channels at nick points where minor waterfalls or rapids are formed. Headward cutting is a continuous process, with the upper end of the drainage expanding.

Cliffs of resistant stone slow the process of erosion; channels become deeply entrenched into sandstone strata as along the inner gorge of the Colorado. Less resistant shales, mudstones, and siltstones are eroded from beneath the edges of the sandstone strata, weakening them and finally causing slabs of stone to fall away, often along joint systems. Vertical cliff faces result. In time they take upon themselves the stain of water-washed minerals and of desert varnish, a thin glaze of silicates of aluminum and magnesium which adorns in tapestries of brown-black on red the myriad walls of the canyonlands of Utah.

Not all of the sweepings of nature's broom and mop are carried directly to the sea or are they trapped in some calcium-cemented fan or bajada. Sand, that eternal building block of stone, tends to accumulate in sorted piles. The fine particles are carried away by more intense winds which flow over the surface of the earth. The larger grains, those of just the right size, become associated with one another in sorted piles. They move in concert; crescentlike in flocks, like sheep at rest, slowly the dunes play leapfrog with themselves.

The grains of sand scurry with the wind to the summit of the dune. Tumbling beyond the blade-edged margin, the grains fall down the steep leeward slope, there to be buried until the dune, moving onward, exposes again those self-

same grains. Dunes accumulate on the east side of valleys in the Great Basin and in fin-blocked parklands surrounded by monoliths of stone in the Canyonlands section on Utah.

Ceaselessly the dunes move over the open eastern foot of the San Rafael Swell. Along a gentle valley west of Kanab, the pink dunes flow riverlike towards the east. Sand Mountain near Hurricane bears the wind borne accumulations from sandstone formations in the central portion of the Virgin River Valley. Also pink in color these dunes are perceived as a pleasant patch of pastel softness, but represent a barrier to travel due to their softness. Because of the dune's softness, tracks in dunes do not persist; they are cleansed by wind, that sweeping forgiveness of nature.

On this setting of mountains, plateaus, mesas, buttes, hills, broad valleys, gorges, defiles, streams, lakes, and dunes, the vegetative cover composed of many plant species reflects the diversity of places for them to grow. Lush forests of spruce, fir, Douglas fir, and aspen grow on higher mountain slopes and summits throughout the state. Above the forests, on the uppermost summits of the highest ranges, the trees become low, with the lower branches spreading laterally, hugging the earth and gaining warmth and freedom from winds. Those stems which reach boldly upwards, as trees commonly do, are stripped of branches on the windward side. Branches on the leeward stand flaglike, in tribute to the force of high velocity drying winds. Snow is blown from the summits in winter, only to accumulate on leeward margins of ridge crests as great angular cornices which persist into the summer of the season beyond. Total precipitation on the windswept ridges may be great, but water that remains available for growth of plants is low.

The land above timberline in high mountains is a cold desert; vegetation there is low, quite like a trimmed fairway. Called alpine tundra, it is distinguished from similar vegetation in the arctic, with which it shares some few species. Arctic poppies, sedges, spike sedges, and dwarf willows give evidence of their resemblance to arctic and alpine plants. Barely above the green of sedge and grass stand the large flowers of old-man-of-the-mountain, with their bright yellow sunflower rays and covering of shaggy white hair. Blue of bellflowers and bluebells, creamy white of bistort and mountain avens, creamy yellow and maroon pink of paintbrushes combine to set the alpine tundra apart as a garden of brightness in midsummer.

Forests of the mountains extend downward along the valleys where deep canyons, shaded for a portion of each day, are cool because of the shade and because of cold air drainage from the mountains above them. This phenomenon, the canyon effect, simulates conditions in mountains. As a result, coniferous forest trees grow down to elevations below 6,000 feet on north-facing slopes in canyons. Conversely, those plants of drier vegetative types, such as oak and sagebrush, penetrate upwards into forest areas along south-facing slopes where incident rays of sunlight strike the slopes steeply angled, yielding high amounts of energy to each unit of area. Water is evaporated readily, therefore, from slopes which face south, resulting in lower amounts of water being available for growth of plants.

Downward the forests give way to brush species, which in places intermingle with stately stands of ponderosa pine, ornamented with angular cinnamon orange plates of bark on magnificent boles crowned by long-needled canopies. In the plateaus and mountains of southern Utah are forests of ponderosa pine, mingling upwards with aspen and spruce-fir forests. Down slope the forests of ponderosa pine give way to the dwarf coniferous forest of pinyon and juniper. The position of the mountain brush vegetative type corresponds with the ponderosa pine and pinyon-juniper zones. Consisting of Gambel oak, bigtooth maple, mountain mahogany, and serviceberry, the mountain brush is best developed in the canyons and slopes of the Wasatch and Uinta mountains.

Sagebrush, considered by some as the botanical motif of Utah, threads upwards to high elevations along slopes and margins of canyons, forms stands in the pinyon-juniper woodlands, and occurs as vast extensions below the pinyon and juniper forest. The sagebrush expanses pass by degree into mixed desert shrub communities of shadscale, saltbush, and low sagebrush and grassland types.

Saline valley bottoms support growths of greasewood, saltbush, seepweed, pickleweed, and samphire. Commonly these are intermixed with saltgrass. The valley bottoms vary from dry to wet, depending on the amount of water which flows to them. In either situation salt is accumulated as water is evaporated. Even where saline valley bottoms are wet, the plants that grow on them are adapted in a manner which indicates drought tolerance.

Water laden with salt cannot be used readily by plants. Only those which can take up water against a diffusion gradient, wherein energy is expended in such uptake, can survive in these regions of physiological drought. It is a situation of "water, water everywhere but not a drop to drink." In more arid bottoms, where chalky playas radiate shimmering heat in summer and where dust devils wind their tortuous paths on hot afternoons, grow plants which tolerate both physiological and physical drought. Plants of saline bottoms taste of salt, like a cucumber soaked in brine.

Plants of the lowland reaches of Washington County in southwestern Utah reflect the general aridity and access of Mojave Desert plants to that region. The cover of vegetation is thin in this arid land of stark gray mountains bordering the southern end of the Great Basin. Red rock formations of the Virgin River Valley are hardly obscured by the vegetation, which tends to take on hues of soil, or being gray in color merely blends with the sere landscape.

The western slope of the Beaverdam Mountains presents an alien appearance, where figures of Joshua trees with branches raised armlike give one the feeling that he is not alone. Slopes above this Mojave Desert vegetation indicate subtle changes in temperature and evaporation rates. Gradually, the creosote brush vegetative type gives way upwards to a mixed shrubland of live oak, manzanita, and mountain lilac, which blends into pinyon-juniper and mountain brush.

Lakes, streams, stream sides, and other wet lands each support a growth of vegetation that is characteristic. Cattails, reeds, and rushes grow in lake and pond margins, or in seeps and springs where moisture is available on a continuous basis. In lakes are duckweed, pond weed, pond lily, and numerous other kinds of plants attached, suspended, or floating. Sedges, grasses, and willows line the meadowlands. Cottonwoods, alder, willow, and hawthorn mark the stream margins in middle elevation reaches, and in some places cottonwood and willow alone form the woody vegetation along streams. Spruce and fir, sometimes mixed with aspen, border high elevation streams. Box elder, bigtooth maple,

and cottonwood and important streamside forest trees in the Wasatch Mountains. Arizona ash grows along a stream named for that tree in Washington County.

Aridity controls the vegetative type and appearance away from the moist sites at low elevations. In distant vistas in these dessicated lands a swatch of green gives promise of cooling shade and of water to quench the thirst of inhabitants and of travelers. Fremont poplars are nature's benediction of shade in a sun-parched land of arroyos, benchlands, and ridges. They stand boldly green with spreacing canopies and branches which, falling from sheer weight or tumbled by a passing flood, persist in reclining form for a few decades, their roots anchored in water-bathed gravels. Massive trunks to several feet in diameter are protected by inches-thick layers of furrowed bark and provide a support for weary travelers who recline in shade against them.

Perhaps the most unique of the discordant and discontinuous green stands of vegetation are the assemblages of plants which cling to sandstone cliff faces, or which cluster about alcoves in southern Utah and in the Zion Canyon area of southwestern Utah. Known as weeping rocks at Zion and as hanging gardens elsewhere, the greenery results from seeps and springs which issue along perched water tables that intersect cliff faces.

On the continuously wet surfaces cling seeds as fine as table salt. They germinate there, sending roots along the fine indentations of stone; leaves are formed and the plants grow to maturity, often dangling pendulously from the cliff face. In growing, the plants produce weak acids which aid in dissolution of materials that cement sand grains. The weight of the plants and of sand which adheres to them and to the wet surface act together in causing the plants to fall from the cliff. A small alcove results from the loss of plants and a thin layer of rock. With reestablishment and subsequent loss of plants and layers of stone, the alcoves are enlarged. Large alcoves support complex plant communities peculiar to them alone.

Water, cool and transparent, in pools of deceptive depth awaits a passing bird, a small mammal, or a human. All of these and more have visited the hanging gardens for water, for shade, and to rest before moving again into the sea of dessication, the dominant sphere along the gorges of the Colorado River. The gardens continuously produce vegetation, unlike the surrounding arid land. They serve as refuges for small desert mammals in years of severe drought. In favorable times, animals spread outward from them into the desert lands. And, they provide water which serves as the habitat of tree frogs and red-spotted toads.

During an evening in early summer, the trill of a canyon wren sounds high and lilting, marking the closing of a day. Simultaneously, the first rough croak of a tree frog or of a red-spotted toad, or sometimes of both together, marks the beginning of an evening where males attempt to attract females by the beauty of their songs. Gradually the calling begins, a call here, then there, then several together. By mid-evening the singing of the frogs and toads reaches a maddening crescendo, the symphony of sound is reflected from the arched back and vaulted roof of the hanging garden alcove — cathedral of nature. In this play of the natural world, mates are found by the singers, and the next generation of life is assured.

More than 3,000 kinds of plants are present in the flora of the state. Among them are the endemics, those plants of limited distribution whose entire range is included within Utah. Almost 10 percent of the plant species are found only in this state. Few other regions support such a high proportion of endemic plants. Most of the endemics are restricted to geological strata with peculiar chemical composition in the southern two-thirds of the state, but some are to be found in all sectors.

Plants tend to reflect the interactions of climatic factors and of the substrates available to them. The great number of plant species and of endemic plants is an indication of the numerous places for plants to grow. Animals tend to reflect, however, the kinds of vegetation available as food and cover more than they reflect climatic and soils interactions. Mammals, birds, reptiles, amphibians, and numerous kinds of invertebrate animals are present within Utah. Some 250 kinds of mammals are known. All of the larger animals are represented beyond the boundaries of Utah, but about 20 small mammals, mainly rodents, are endemic.

Deer, elk, and moose, a recent migrant to Utah, are members of the deer family. Deer are found in practically all portions of the state. They live among the canyons and valleys from lowest to highest elevations where they eat twigs and branchlets from shrubs and trees along with herbs and grasses. Elk and moose are present in the higher mountains. These large animals are seen in meadows and along streams in forested regions. Elk, also known as wapiti, are shy and graceful animals. Bulls grow large antlers with sharp tines. Similar to those of deer and moose, the antlers are shed each winter, following the rutting season. In springtime the antlers grow again, clothed until full grown by a covering of velvet. When the antlers have hardened the velvet is removed as the elk polish them against branches of trees and shrubs.

Smaller herbivores, eaters of plants, abound in the region. Hares, jackrabbits, cottontails, rodents, all belong to the natural scheme, and depend on the annual growth of plants where they reside. They reproduce and bear their young in

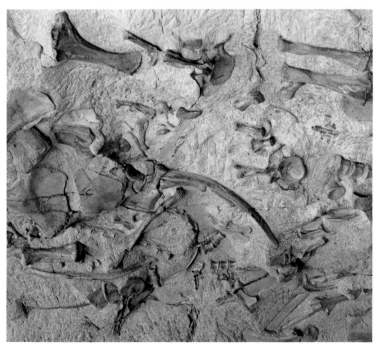

Silent evidence of animals of immense size, long extinct, lay exposed in a "tomb of stone" graveyard. Dinosaur National Monument.

nests lined with fur or with pieces of plants, and run the gauntlet of survival in their animal communities. Meat-eating mammals and birds stalk the rodents and rabbits.

Fewer in number, both in kinds and in individuals, the carnivores pursue their prey with silent stealth and cunning. Swiftly ends the life of the meadow mice (the vole) in the talons of a graceful redtail hawk or in the jaws of a foraging skunk. Grass provides food for the vole; the vole is food for hawk; and the flow of energy from sun to grass to vole and on to hawk forms a portion of the energy cycle in living things. Shrews and bats, both mouselike in appearance, depend on insects for food. In the energy cycle they are in the position of hawk and skunk, not in that of the mouse.

Small rodents of many kinds are scattered in all parts of the state. Each is adapted to survival in its environment. Pocket mice and kangaroo rats exhibit one of the most bizzare adaptations. Both are nocturnal, as are most of the rodent species. Emerging from burrows as evening begins, they search for seeds which they place in pouches in their cheeks with handlike front paws. The seeds are gathered in large quantities, stored in caches, and retrieved at other seasons.

Drinking water is at a premium in desert lands, and small rodents cannot travel long distances for water. Storms occur at irregular intervals, and not all areas receive rain at the same time. Pocket mice and kangaroo rats have solved the problem by giving up drinking altogether. They spend the hot part of each day in burrows where they are protected from searing heat, but mainly they accommodate the necessity for water by utilizing that derived from digestion of food. Urea is excreted in pellet form. Large of eye and balanced on an elongate hairy tail, the kangaroo rat hops in its peculiar undulating way across the sandy deserts. It is in harmony with its arid environment.

Mountain sheep, of hue similar to the redrock canyons in which they live, walk gracefully along trails on towering canyon walls in southeastern Utah. Pronghorn antelope bound in fluid motion across valley bottoms and foothills of the Great Basin. Born to run on slender legs, they watch a passing coyote hunt for rodents and rabbits on the sandy plains, with a sure knowledge that they can escape by swift retreat. Cougars, shy and nocturnal, lie in ambush for deer, rabbits, and rodents which they capture in bounding leaps. Gray, kit, and silver foxes, bobcats, black bear, and other carnivores keep the plant eaters watchful and their populations within reasonable limits.

Migratory birds characteristic of the Pacific flyway pass above Utah. Many come to build nests and to rear young. They sweep through the air to land where food can be obtained, to feed their fledgling young, and to fill the evening and early morning air with songs which delight the senses of those who listen. Others merely pass through the region and, dictated by instinct, that subtle gift of nature, pause for water and food. Shore birds wade on slender long legs among the cattails and reeds of ponds and lakes where they bob for insects in water and mud.

Gulls and terns glide in grace on currents of air while en route from lake to mountainside or other places in search of food. Geese, ducks, and swans glide over surfaces which mirror them upside down, in glassy context, or bob like floating corks on wave-decked water in wind. Eagles, hawks, and falcons wheel in arcs on torrents of rising air; spirally upwards they float above the mountains and deserts in quest of prey, or in soaring seem merely to demonstrate their mastery of unseen currents. Swallows and swifts race the wind along ridge crests, over water surfaces, and past gigantic faces of stone, catching insects in flight. Harbingers of changing seasons, masters of sound, experts of flight, the birds move and play a role in the totality of nature. The raven soars high as it inspects an area for carrion, calling in its peculiar way to those who pass below. Nature's garbage disposals, clad in somber black, aid in keeping the earth uncluttered of cadavarine remains of animals in death.

The interaction of living things with the physical setting and the interplay of both with the lives of people allow for the quality of Utah's civilization.

Utah's capitol is marked by stern colonnades that contrast with landscaped terraces of trees and flowers. Salt Lake City.

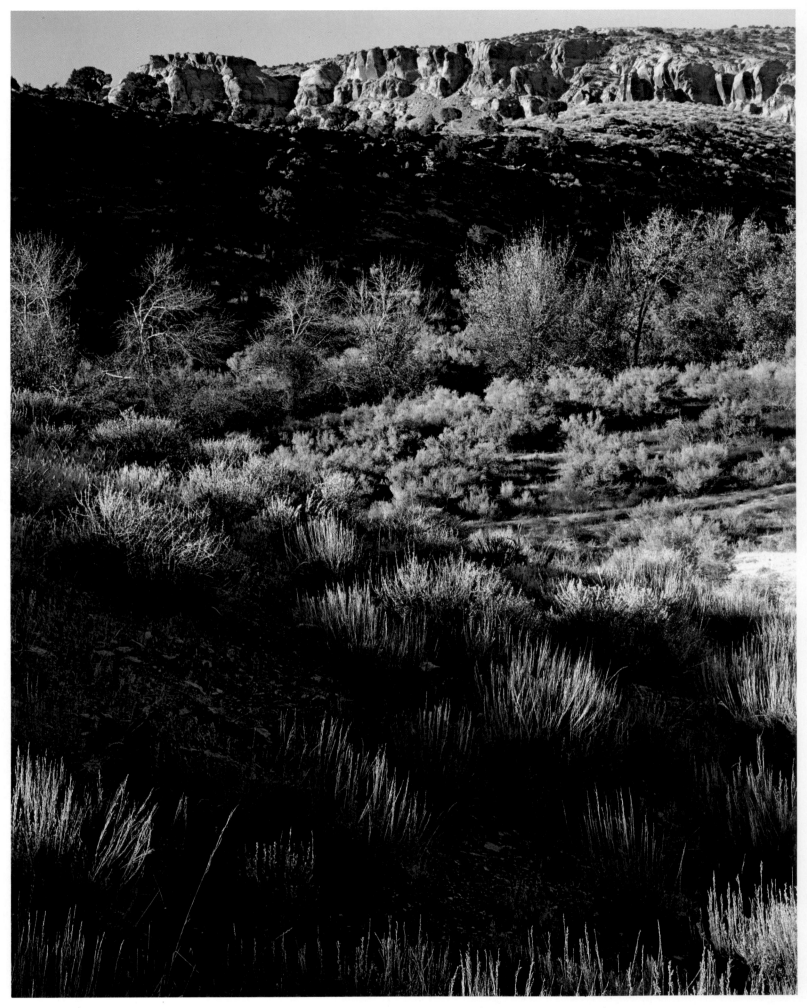

Through this arid valley on September 13, 1776, the Dominguez-Escalante Party passed west of Musket Shot Springs to the Green River, which they named San Buenaventura. Uintah County. *Right:* Algae thrives on an ice margined stream in water whose temperature is warmer than the air in winter. American Fork Canyon.

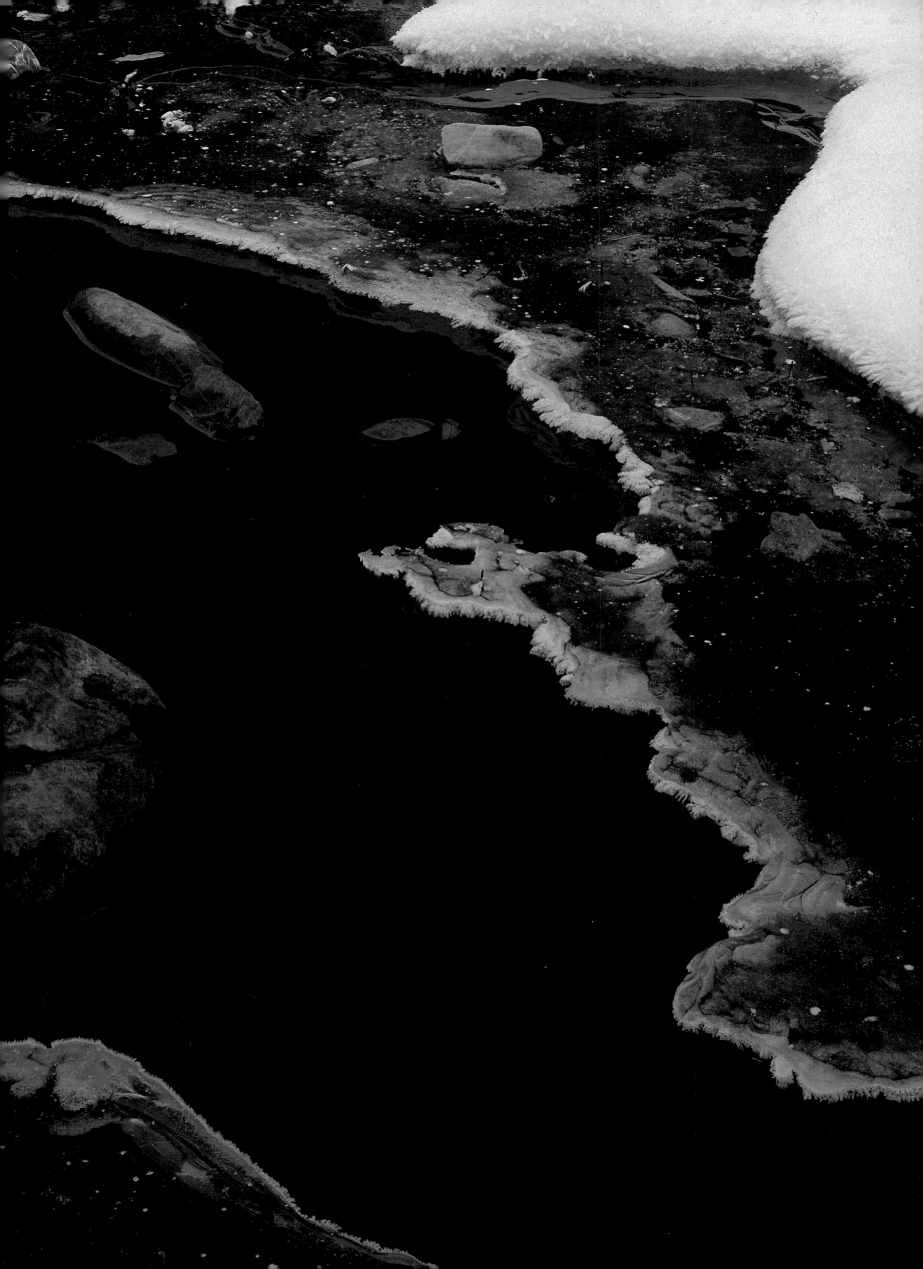

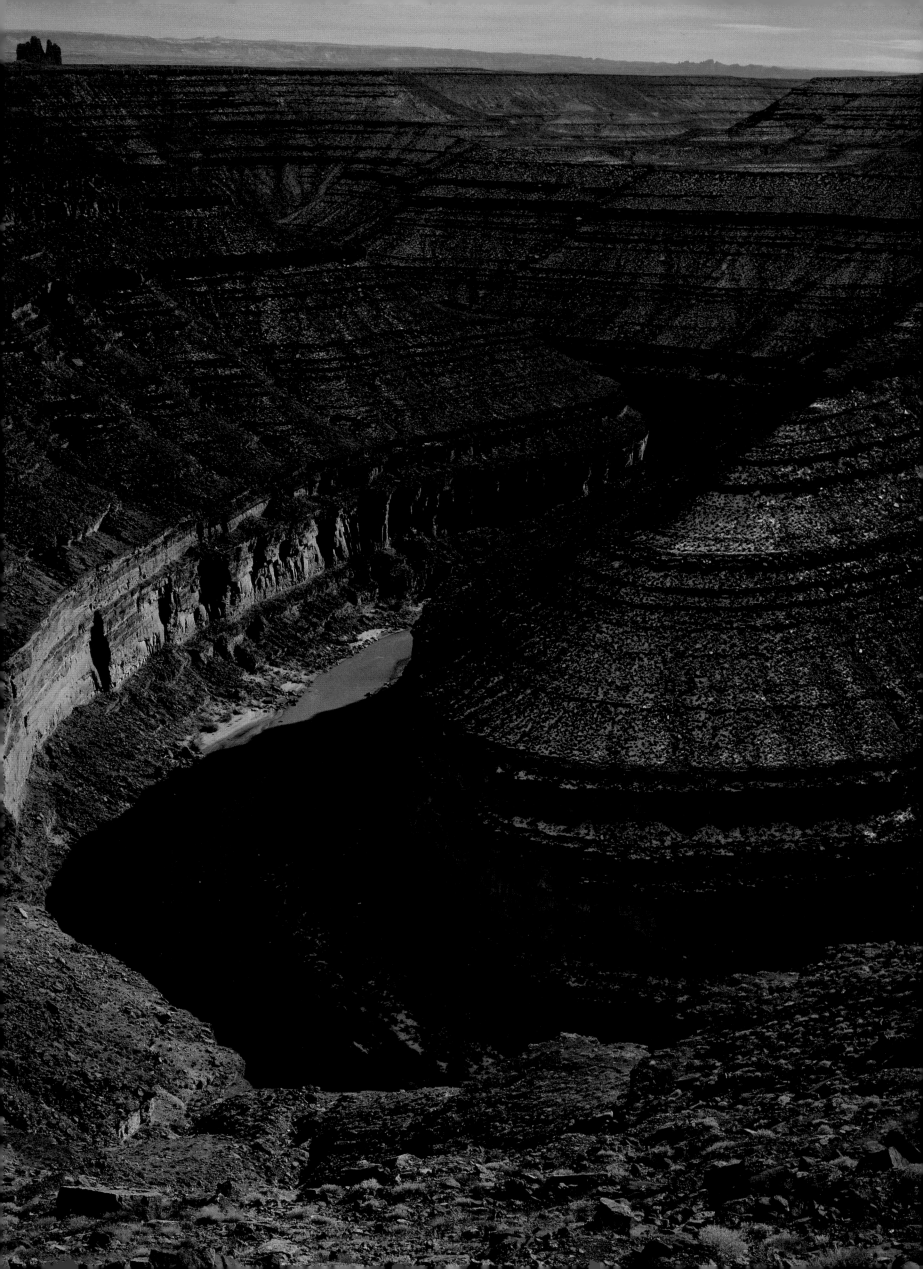

The placid waters of Fish Lake serve as habitat for aquatic plants and
animals, part of the energy chain of lake trout which grow to as long as 36
inches. Sevier County. *Left:* Centuries ago the exotic waters of the San Juan
River carved the strata of a desert land to produce this stark and barren
meandering canyon. Goosenecks of the San Juan.

The flowers of rabbitbrush stain the landscape with an aura of living gold—hallmark of autumn. Near Clover Spring, Tooele County.

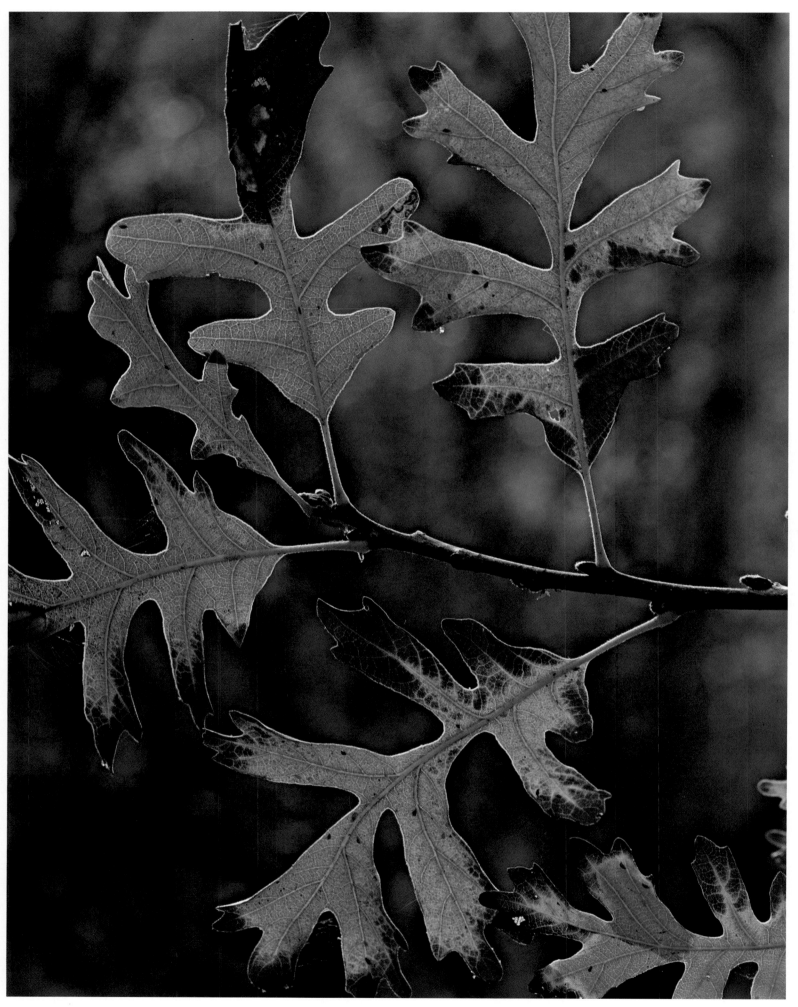

Gambel oak reproduces vegetatively by sprouting from roots, giving a patchwork quilt appearance to the foothills in autumn. Mill Creek Canyon. *Overleaf:* Playas exist in arid valley bottoms, where sluggish waters slowed on gentle slopes deposit fine particles. They crack on drying, texturing the chalky surface with abstract patterns. Ibex Playa, Millard County.

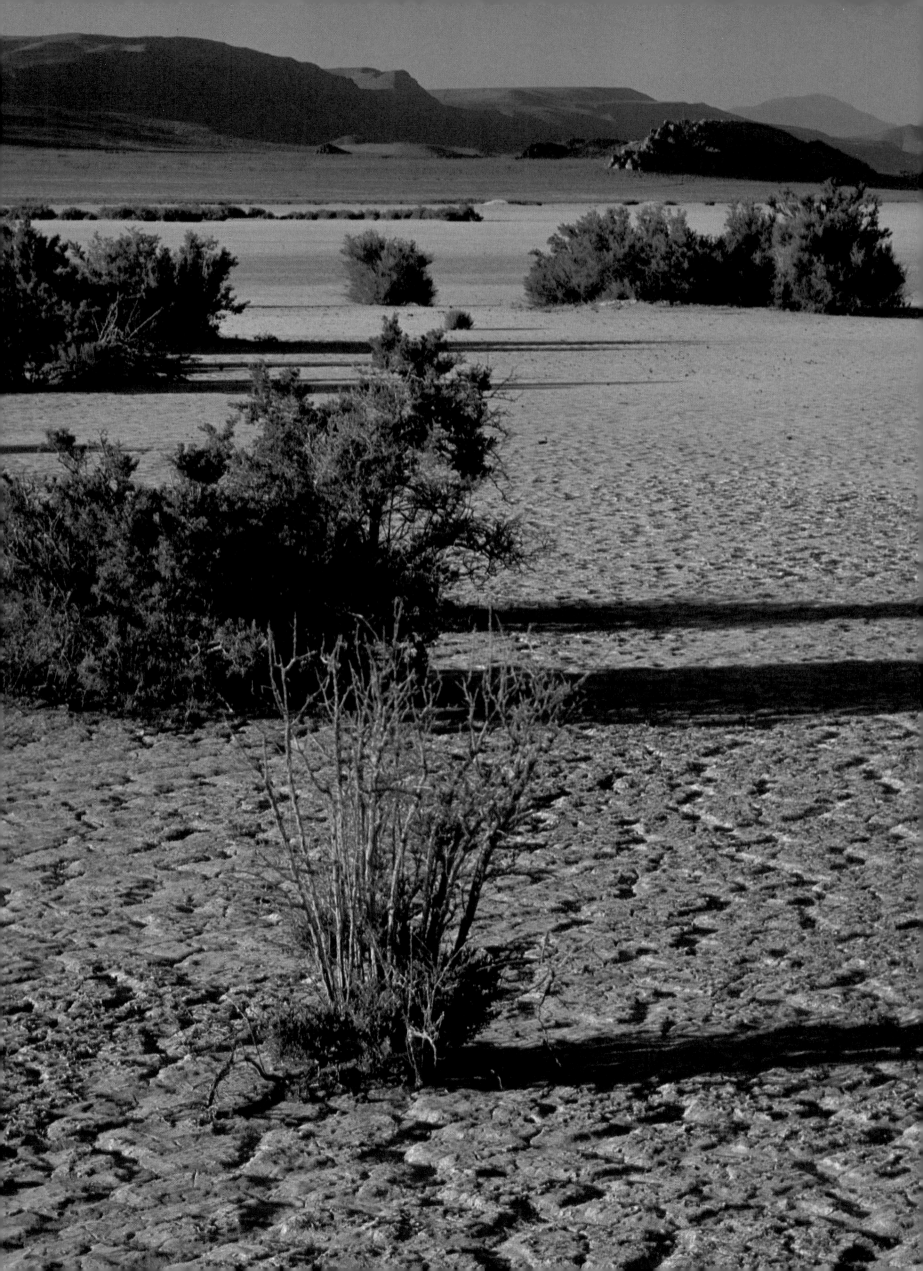

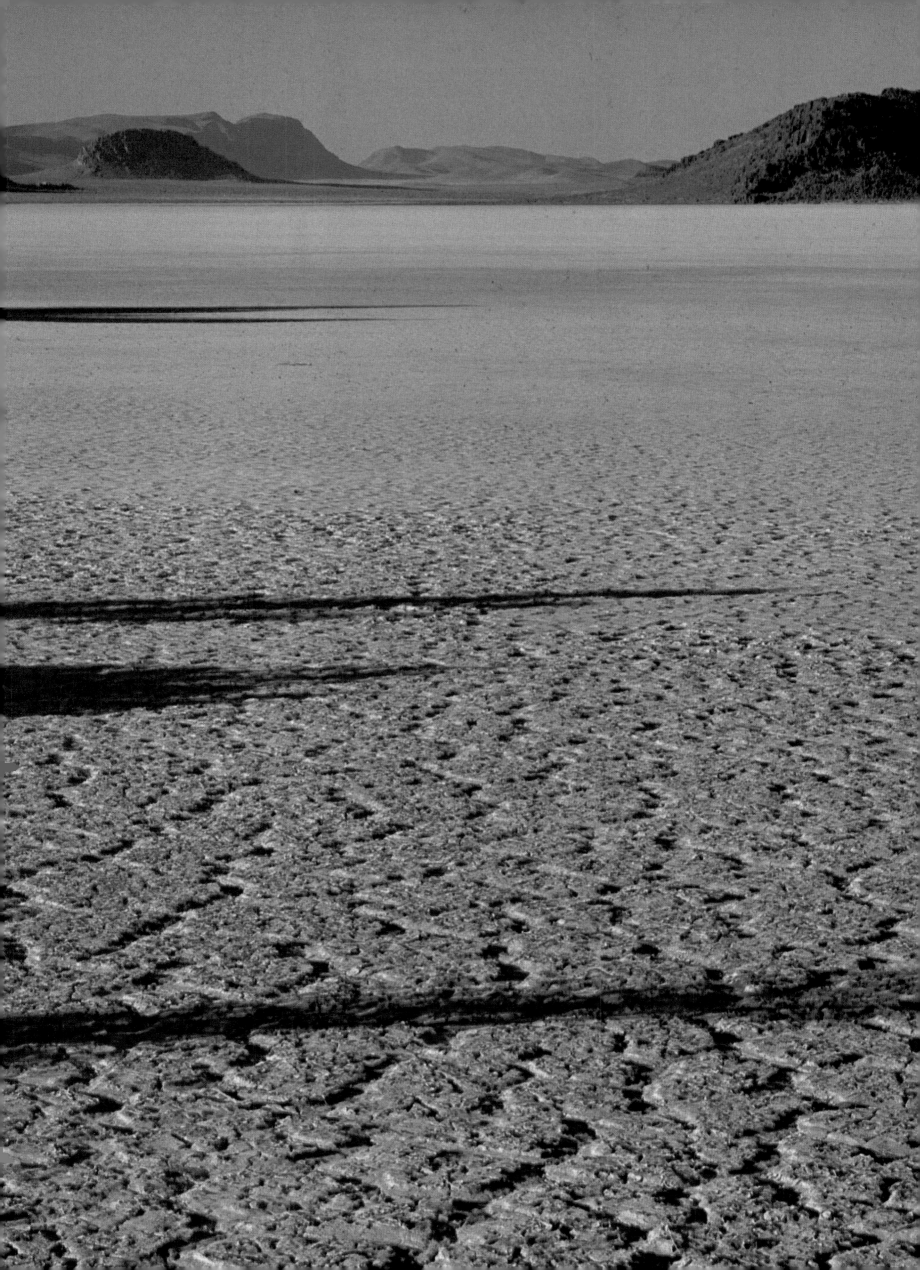

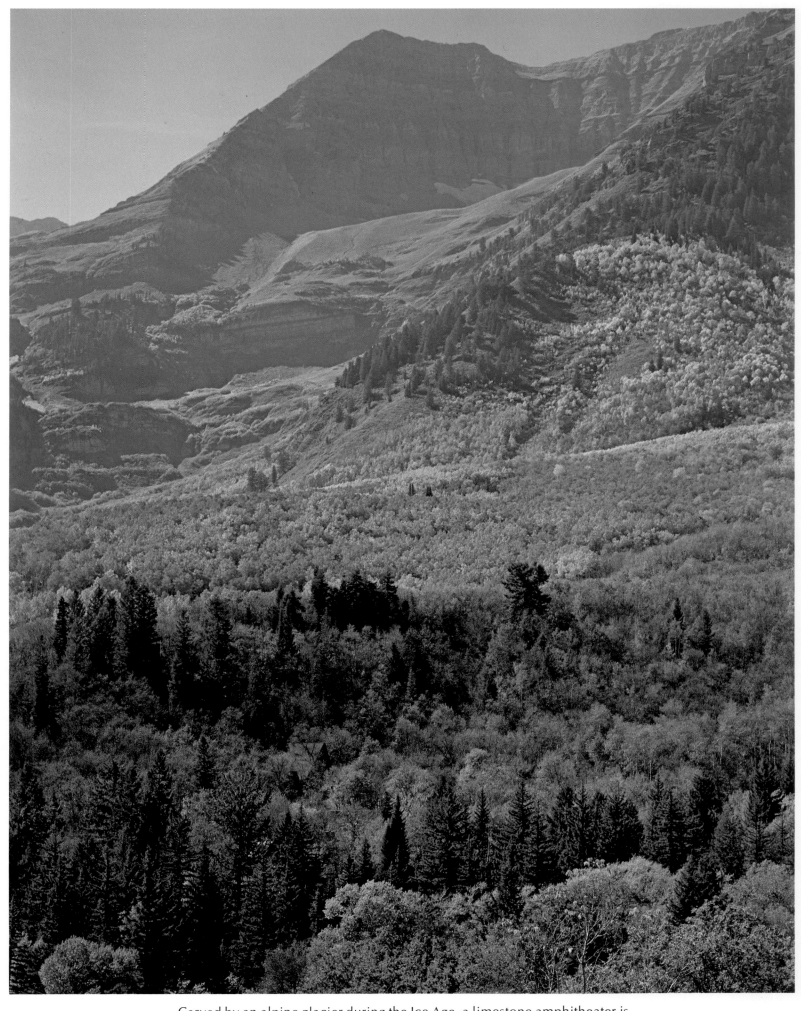

Carved by an alpine glacier during the Ice Age, a limestone amphitheater is
a reminder of a cooler climate in the distant past. Mount Timpanogos.

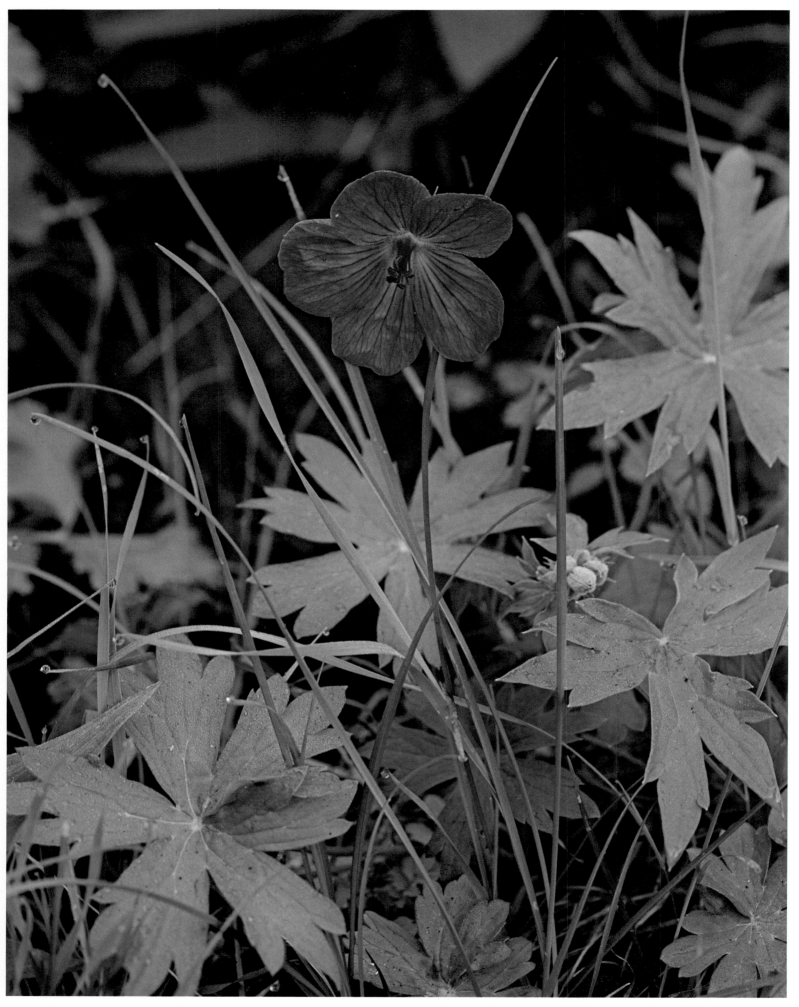

The Fremont geranium nods in subtle splendor among the grasses of aspen forests. American Fork Canyon. *Overleaf:* Wilson phalerope swim and dive at sunset for food in the shallow saline water of the Great Salt Lake. Antelope Island.

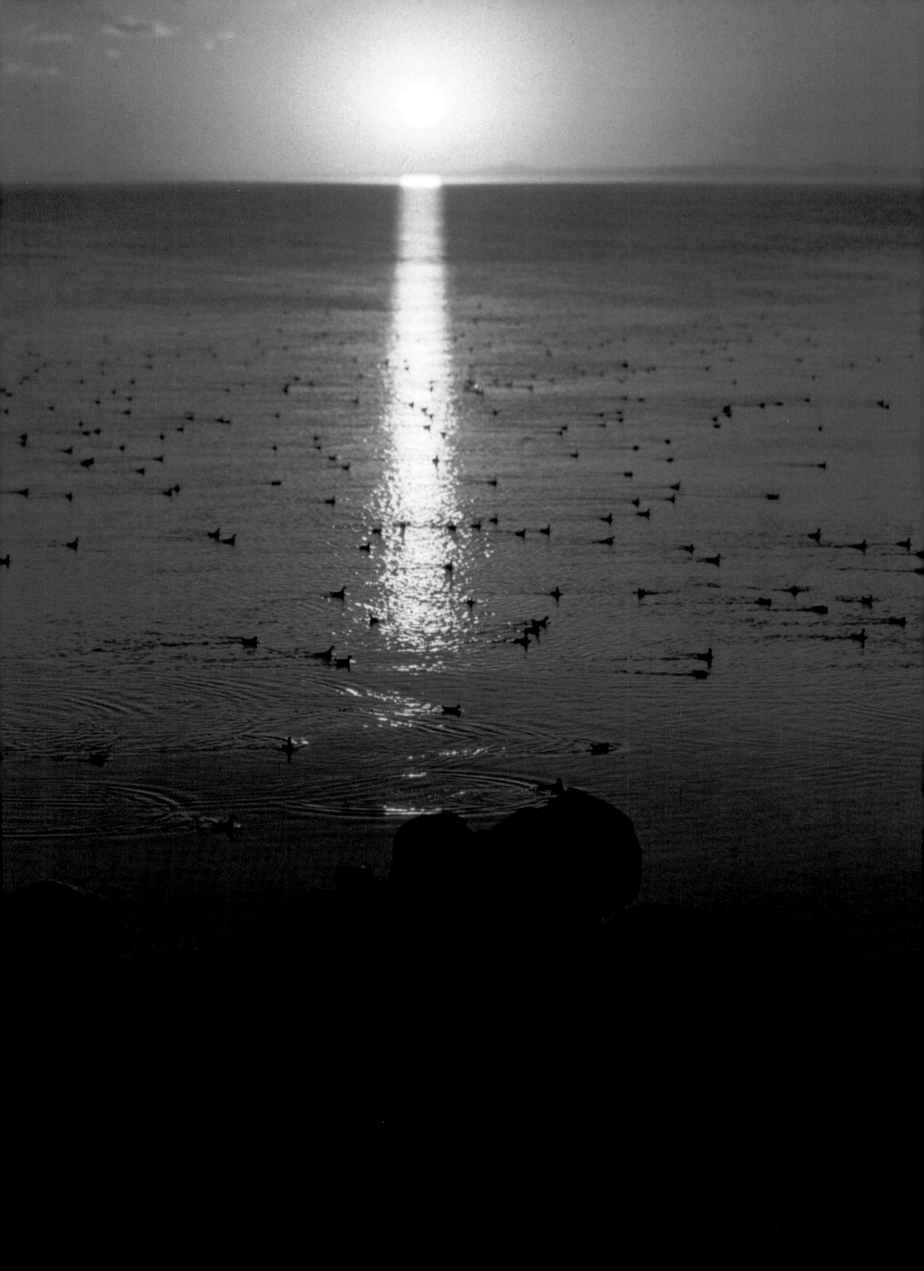

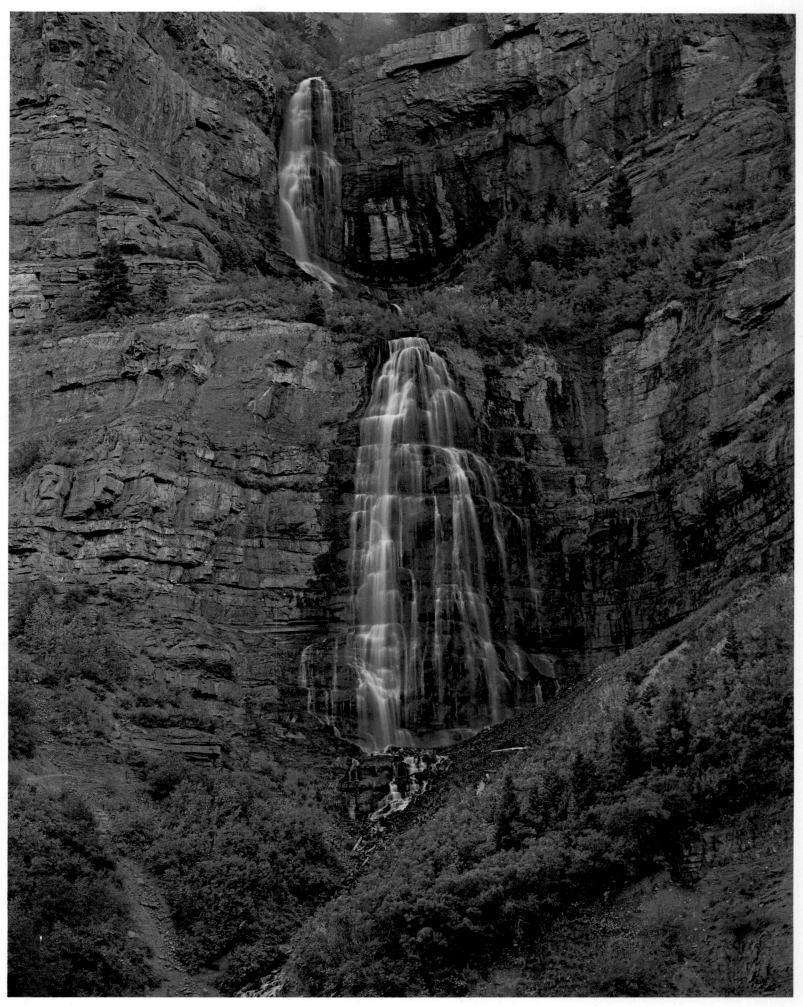

Bridal Veil Falls cascade in lacy beauty over limestone strata during autumn in Provo Canyon. *Right:* For the Donner Party its ordeal by hunger in the Sierra was partly caused by the difficulty of passage through these saline pans. Here James Reed had to bury his Palace Car, a special wagon containing a fortune of goods, in the struggle for water. Bonneville Salt Flats.

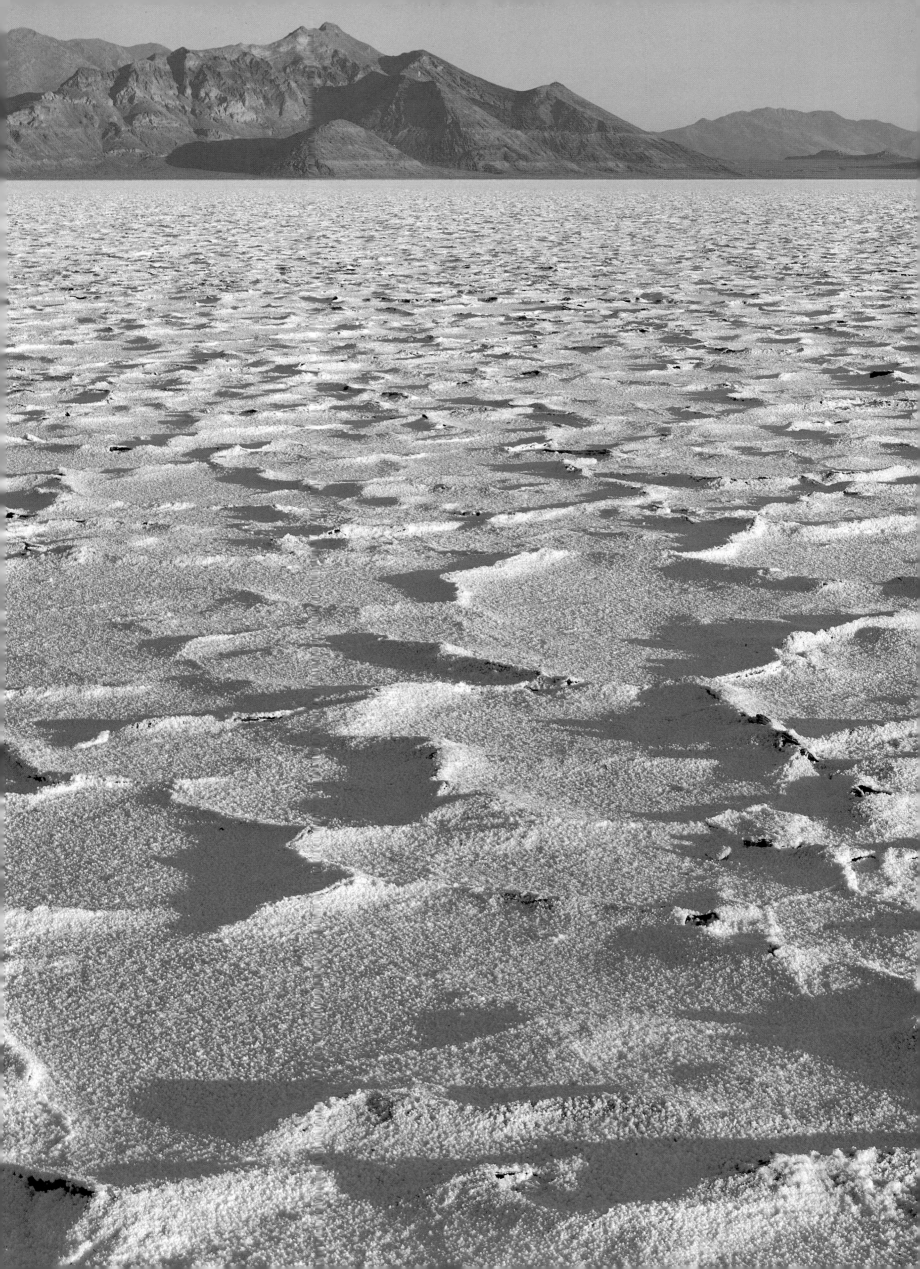

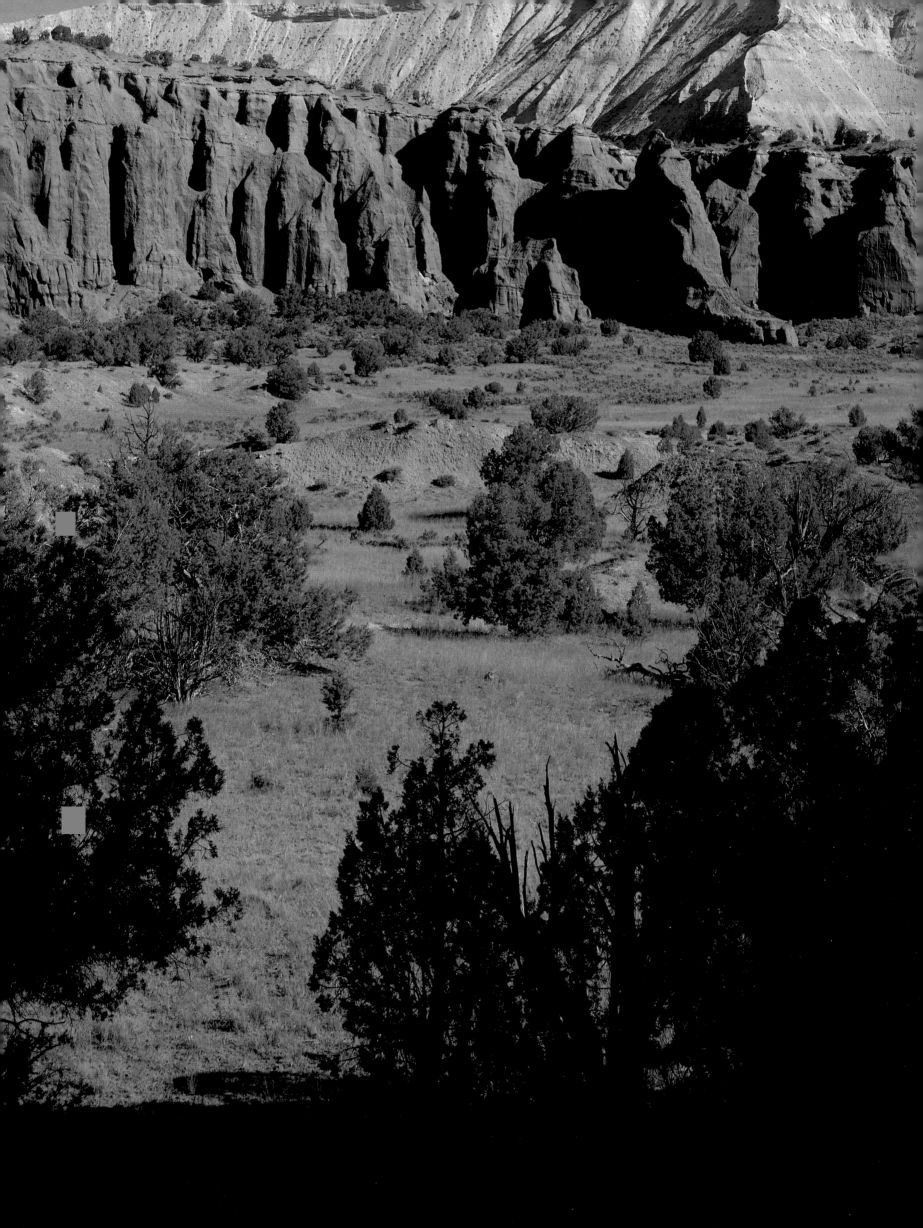

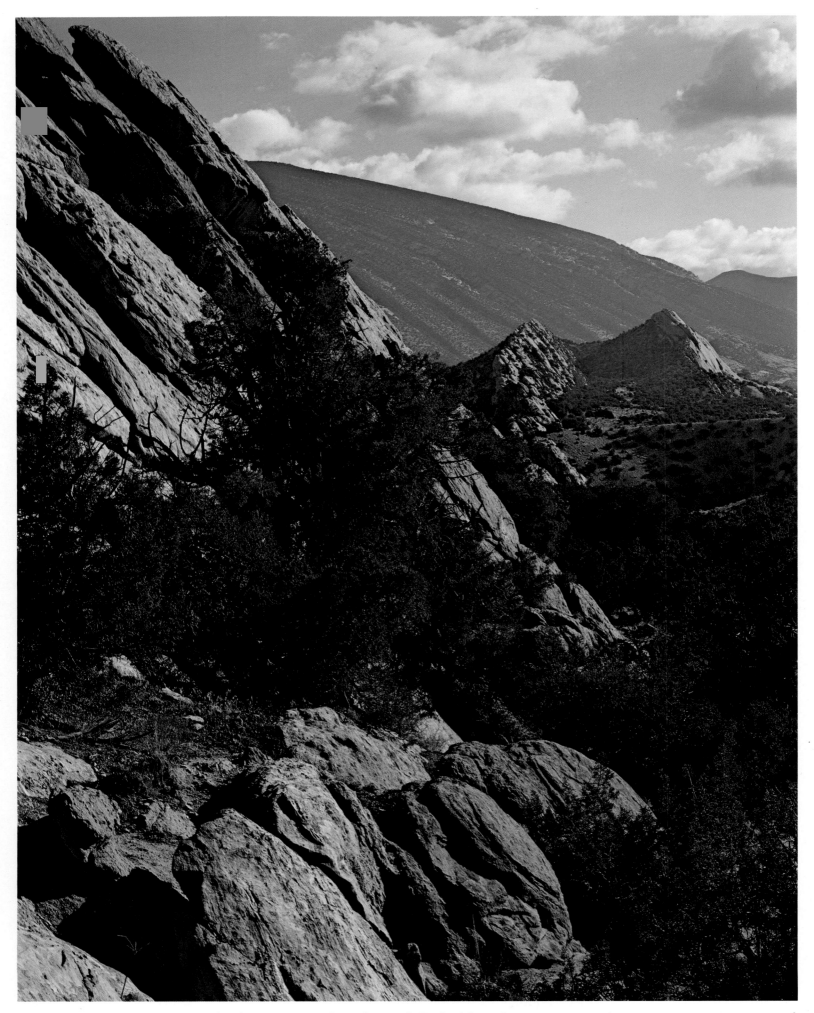

Steeply plunging strata along the south flank of the Split Mountain anticline form parallel hogbacks of resistant sandstone, altering with softer layers of mudstones, siltstones, and shales. Dinosaur National Monument. *Left:* Poorly consolidated formations erode in weird form in this region where precipitation is low and vegetative cover scanty. Kodachrome Flats, Chimney Rocks State Park.

The Utah agave or century plant grows in rosettes of spine-margined thick-
ened leaves, persisting for several years until a flowering stalk is produced.
After flowering, the plant dies to stand flag-like while young plants pro-
duced from its base continue to live. Snow Canyon.

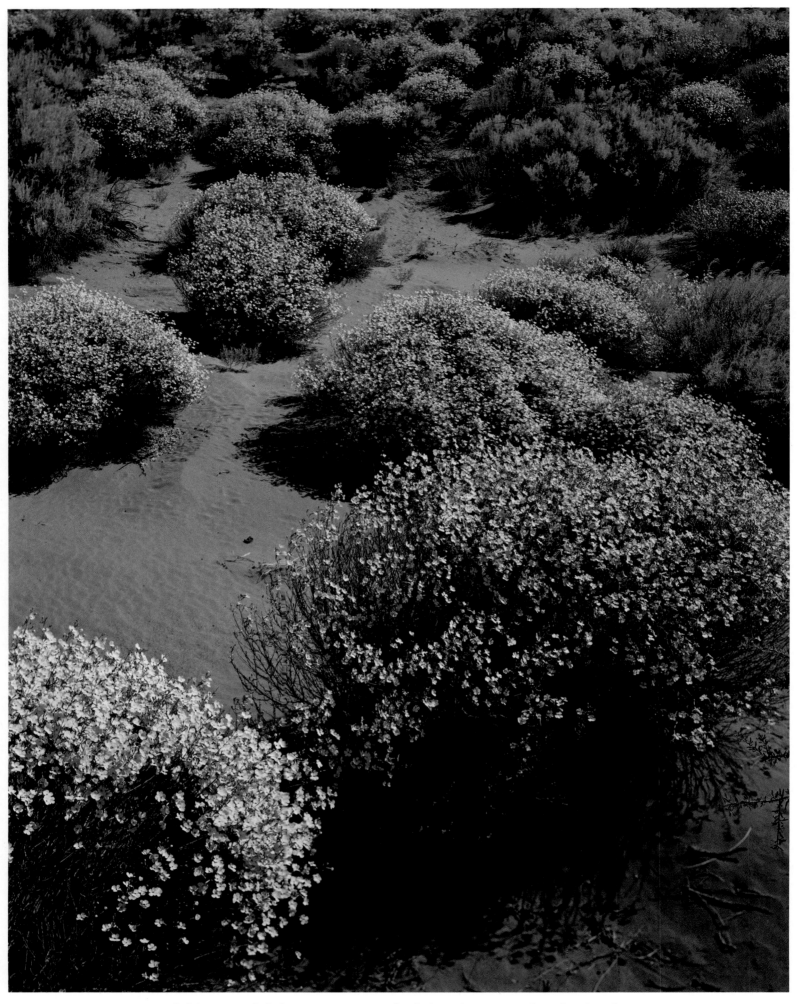

Sublime in subtle beauty is a scene of pale beardtongue, with its flat-faced flowers. It grows profusely in the sandy soils of southern Utah. Snow Canyon.

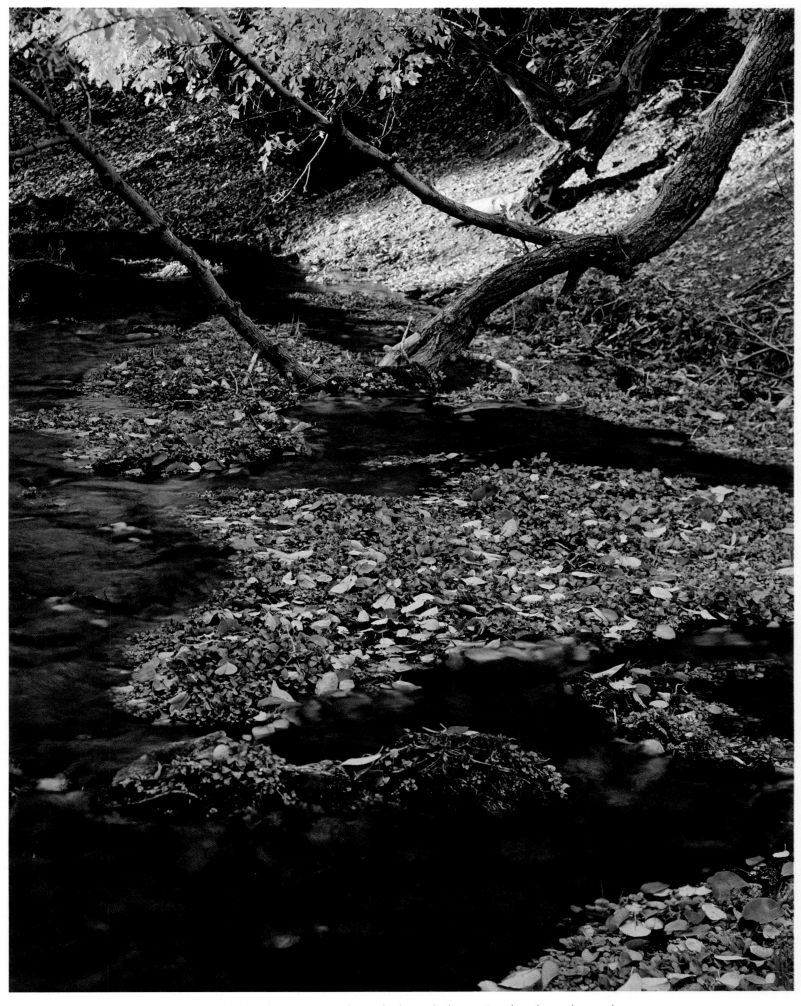

Leaves clothe the mossy rocks and islets of Clover Creek, where they color
the carpet of a streamside forest in the coolness of autumn. Tooele County.

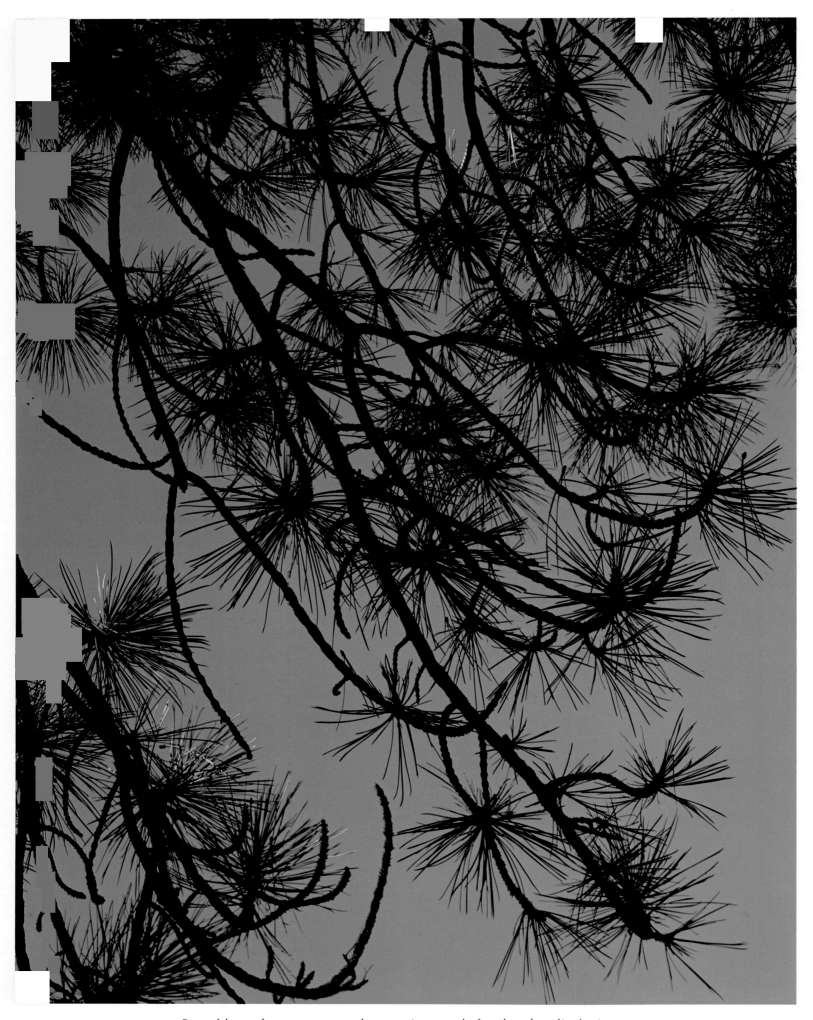

Branchlets of a mature ponderosa pine reach for the sky, displaying a pattern in which maximum use of space guarantees efficient use of life-giving sunlight. U nta Mountains.

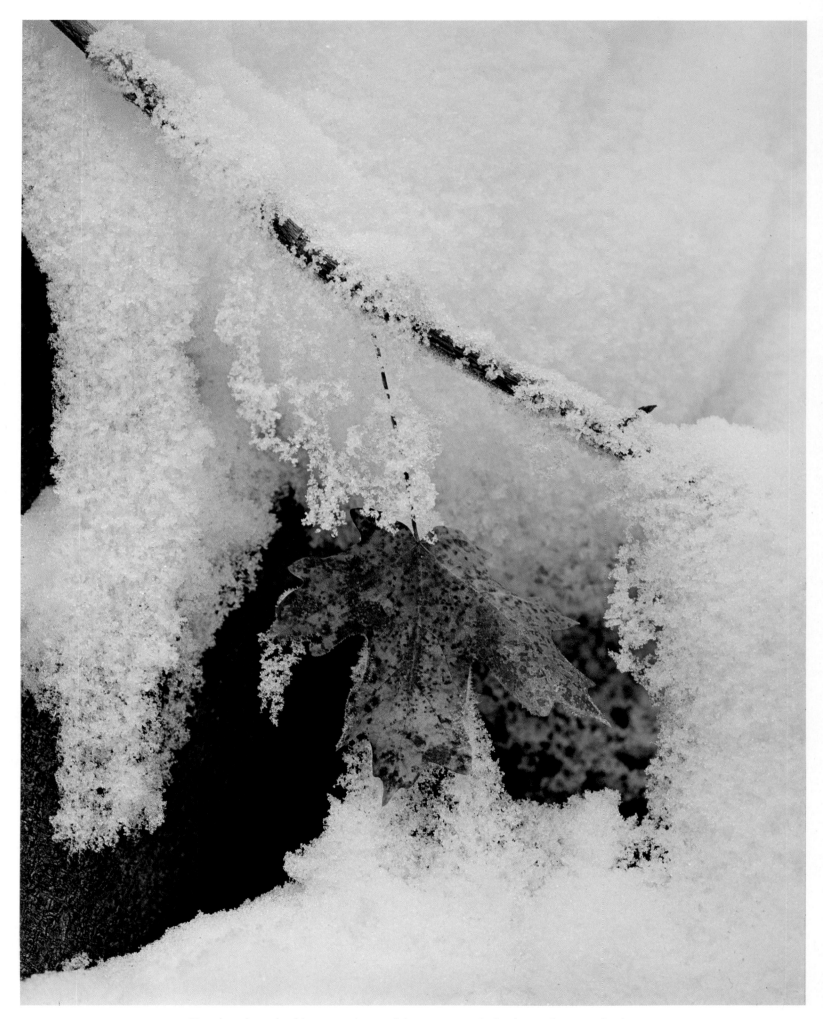

Dead and marked by organisms of decay, a maple leaf remains attached to
the twig on which it grew, now adorned with frost of a winter morning.
American Fork Canyon. *Right:* Snowfall, at least in this century, does not
allow glaciers to grow, such as those of the Ice Ages which carved the cirque
and produced the sharp ridges on the east side of Mt. Timpanogos. *Overleaf:*
Intricately sculpted sandstone, cut to form arches and bridges, is accented
by lights and shadows. Eye of the Whale Arch, Arches National Park.

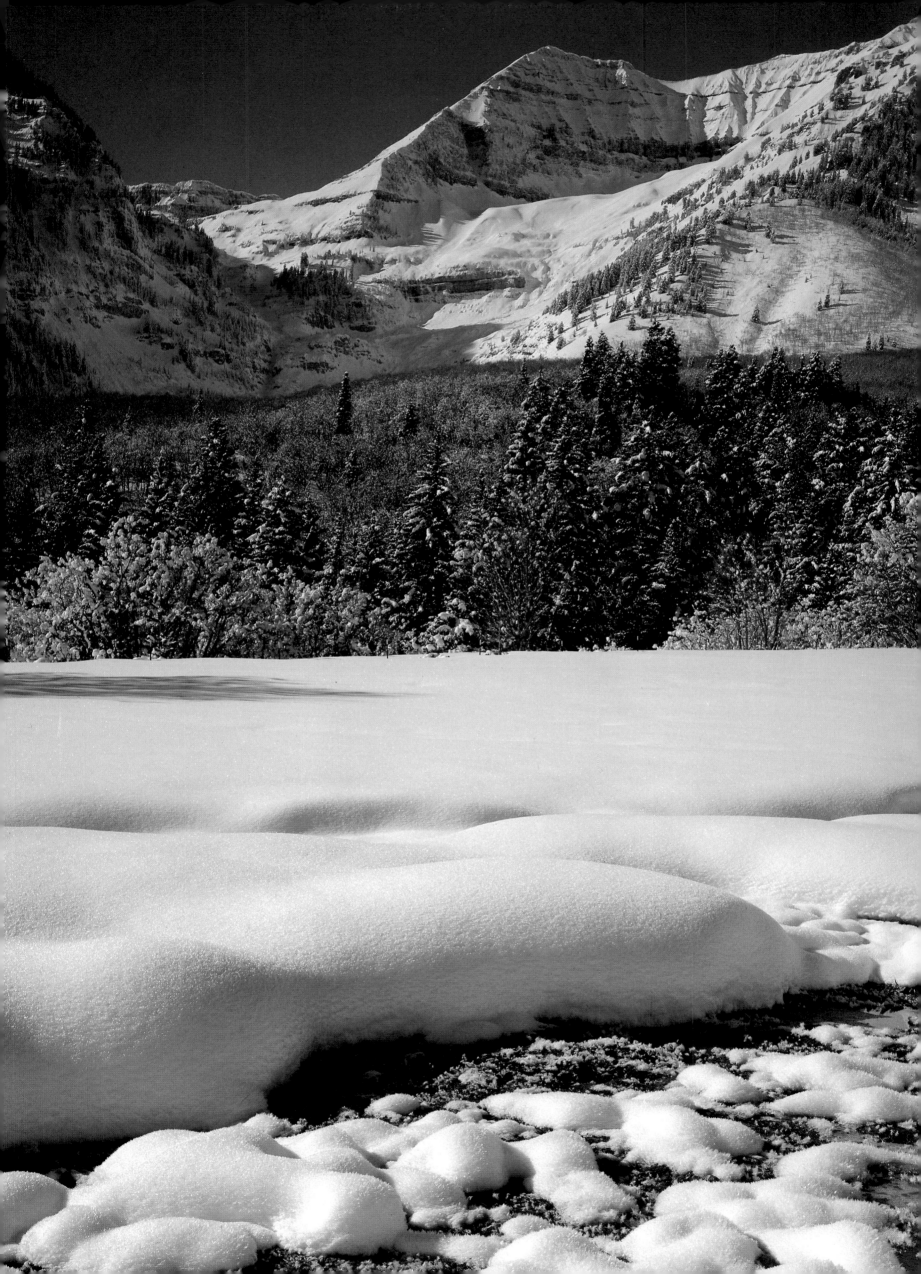

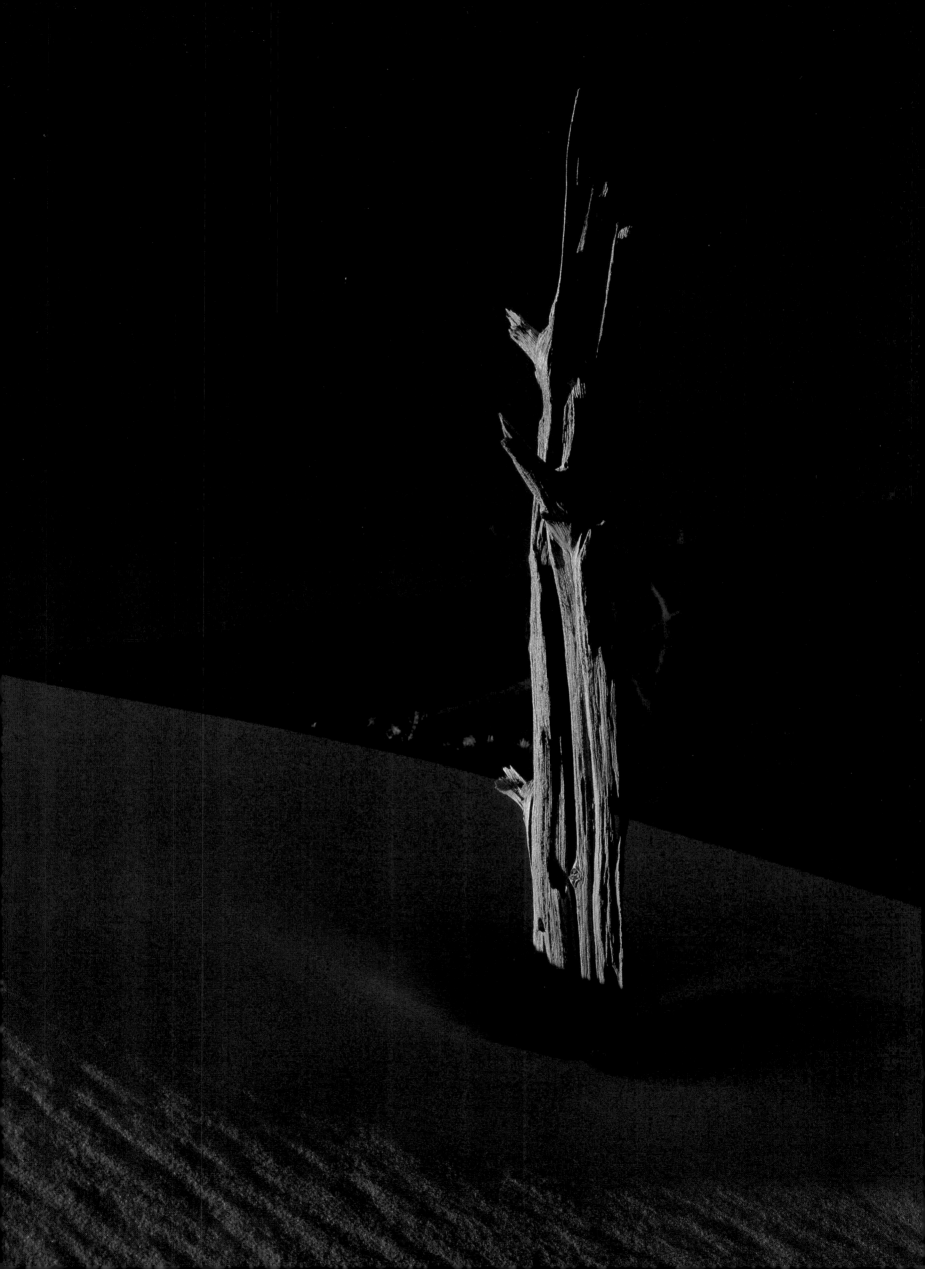

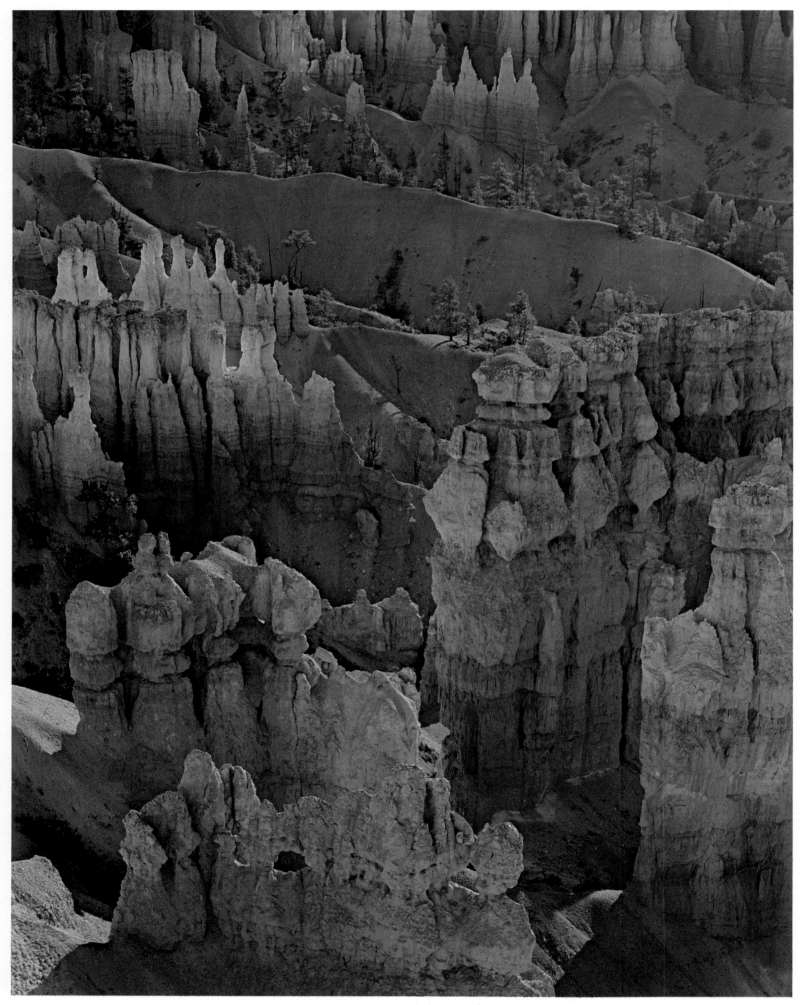

Water, wind, ice, and gravity, acting together through time, carved a myriad of forms in the loosely cemented pink limestone of Bryce Canyon National Park. *Left:* Long rays of sunlight at day's end highlight a ponderosa pine snag, sandblasted by wind-borne grains of Coral Pink dunes as they move eastward. Kane County. *Overleaf:* Verdant fields contrast with stubble following harvest. Tillage exposes bare rich soil adjacent to a corner bearing native grasses and shrubs. Cache County.

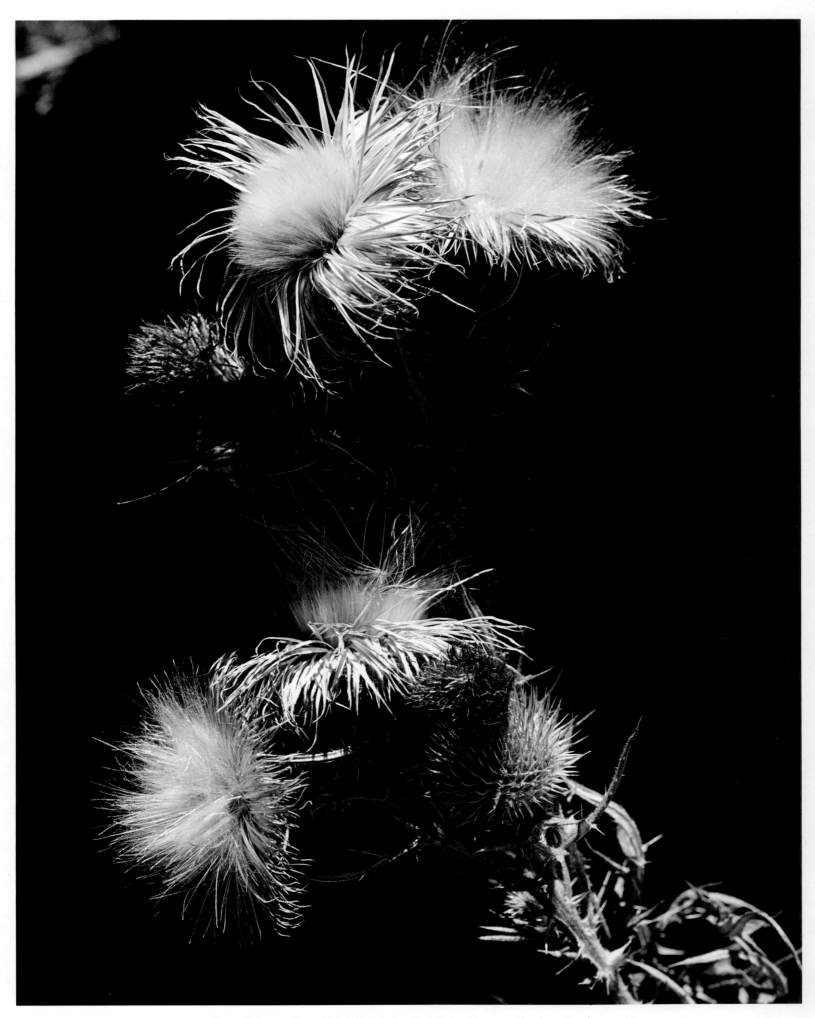

Introduced from the Old World, bull thistle is a waif of agriculture. It produces wounds with its sharp points, yet dazzles the eye with its beauty. Wasatch County. *Right:* Forces of erosion have acted on the geological strata in Goblin Valley where soil salts are high and precipitation is low, resulting in a barren and alien landscape.

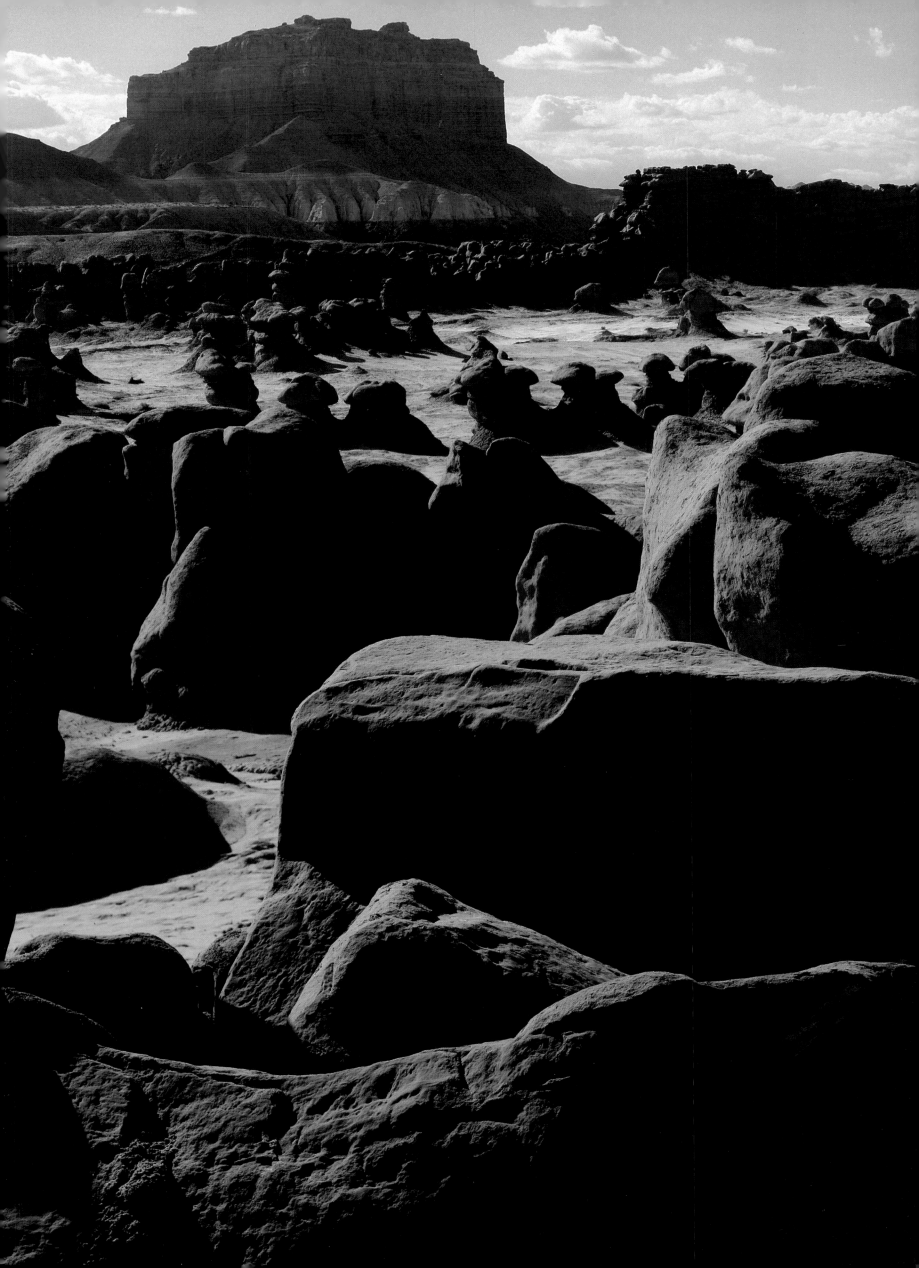

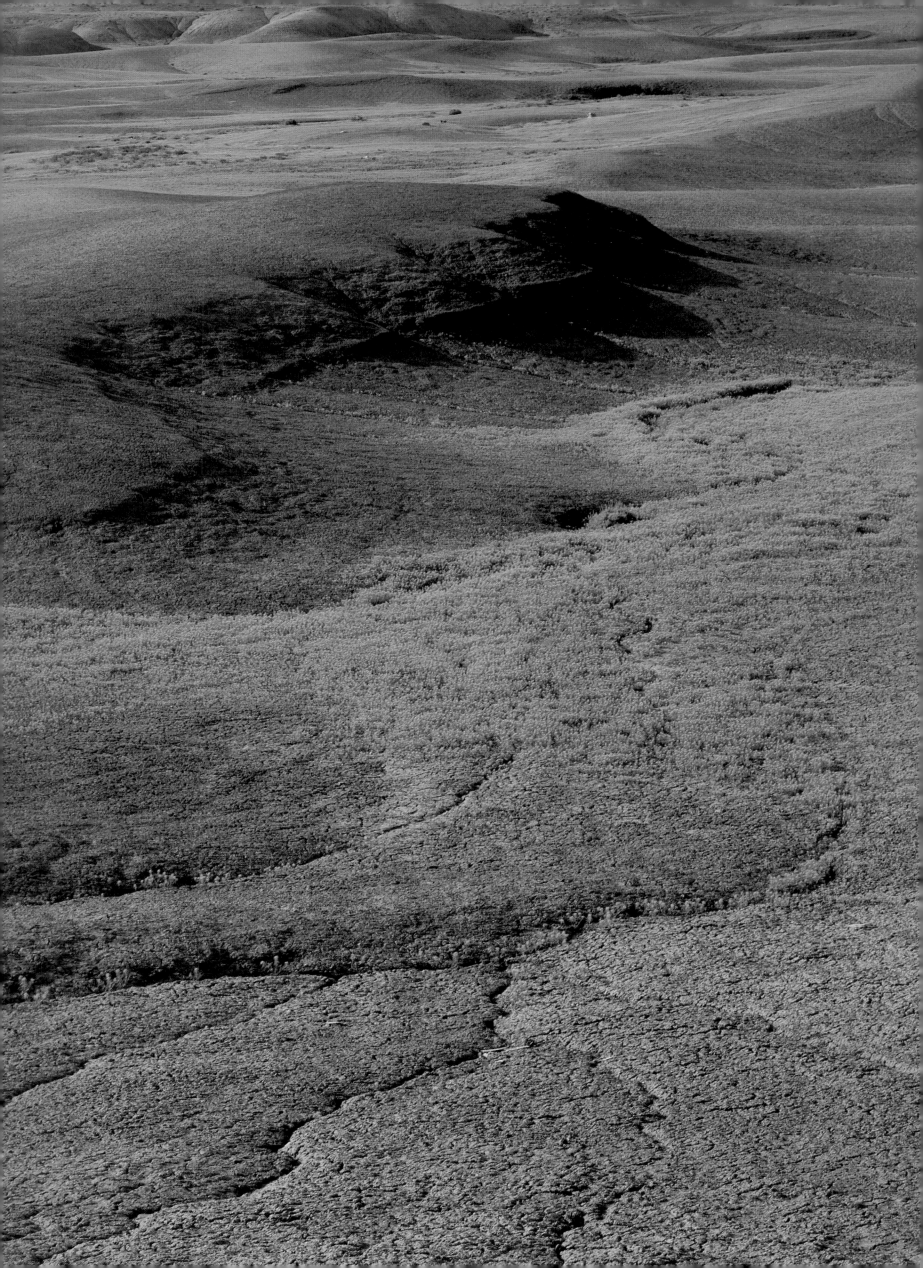

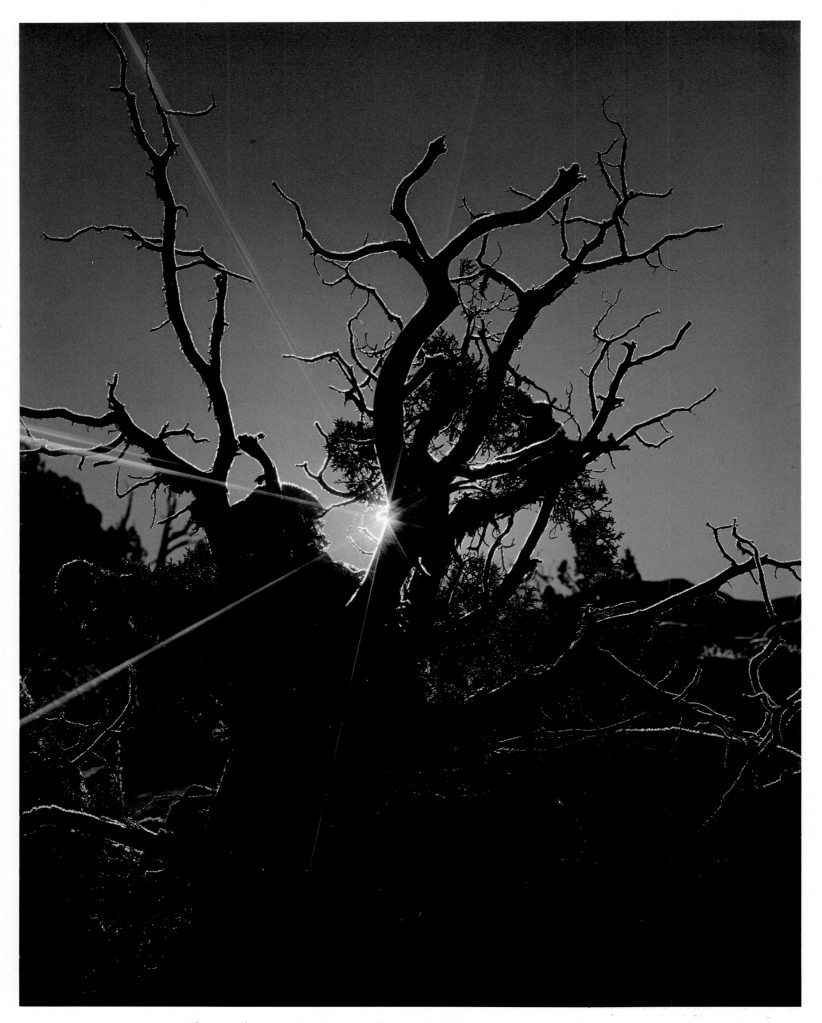

Life in arid pinyon-juniper woods is marked by constant struggle for survival, with some branches dying while others live, clad in the frost of an early winter morning. Arches National Park. *Left:* North of Lake Powell is eastern Kane County, the softly rounded forms of the Tropic Shale Formation dominate the landscape. During the few years of abundant winter precipitation, the clay surface abounds with flowers in springtime.

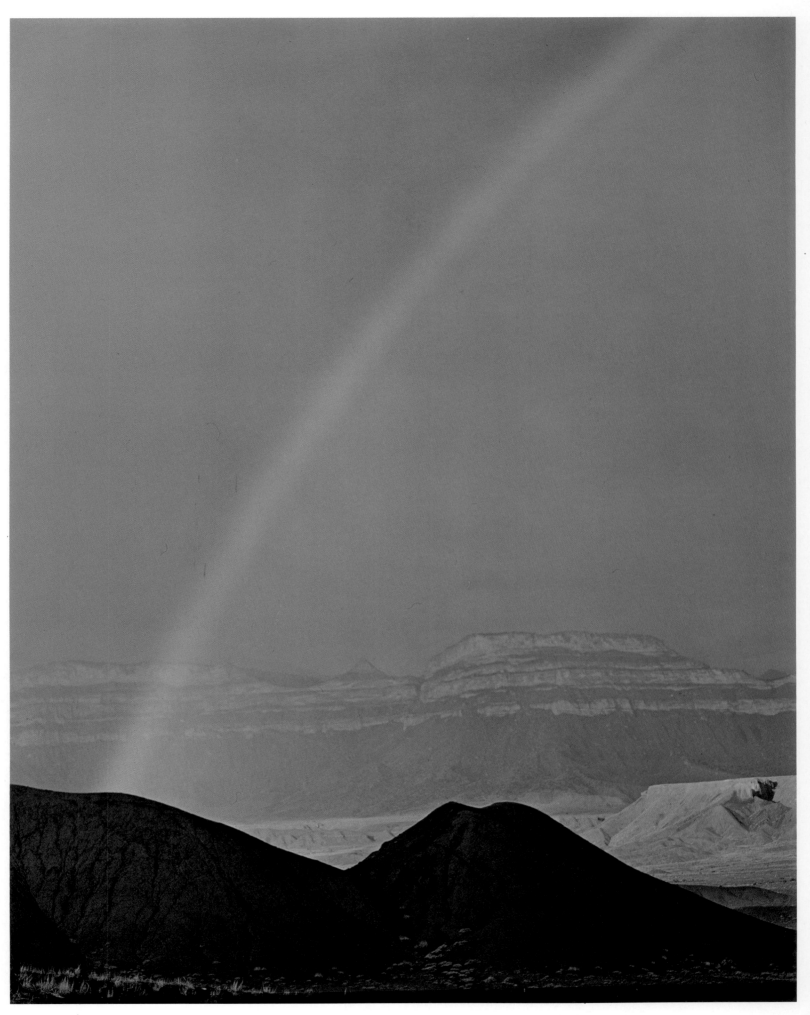

Black to buckskin colored, softly rounded hills and flat-topped buttes and plateaus form the stage for a summer storm against a cyclorama of coal bearing strata. West Tavaputs Plateau, Emery County.

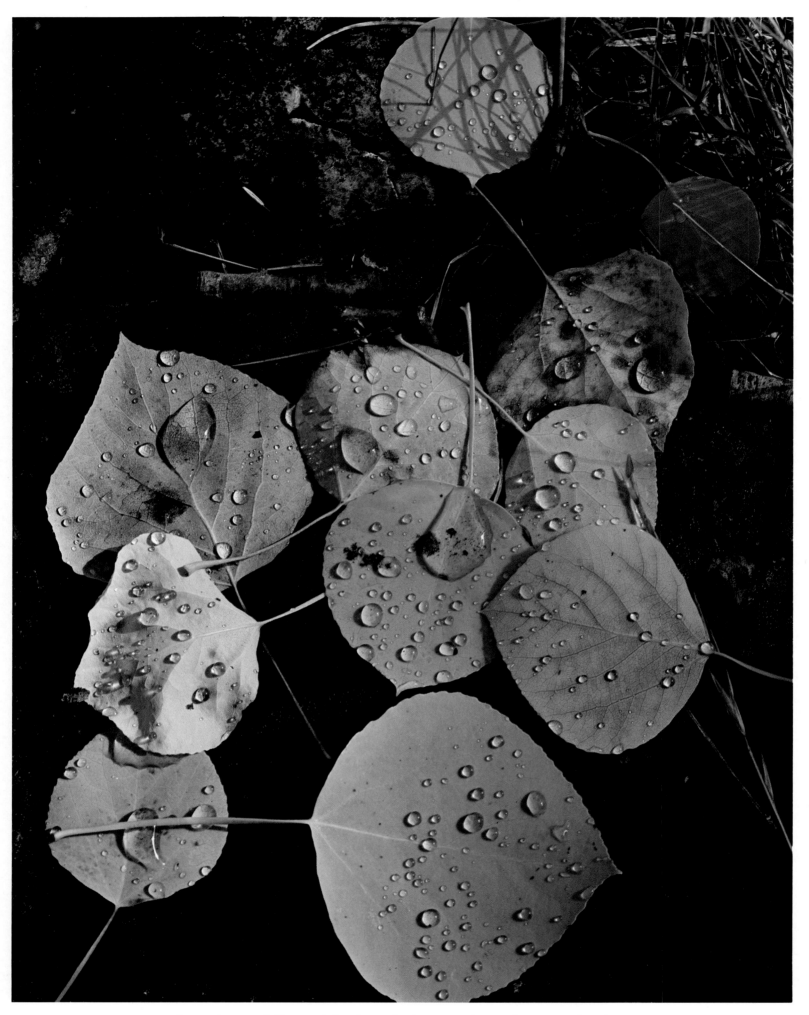

Aspen leaves, fallen and dead, retain the waxy, impervious covering that prevents loss of water in life. In charm and beauty, they carpet the surface of the forest floor before joining it in decay. Utah County.

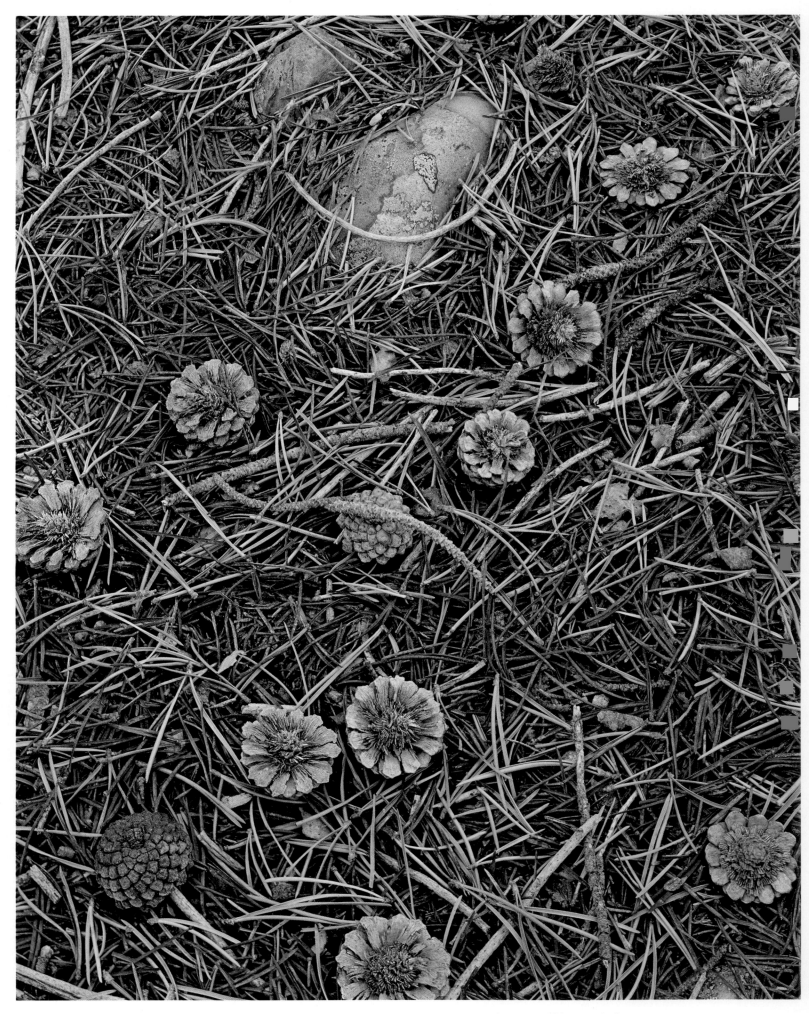

Needles, cones, and twigs of lodgepole pine protect the ground beneath the spreading forest canopy. Uinta Mountains. *Right:* Tangled branches lodged high in trees form nests for herons back lighted in the winter sun. Utah Lake.

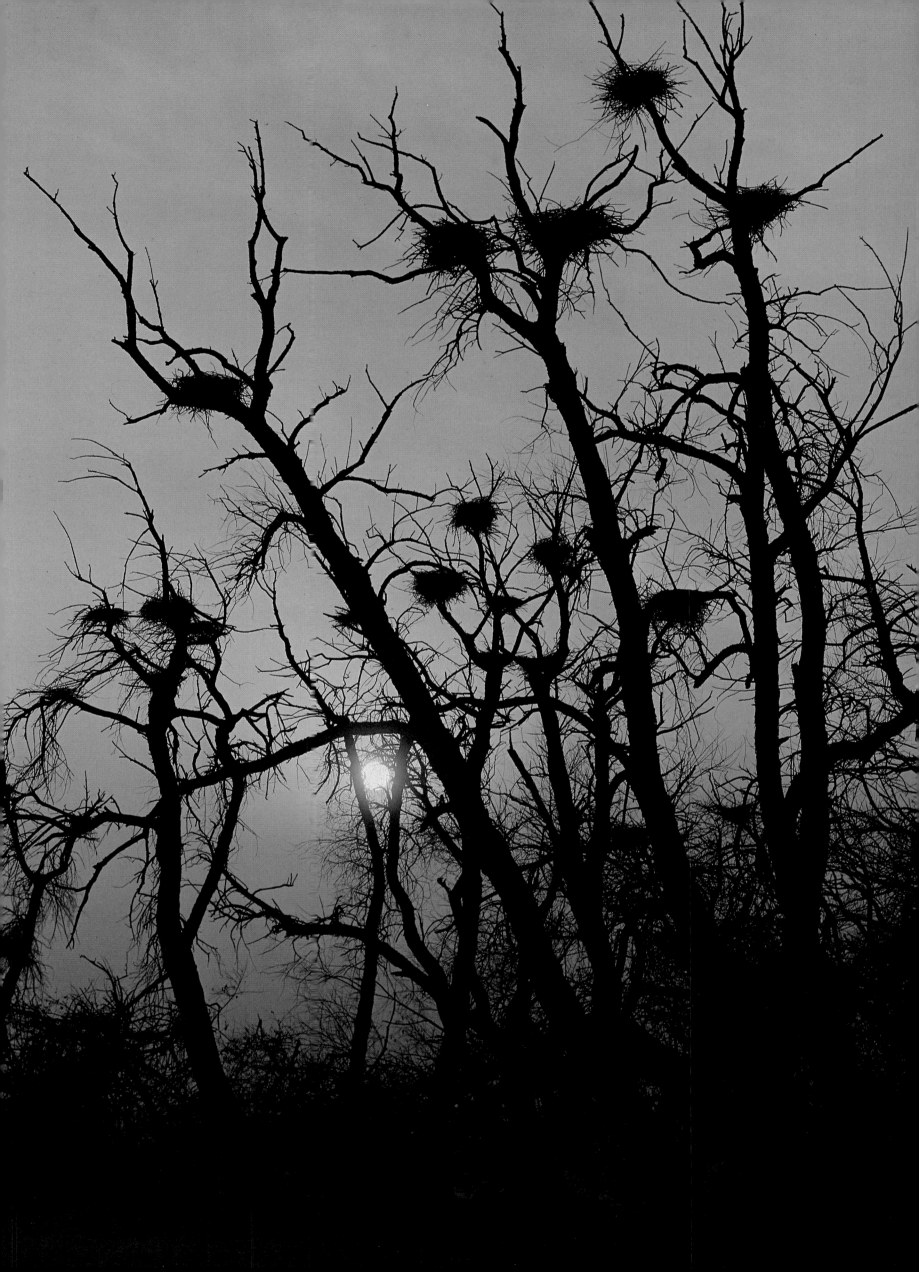

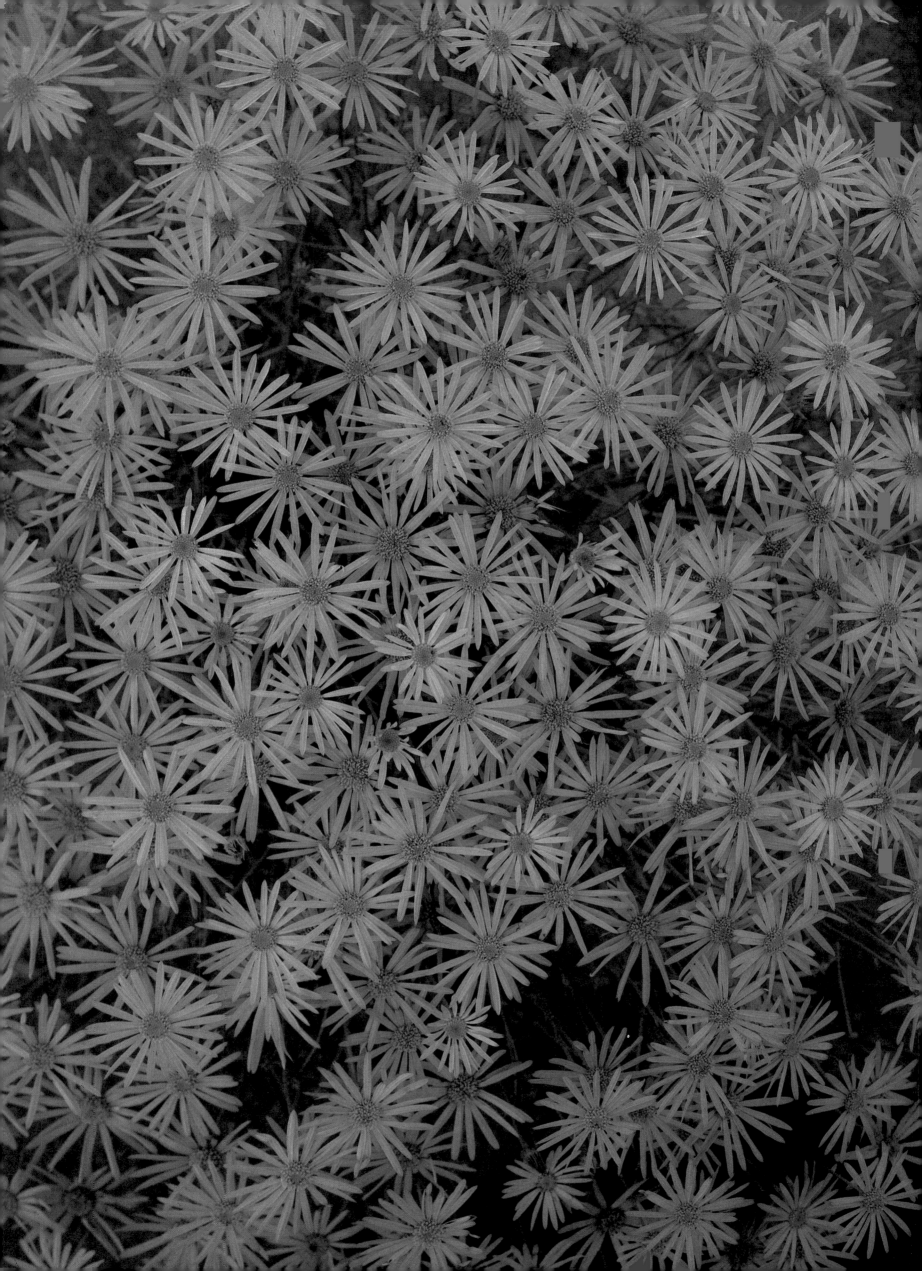

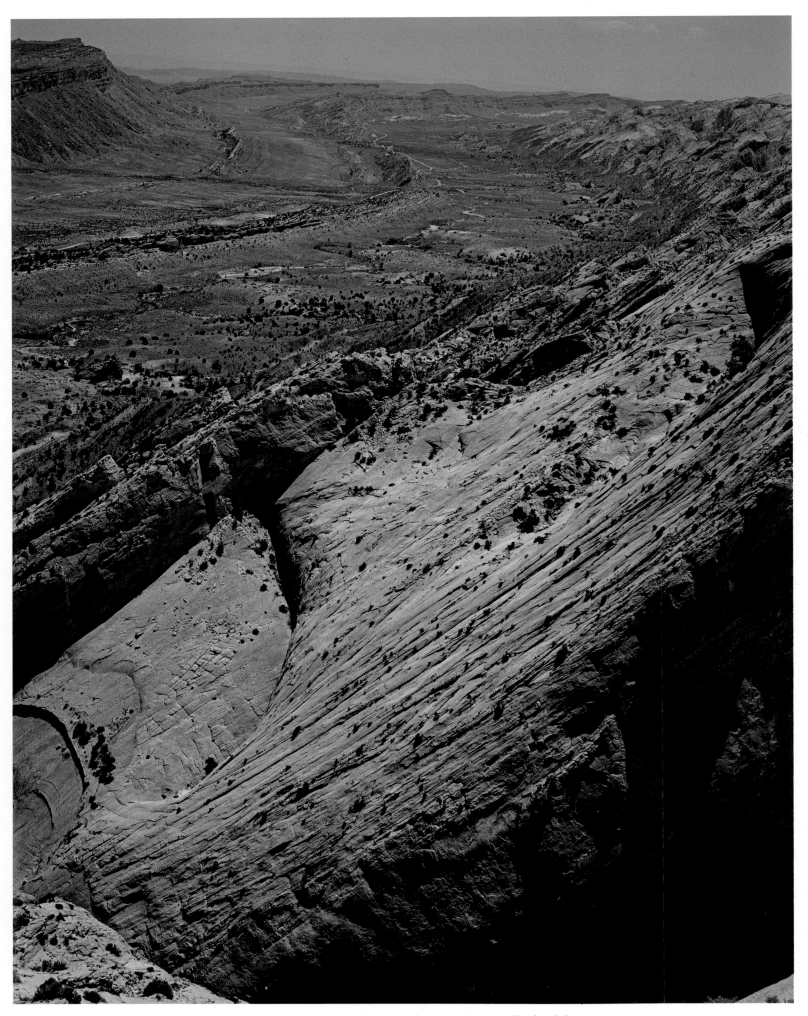

Navajo Sandstone stands steeply angled along the east flank of the Water-pocket Fold, a massive feature extending for more than 100 miles south from its beginning in Capitol Reef National Park. *Left:* Displayed in multilayered pattern are the heads of fleabane daisy. Arches National Park. *Overleaf:* Mancos shale, saline and arid, barren of vegetation, and inhospitable in appearance, erodes in badlands from beneath towering plateaus capped by sandstone. Caineville.

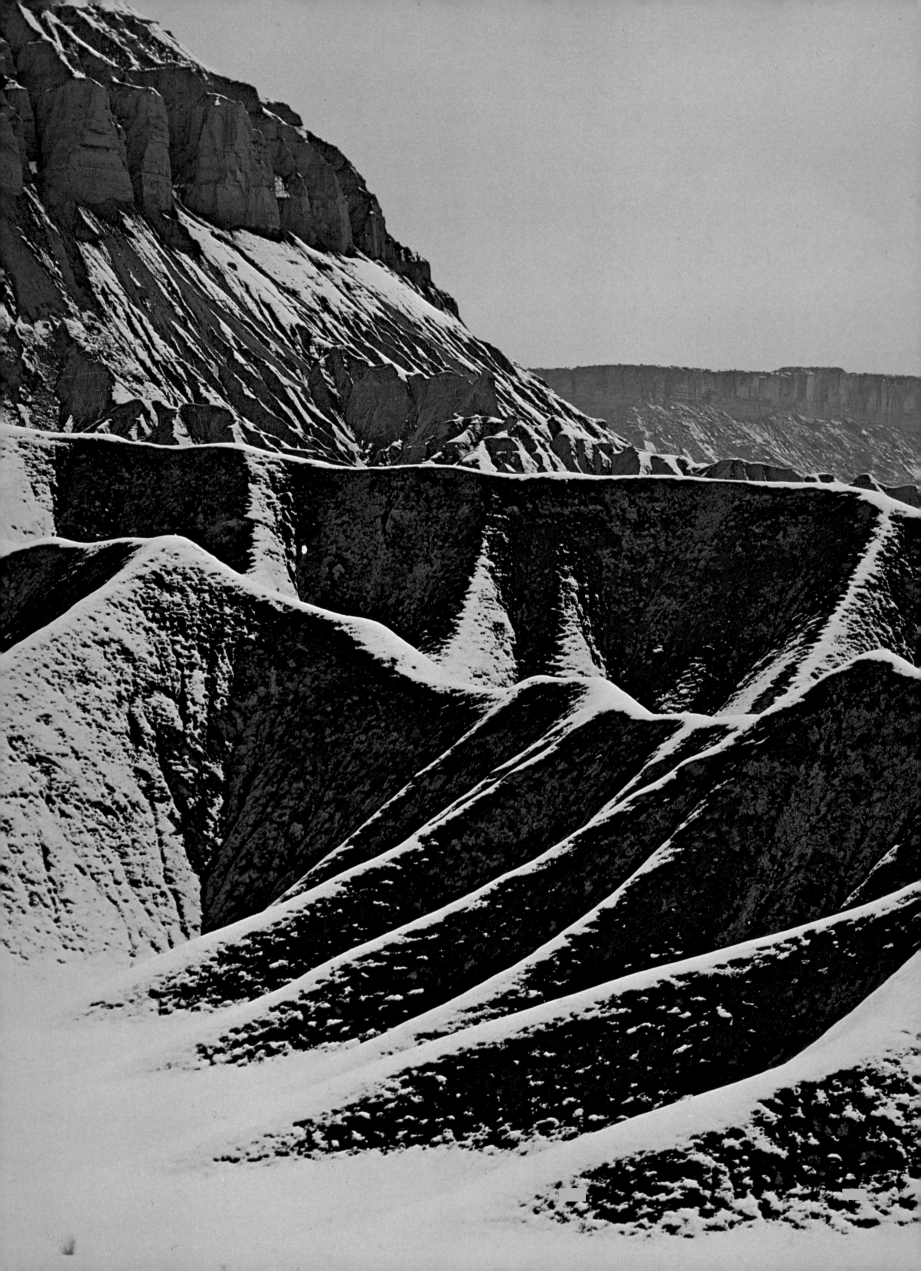

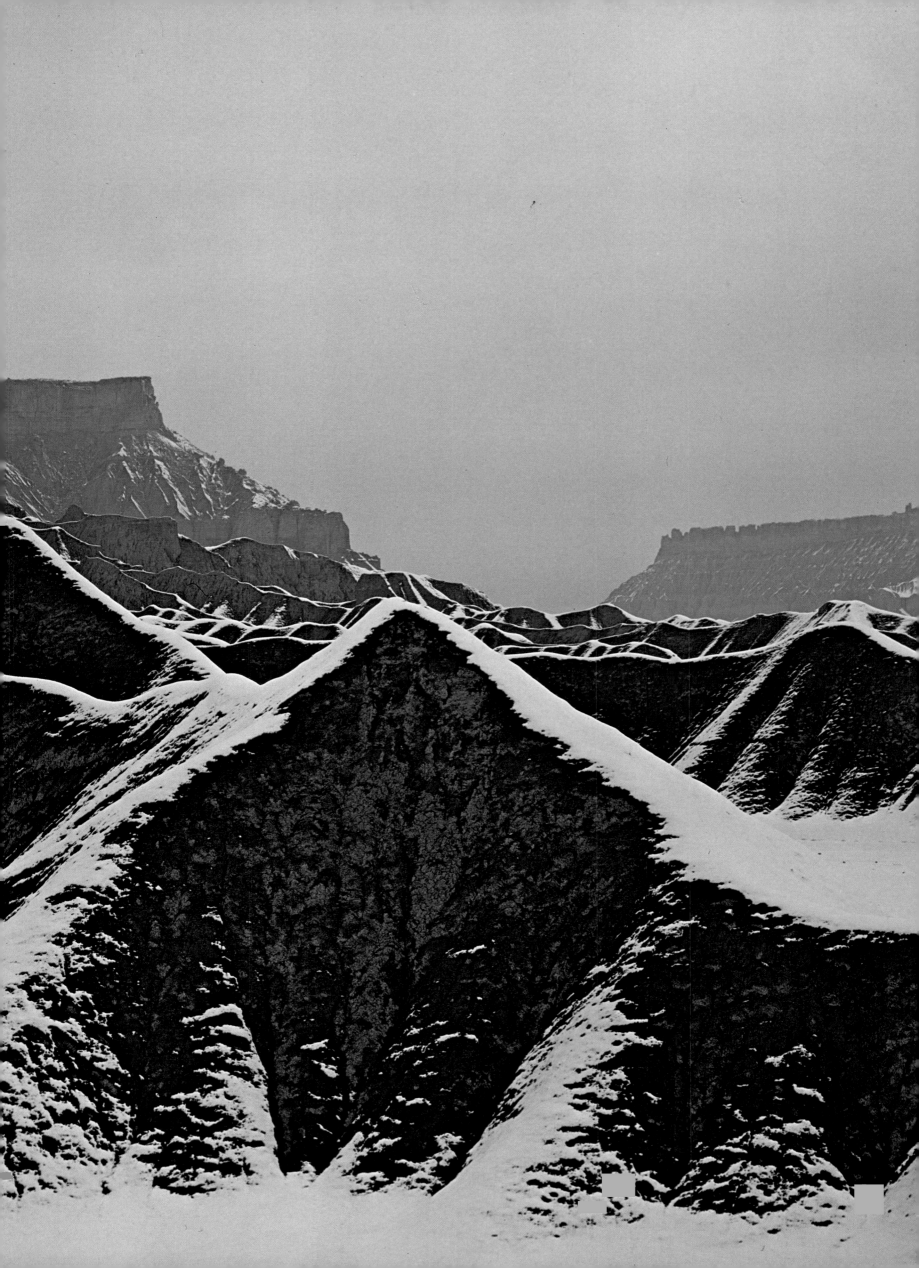

Water is the magic of our existence. In liquid form it complements its setting; in crystalline form it intrigues with charm of pattern dictated by physical laws of nature. Uinta Mountains.

Sand, eternal building material of stone, occurs in sorted piles because of the action of wind. Buried by the snow of winter, it is stationary only for a time. Coral Pink Dunes. *Overleaf:* Multicolored White Rim Sandstone of Permian Age, whose jointed parallel cracks predetermine the weakness of the stone, allows processes of weathering to produce surrealistic sculpture in grand scale. "The Needles," Canyonlands National Park.

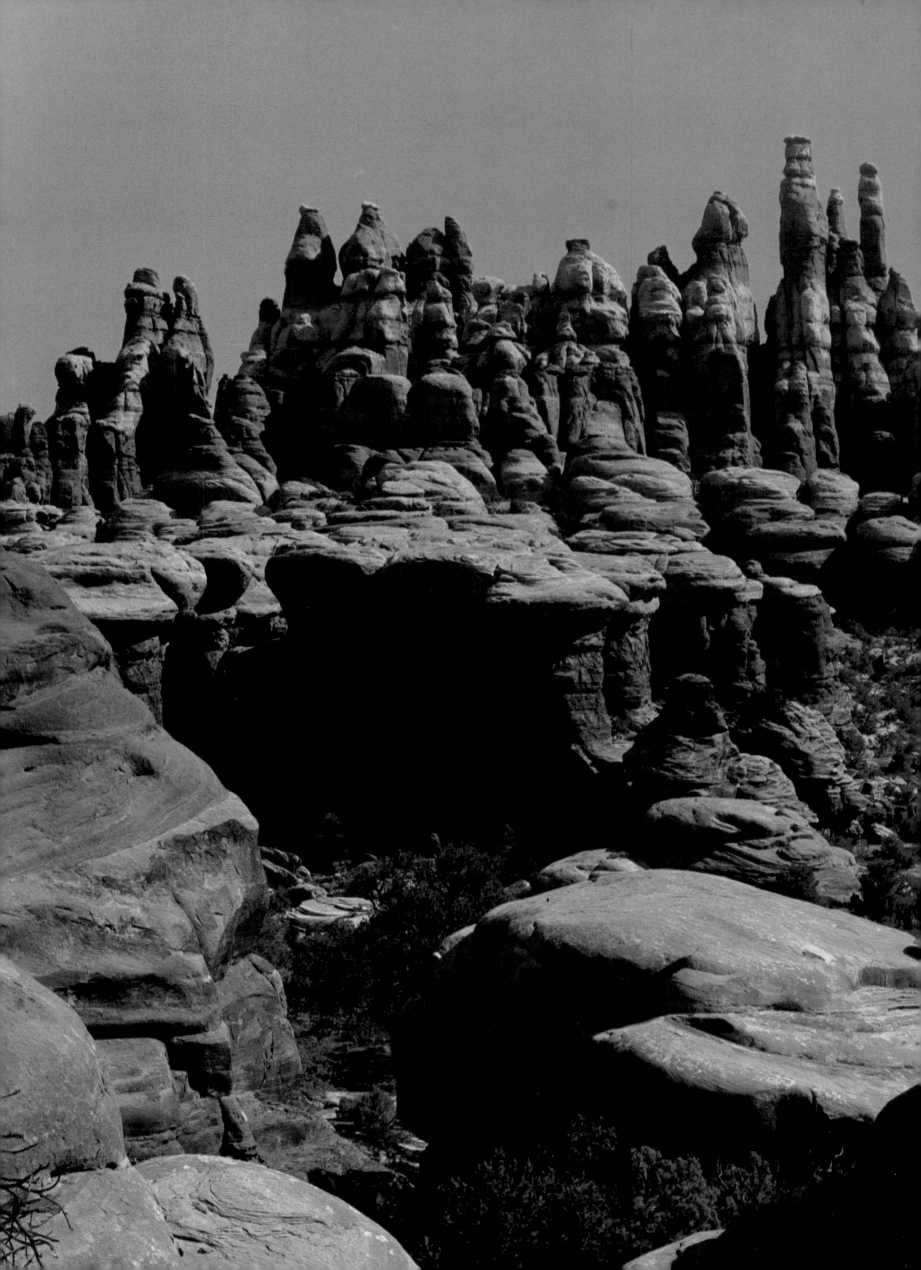

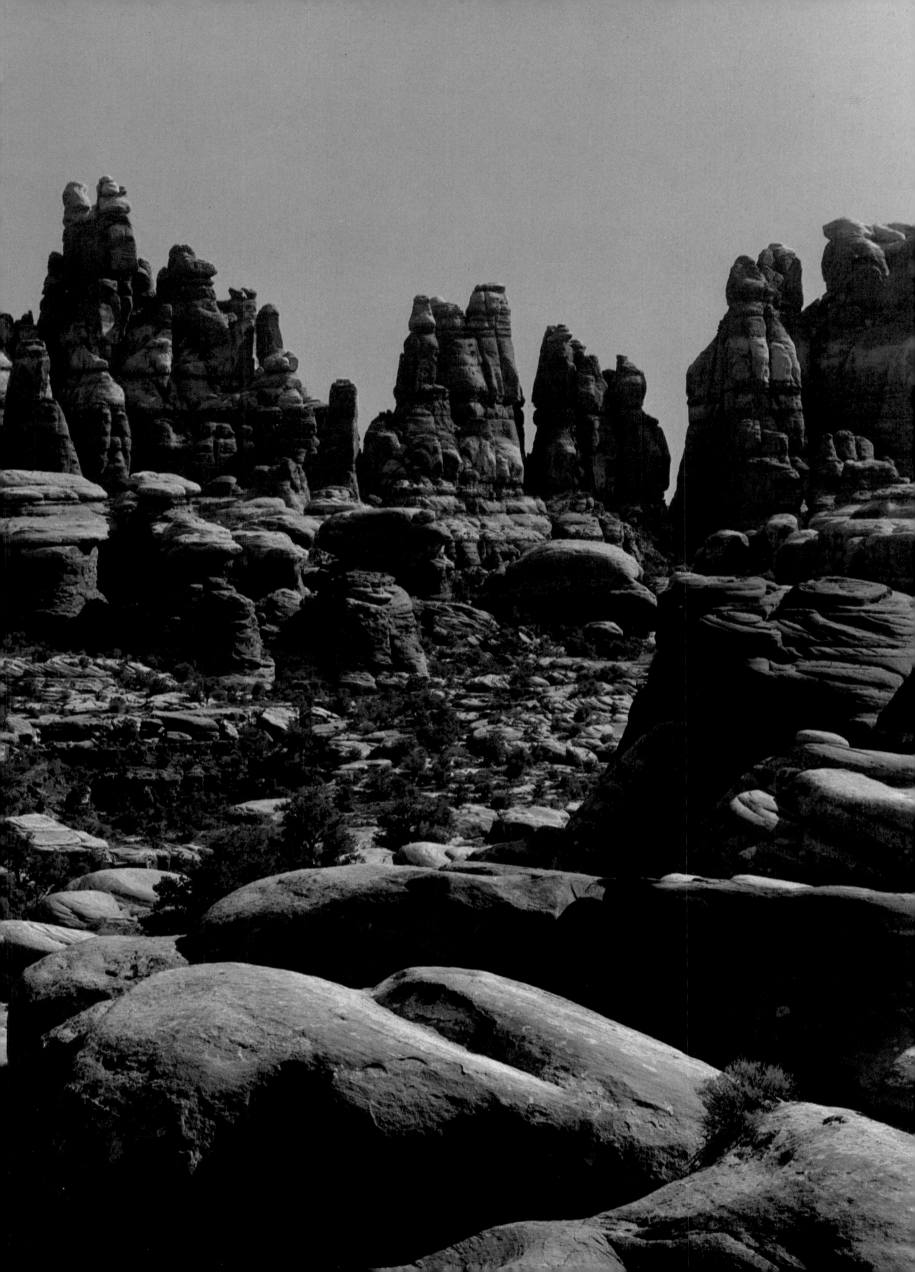

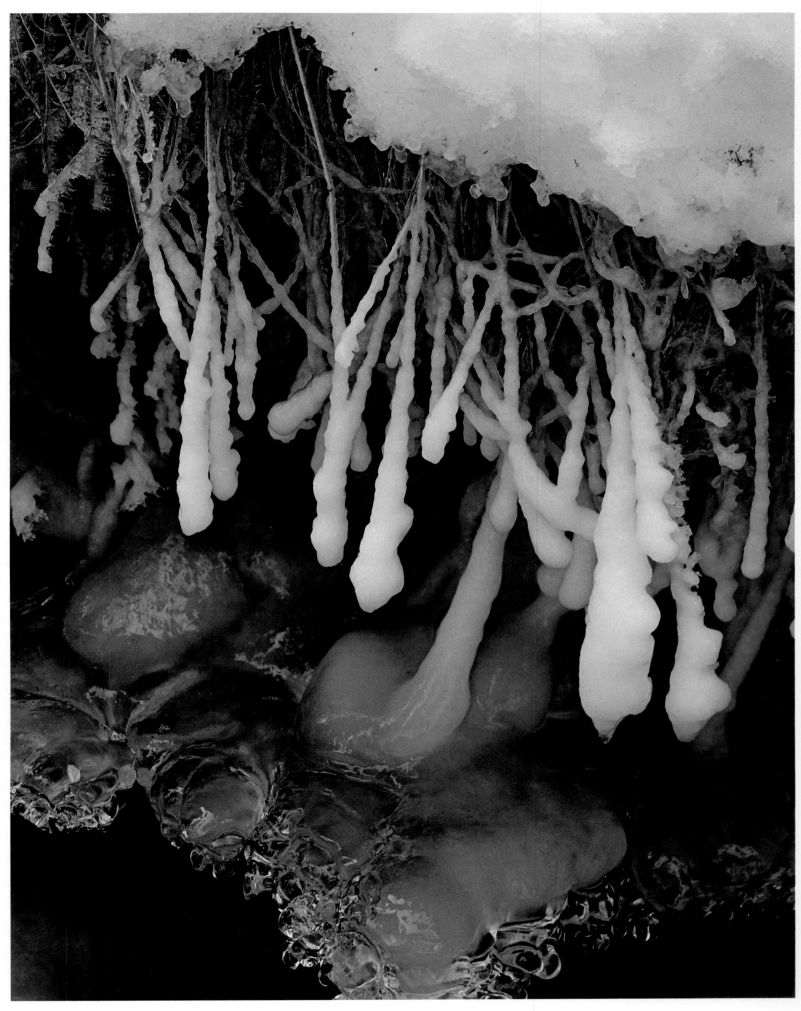

Grass blades and roots, pendulous along a stream bank in winter, trap moisture from the stream. Sundance, North Fork, Provo Canyon.

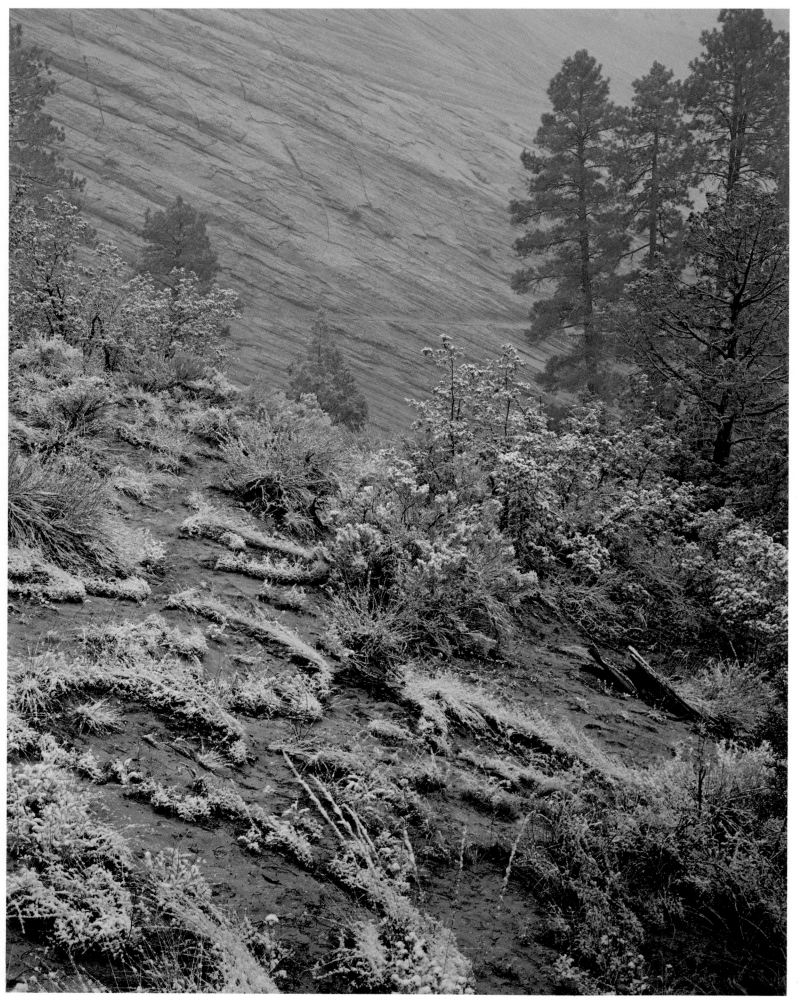

Irregularity of weather is the rule in Utah where late season snowstorms frequently occur. Zion National Park.

A thin cover of melting snow in the low-angled winter sun adds soil moisture for growth of shrubs and other plants in springtime. Valley of the Gods, near the town of Bluff.

Patterns in sand allow one to "see the wind." Repeated in the surface
patterns are the effects of the interplay of wind with sand. Dugway Proving
Ground, Tooele County.

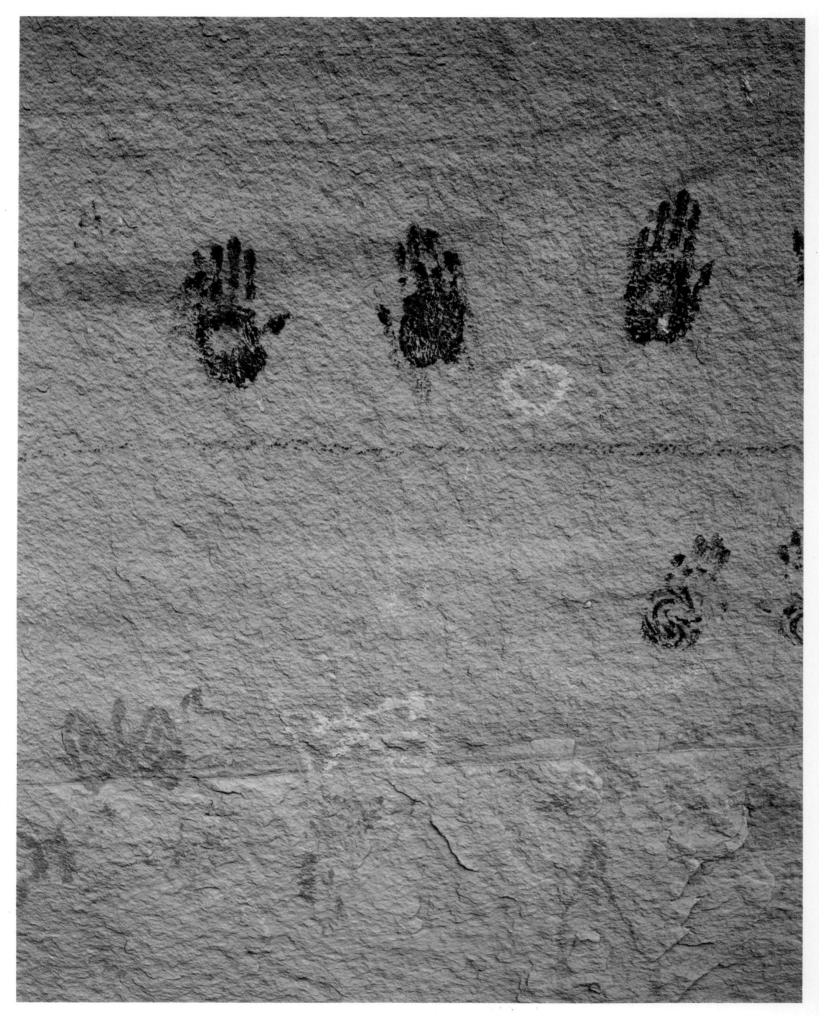

Prints of hands and drawings of "butterflies" mark the existence of prehistoric peoples who knew well the canyonlands of Utah centuries ago. Kachina Natural Bridge, Natural Bridges National Monument. *Right:* Waters of the Colorado River form Lake Powell behind Glen Canyon Dam. Hite, Glen Canyon National Recreation Area. *Overleaf:* Joshua trees, standing with irregular branches outstretched like arms, clothe the landscape and provide an alien appearance to the slopes of the Beaver Dam Mountains.

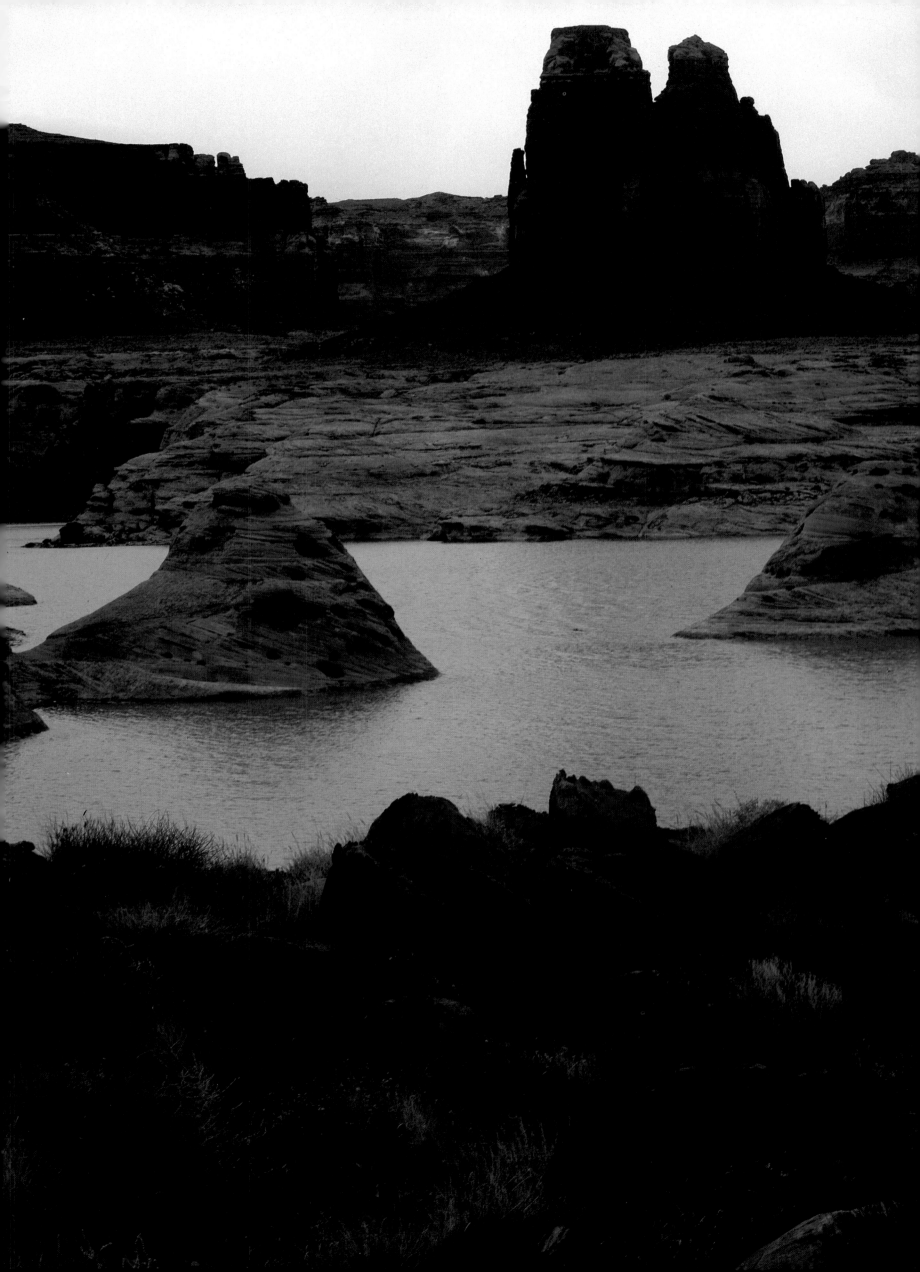

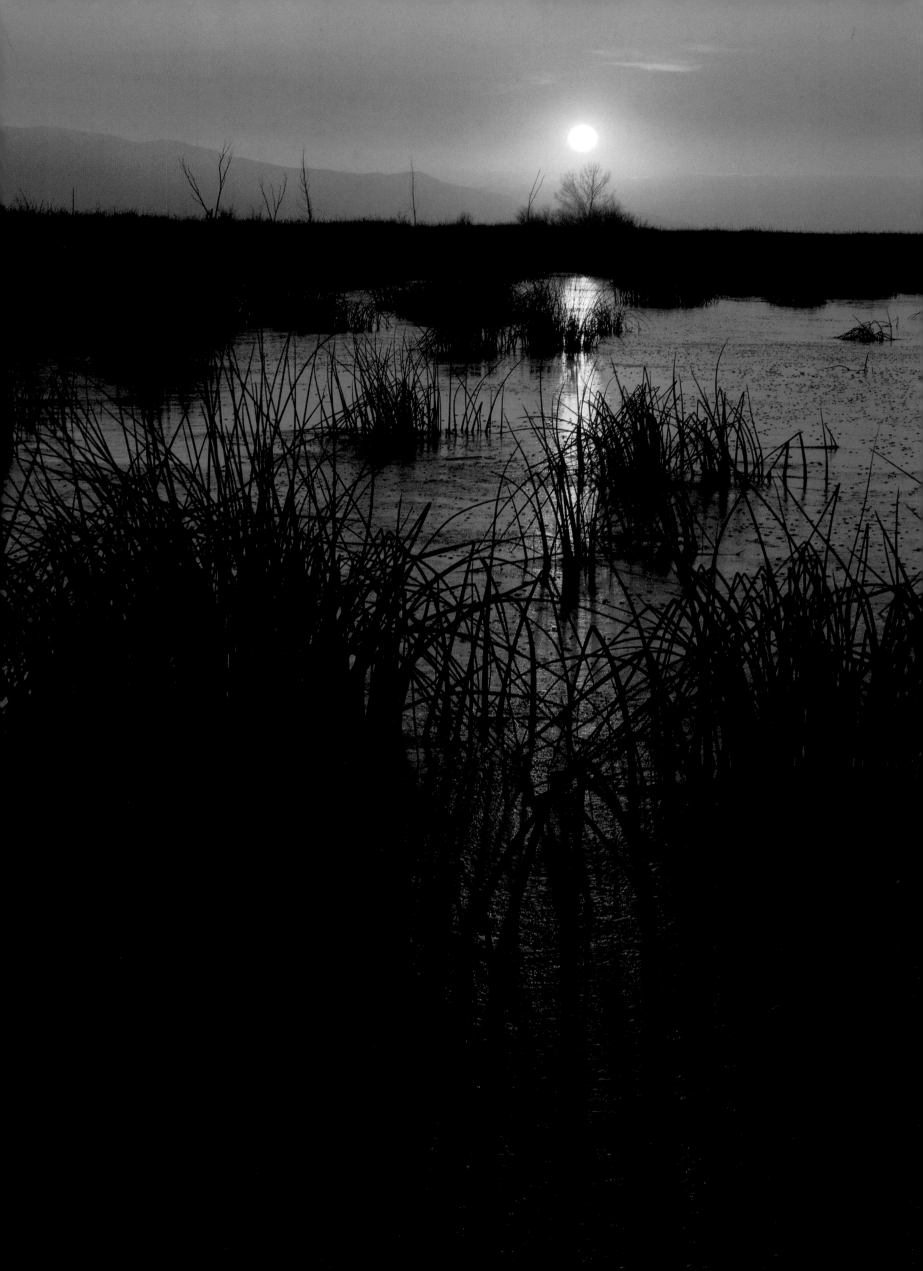

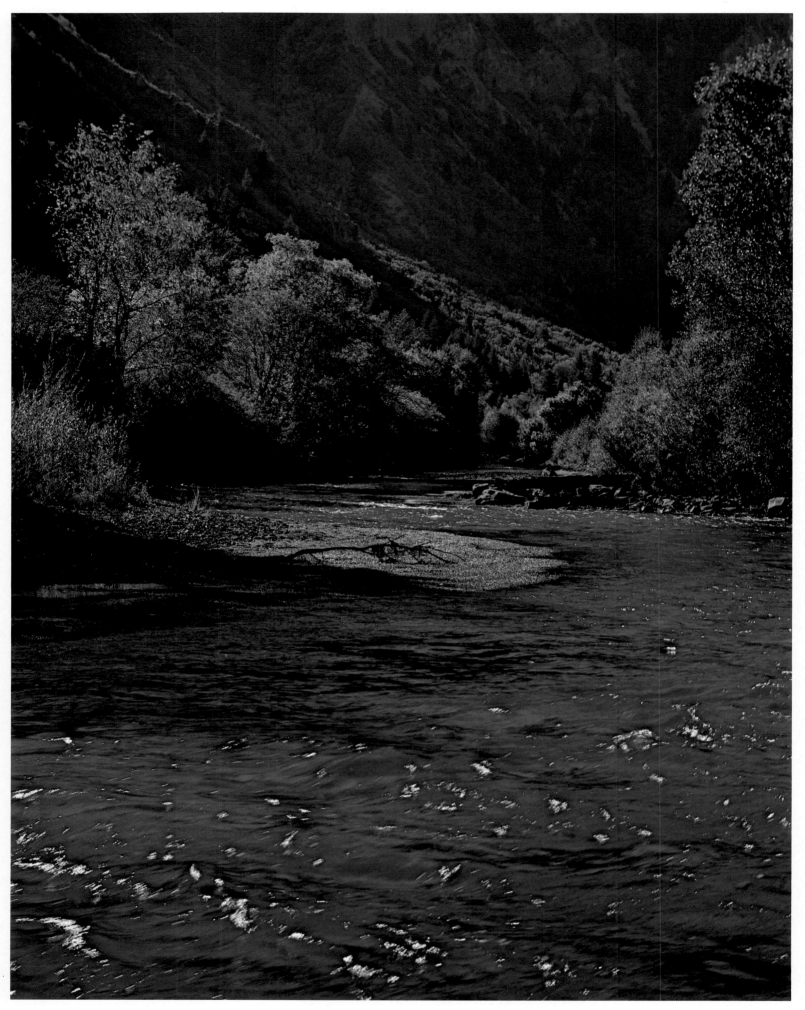

Water is the life blood of Utah. Inhabitants of the state diminish the flow of rivers by use in agriculture, homes, and industry. Provo River, Provo Canyon. *Left:* Freshwater Utah Lake, shallow and margined with rushes, is a holding area for water flowing from the Uinta and Wasatch mountains on its way to Great Salt Lake. *Overleaf:* On a fin of sandstone rests a figure resembling a wooden shoe. A remnant produced by erosion of stone, it is framed by branches of a senescent juniper. Woodenshoe Arch, Canyonlands National Park.

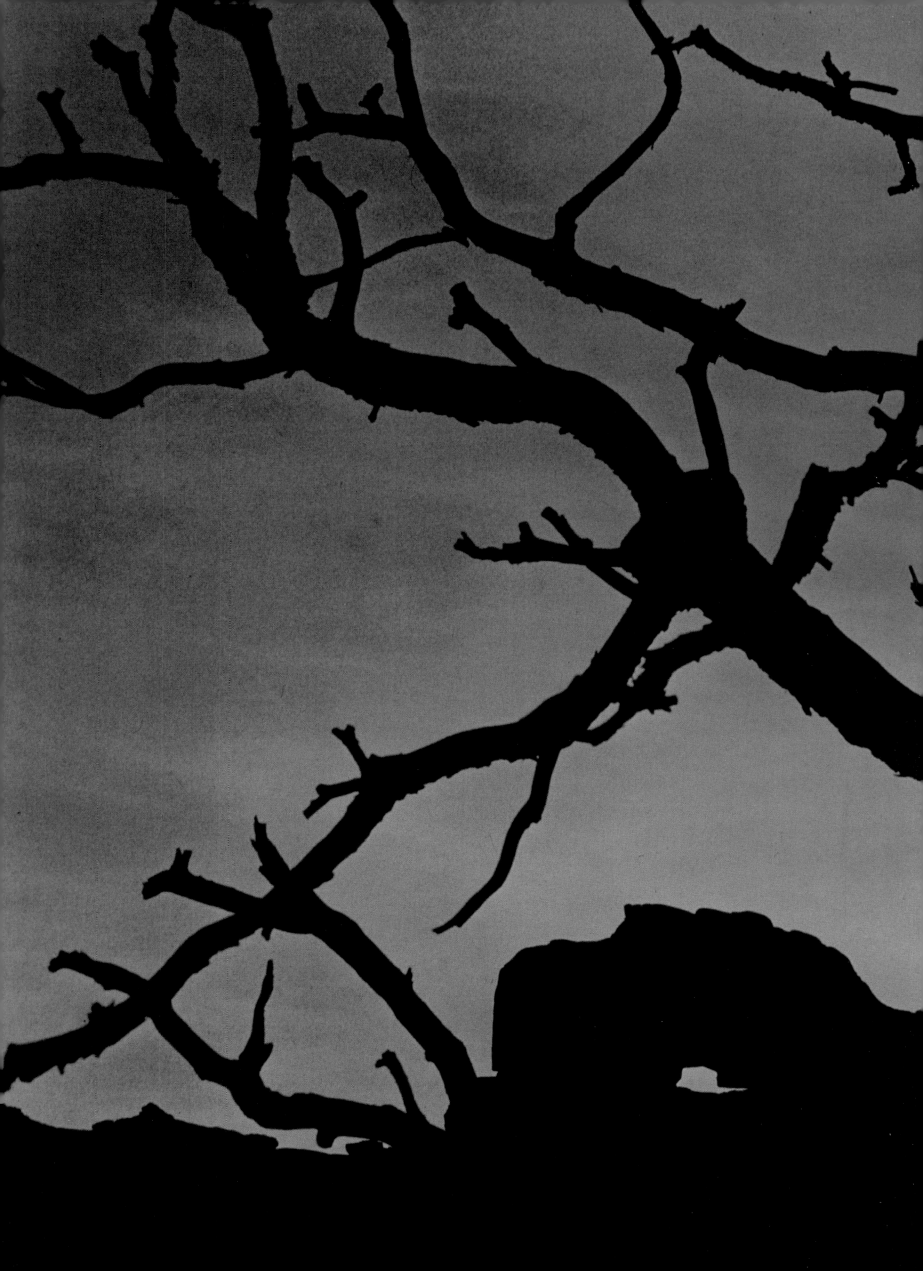

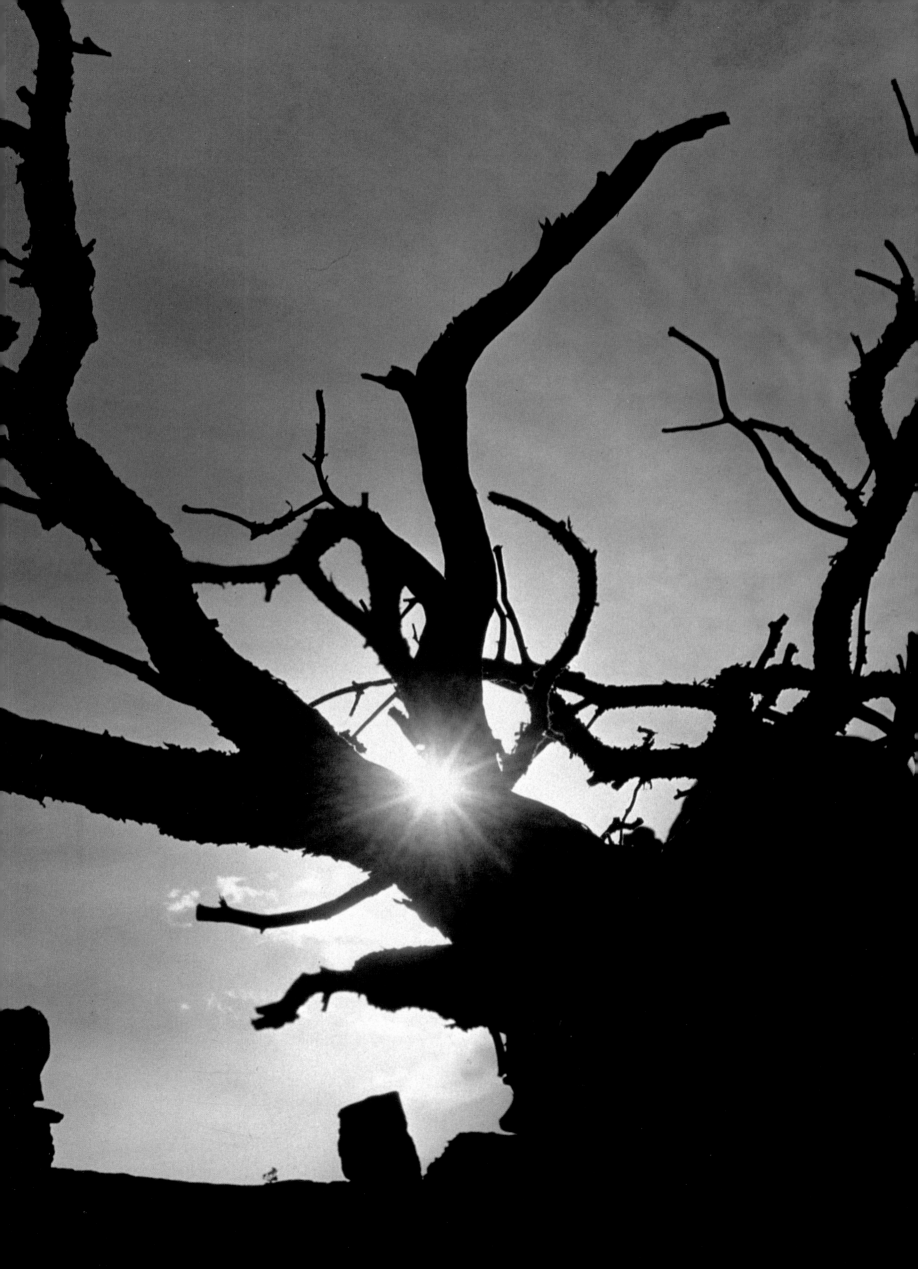

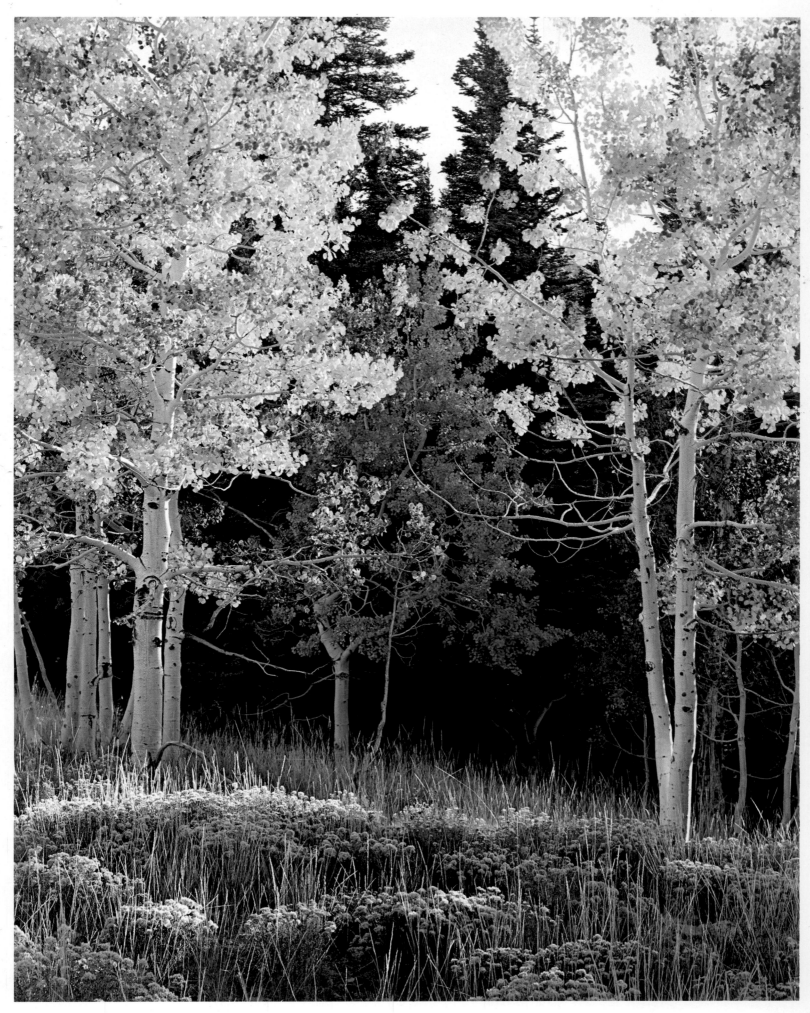

Aspen, which occur alone or with conifers on mountain slopes, turn to
shades of yellow and golden-orange in autumn. Spanish Fork Canyon.
Right: Deeply cut canyons intersect joint systems or impervious layers in
stone. These contain water tables which leak that life-giving gift of nature.
Weeping Rock, Zion National Park. *Overleaf:* Waves of water-washed mud
pattern a shoreline of Great Salt Lake.

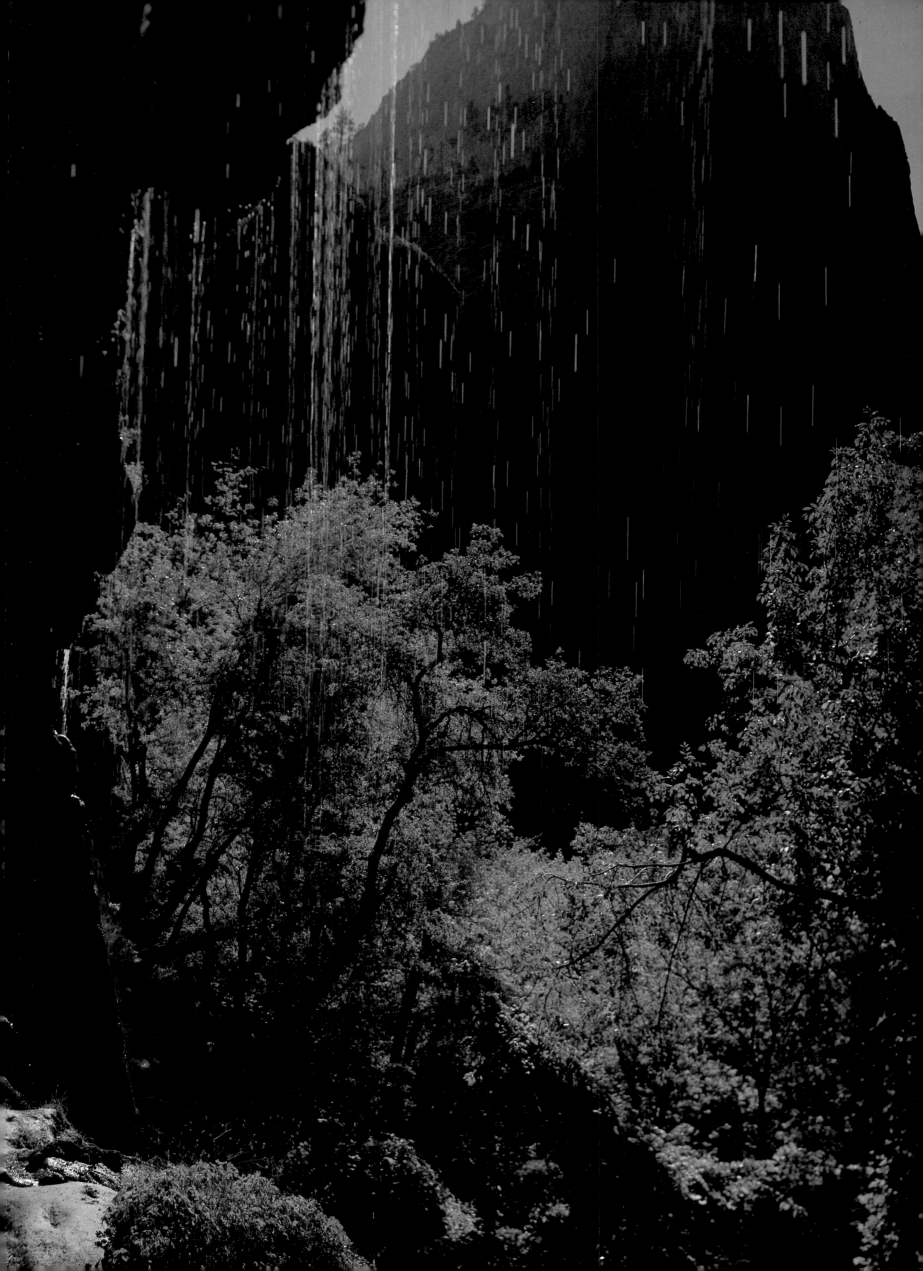

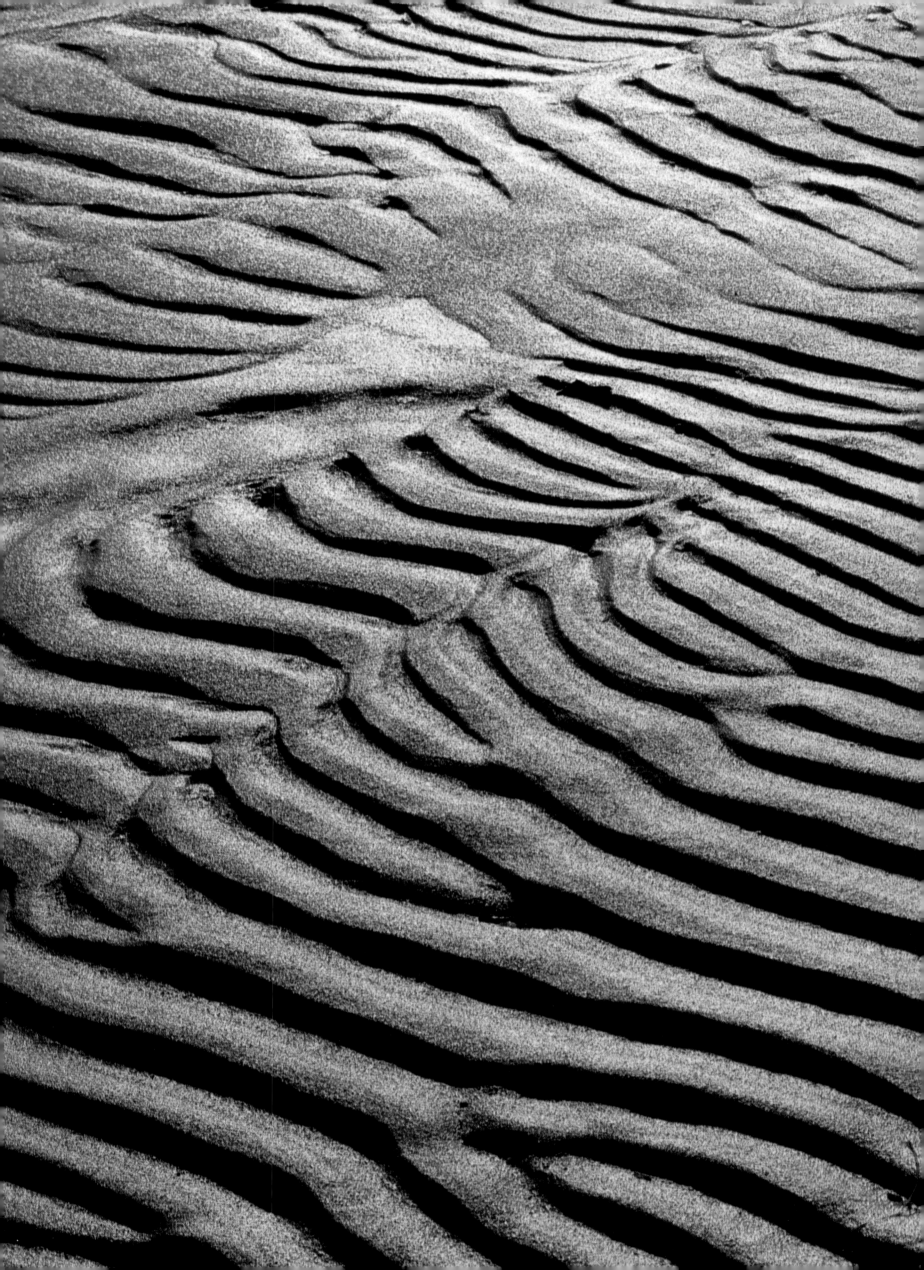

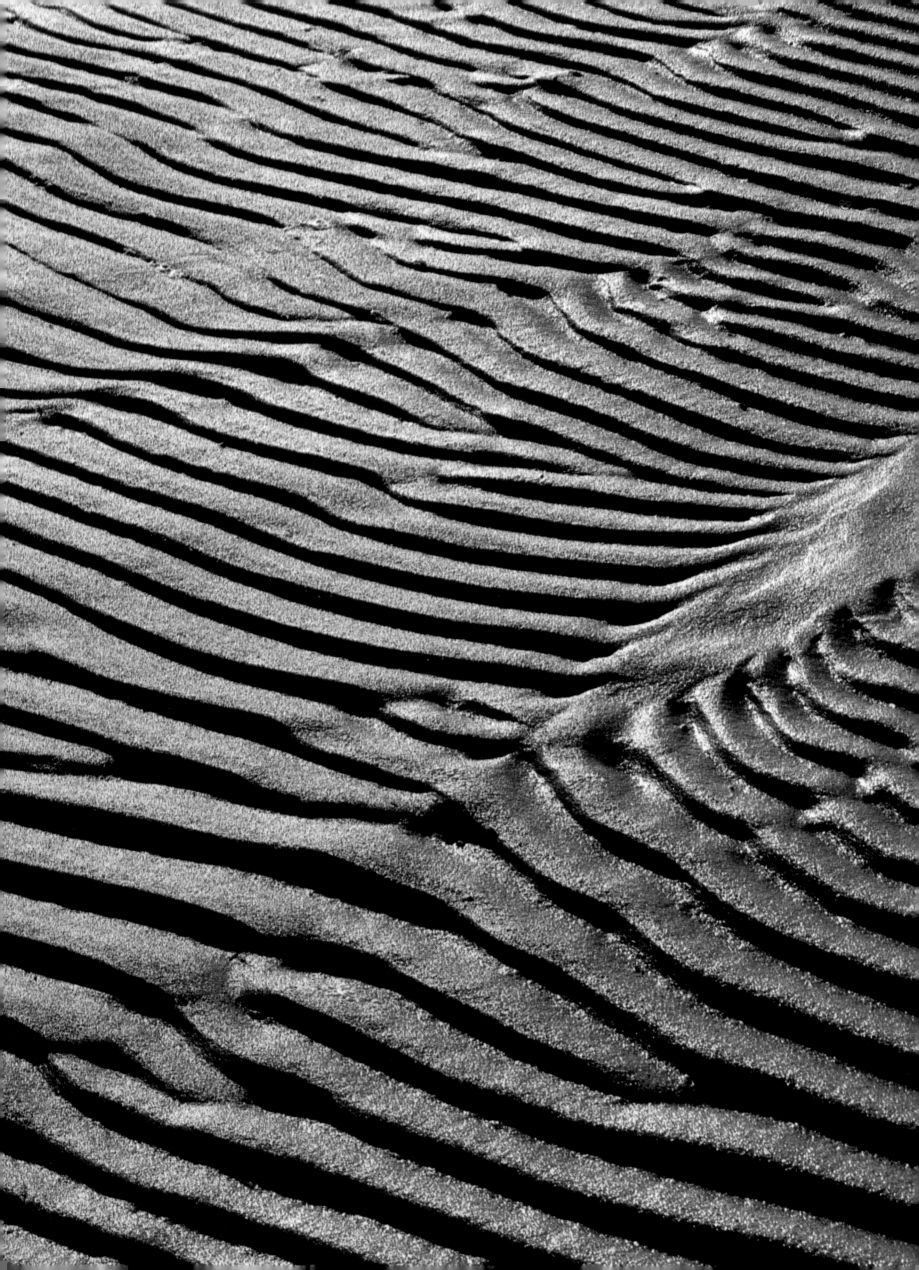

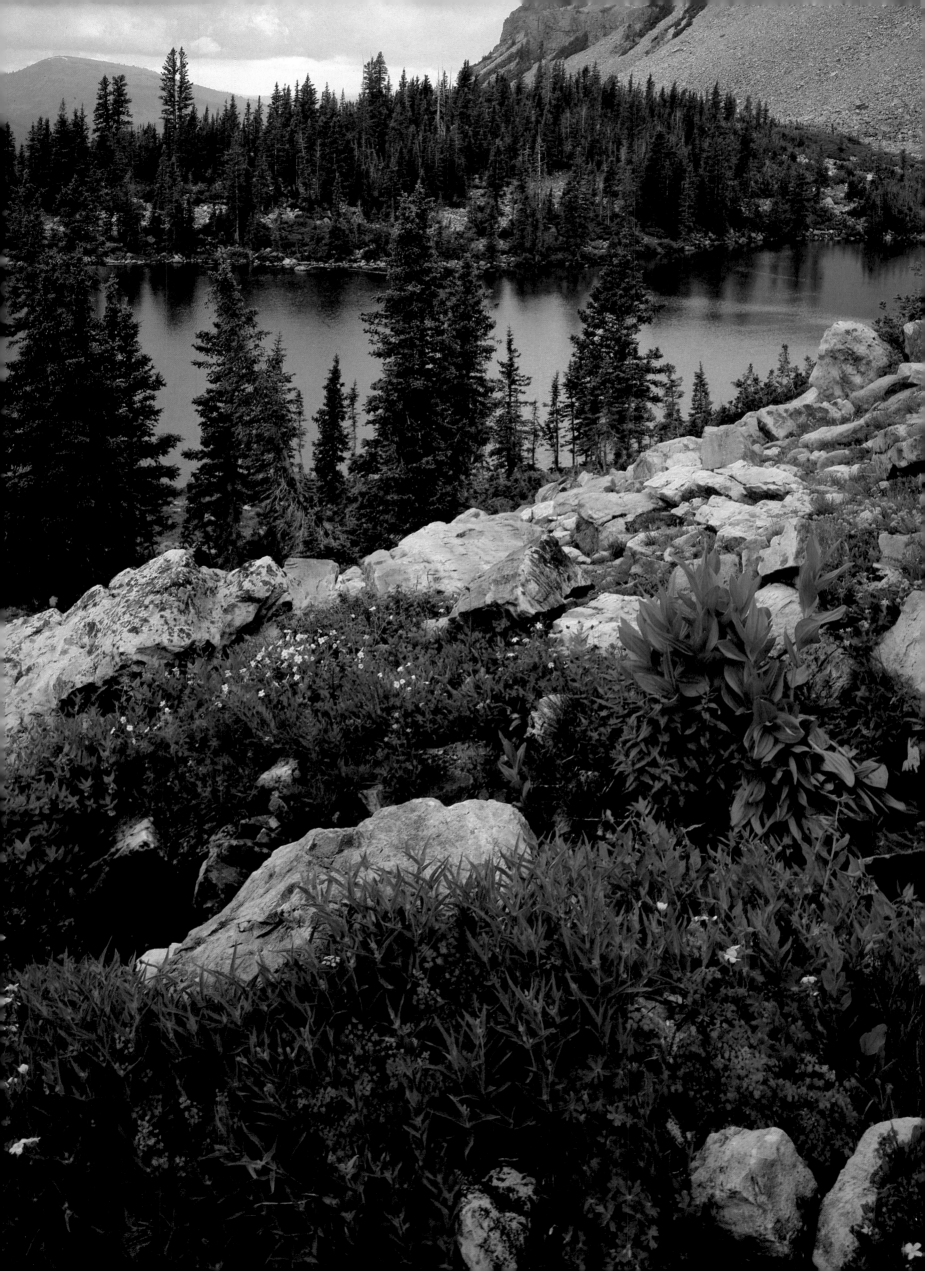

Rocks more than half a billion years in age and marked by lichens serve as the backdrop for Parry's primrose. Uinta Mountains. *Left:* Glacial erratic boulders were abandoned as glaciers melted, yielding natural dams for water. Upper Morat Lake, Naturalists Basin, Uinta Mountains Wilderness.

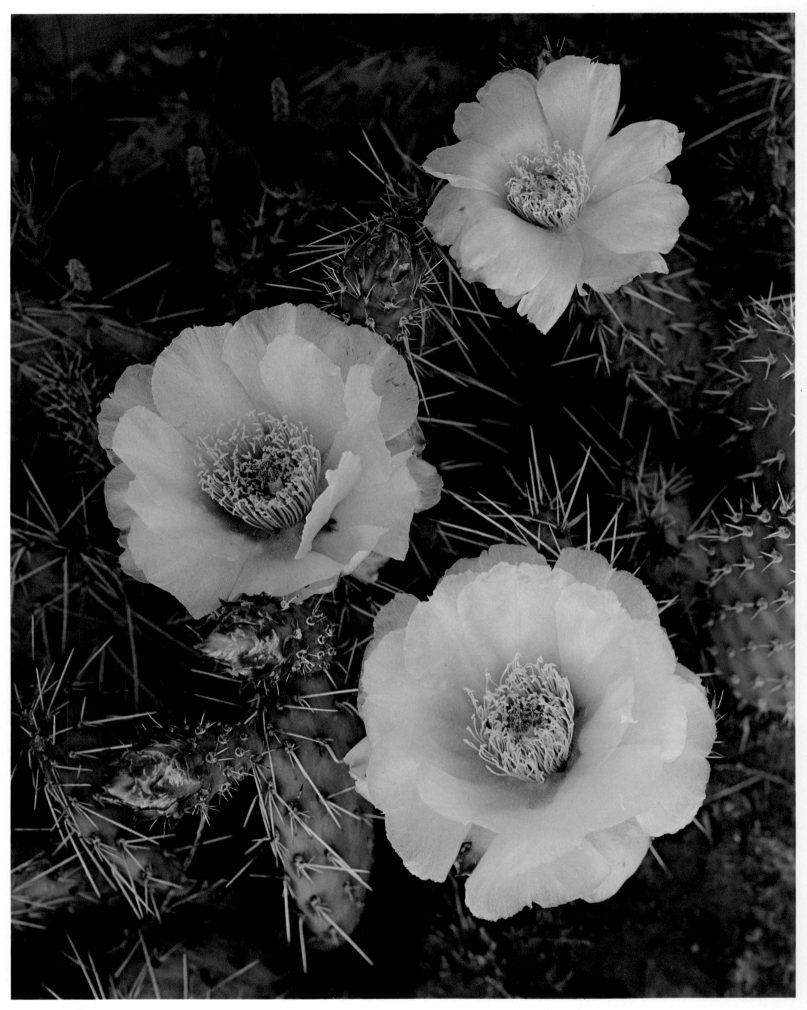

The yellow prickly pear is modified for growth in arid sites. Lacking leaves and with thickened stems in which water and food are stored, its brightly colored flowers attract insects who benefit from pollen and nectar. Arches National Park.

Arid are the slopes, almost to the water's edge, where the exotic water of the river nurtures a thin line of deciduous trees and shrubs. Although green in summer, they become sere in the winter. Rainbow Park, Dinosaur National Monument.

The Indian paintbrush take advantage of early warmth of springtime to grow
and begin to flower before drought of summer begins. They persist through
late snowstorms to complete the cycle of flowering. Zion National Park.

The setting sun casts a glow over grass and brush where Mormon pioneers followed tracks of the Donner Party into Emigration Canyon in July 1847. *Overleaf:* Barren is the view of redrock lands in Capitol Reef National Park. The area supports a scanty vegetative cover, made beautiful by its paucity and its contrast with rich hues of stone.

Cut off from water supply in twigs by layers of cork, maple leaves still cling
to the trees. Later they fall to clothe the surface of boulders beneath already
clad with moss and lichens. Clear Creek, Zion National Park.

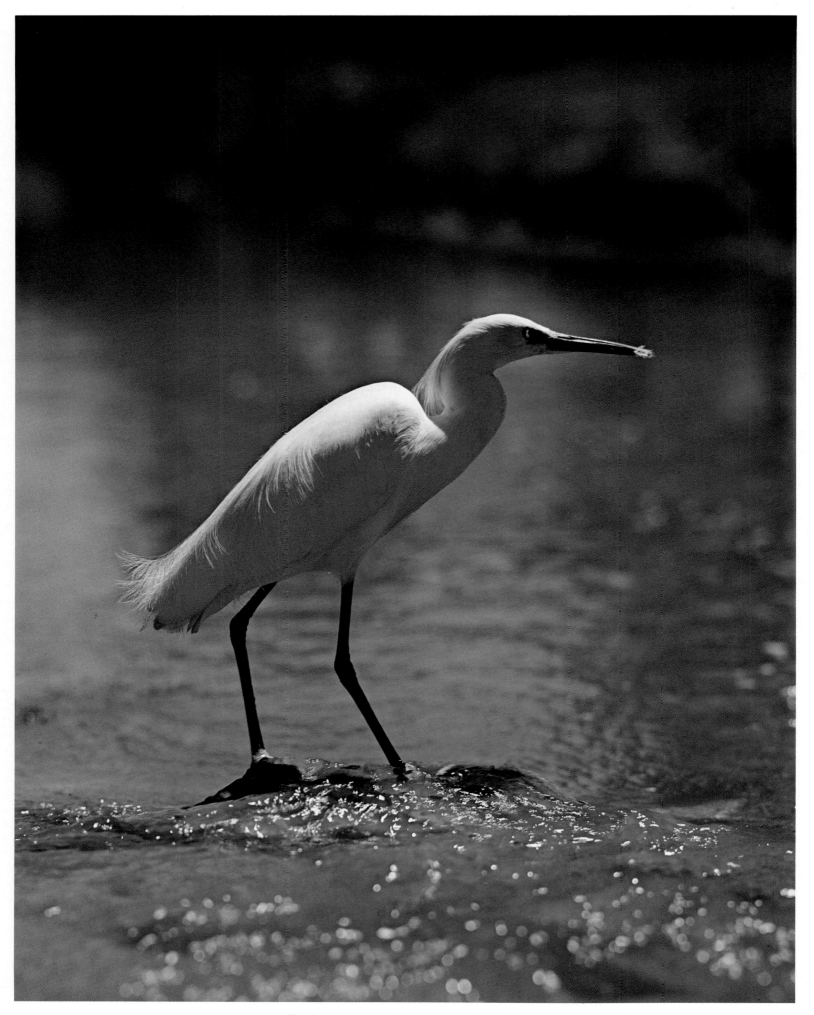

A snowy egret stalks for prey in shallow waters. Bear River Migratory Bird Refuge, Box Elder County. *Overleaf:* Trees not only offer the promise of cooling shade, but also the possibility of water to quench the thirst. Mill Creek, Salt Lake County.

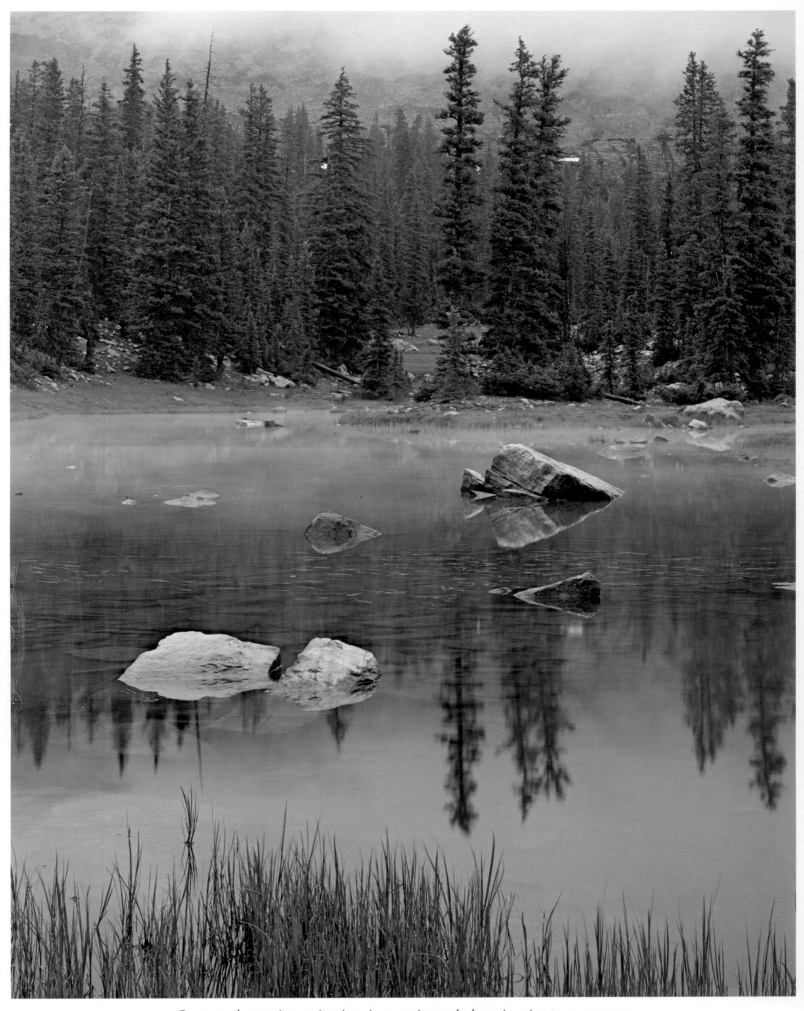

On a cool morning, mist rises into moisture laden air prior to a summer storm. Jordan Lake, Naturalists Basin, Uinta Mountains.

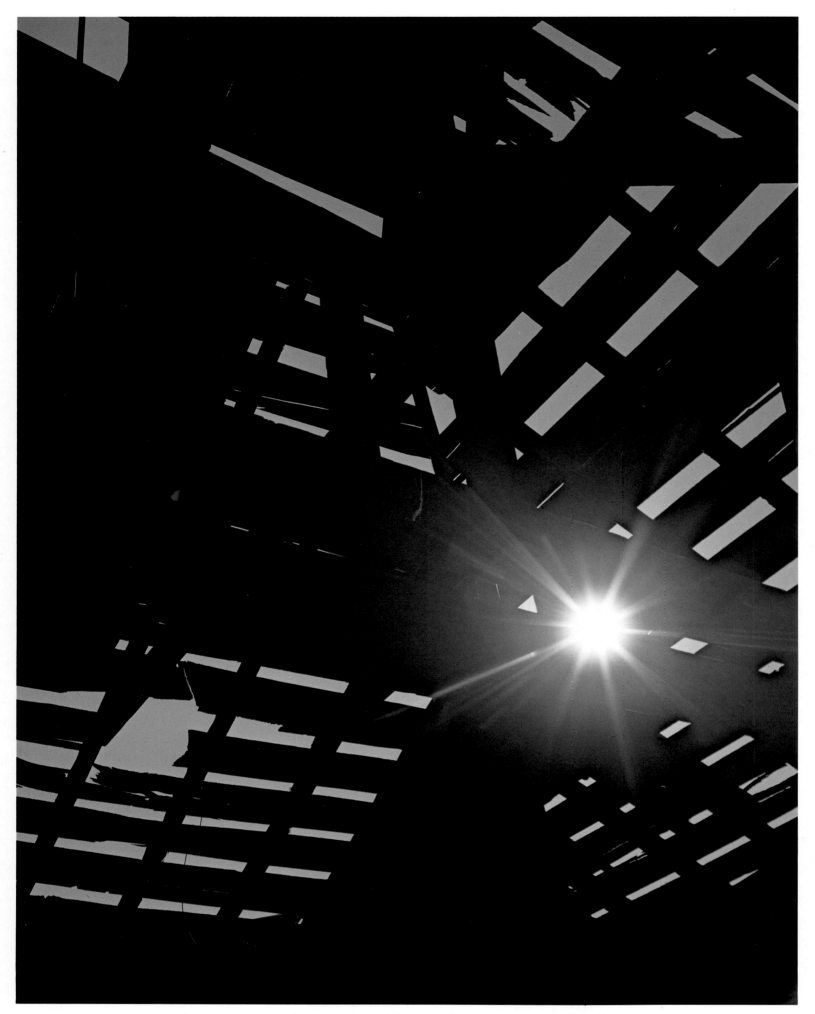

Symmetry in wood, under glare of the noonday sun, gives beauty to abandoned buildings, torn by wind, rain and snow at the ghost town of Frisco. Beaver County. *Overleaf:* In canyons trending east-west, the north-facing slopes are shaded throughout the year. In winter the shadows protect snows from melting, and in summer they prevent excessive loss of water by reducing evaporation rates. Sundance Turnoff, Provo Canyon.

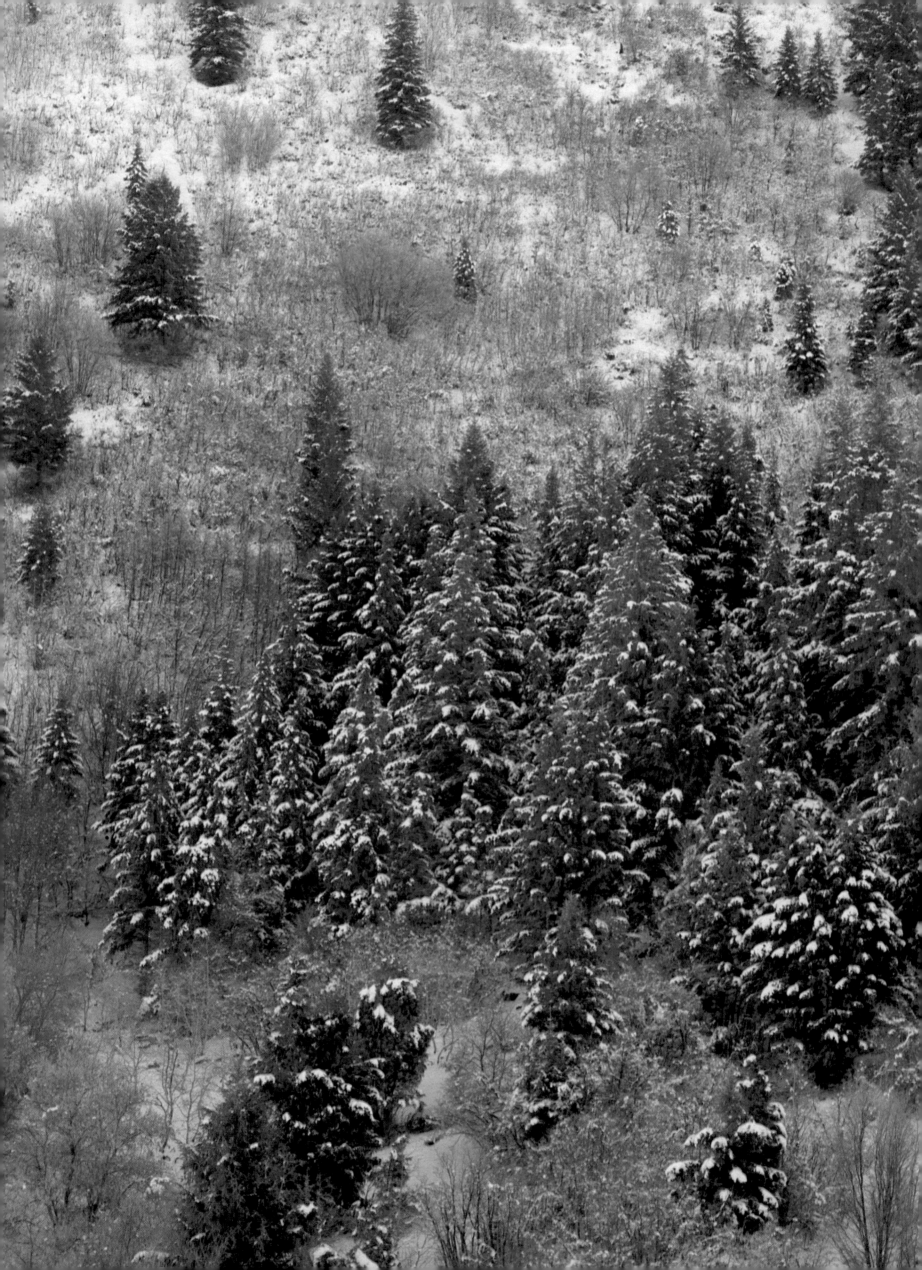

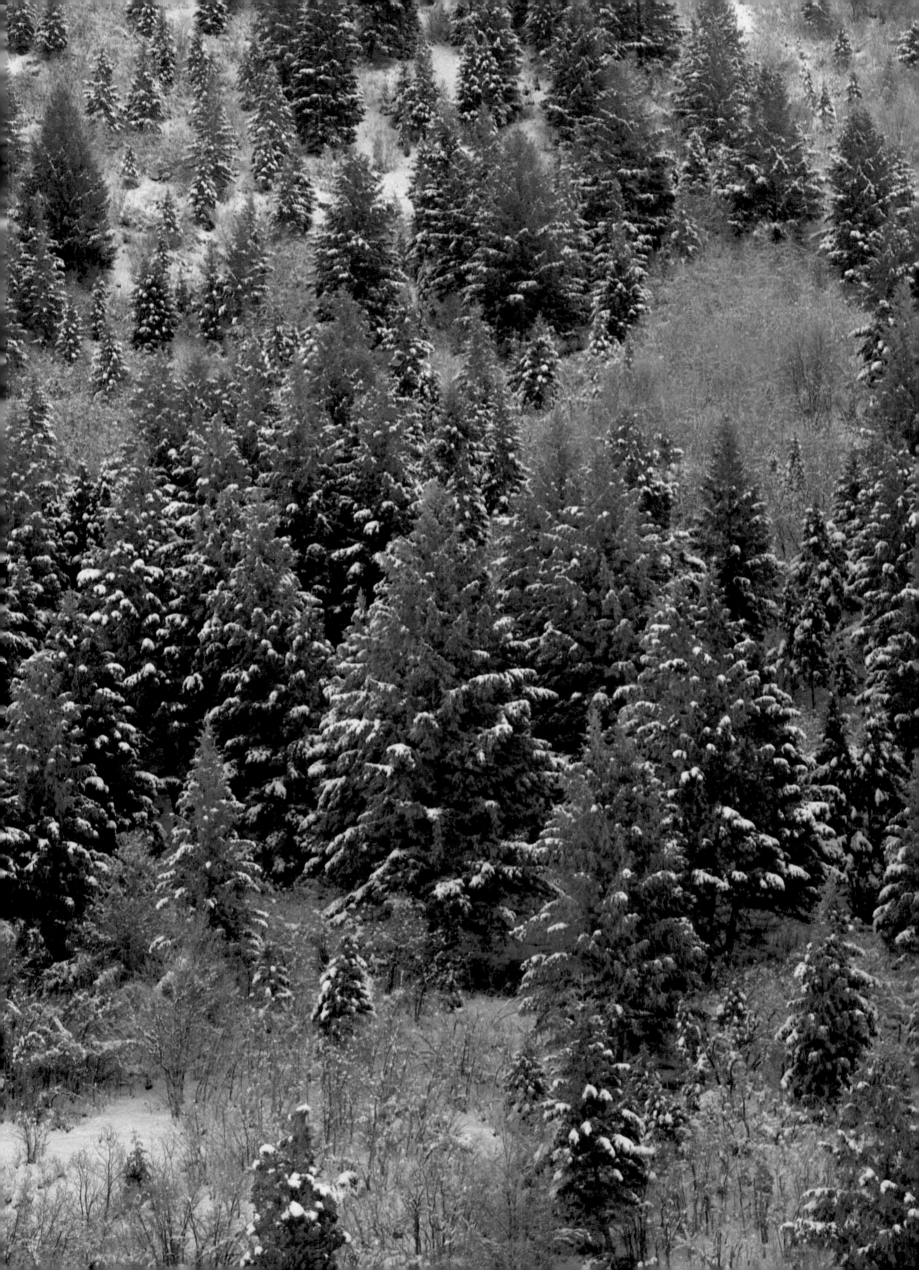

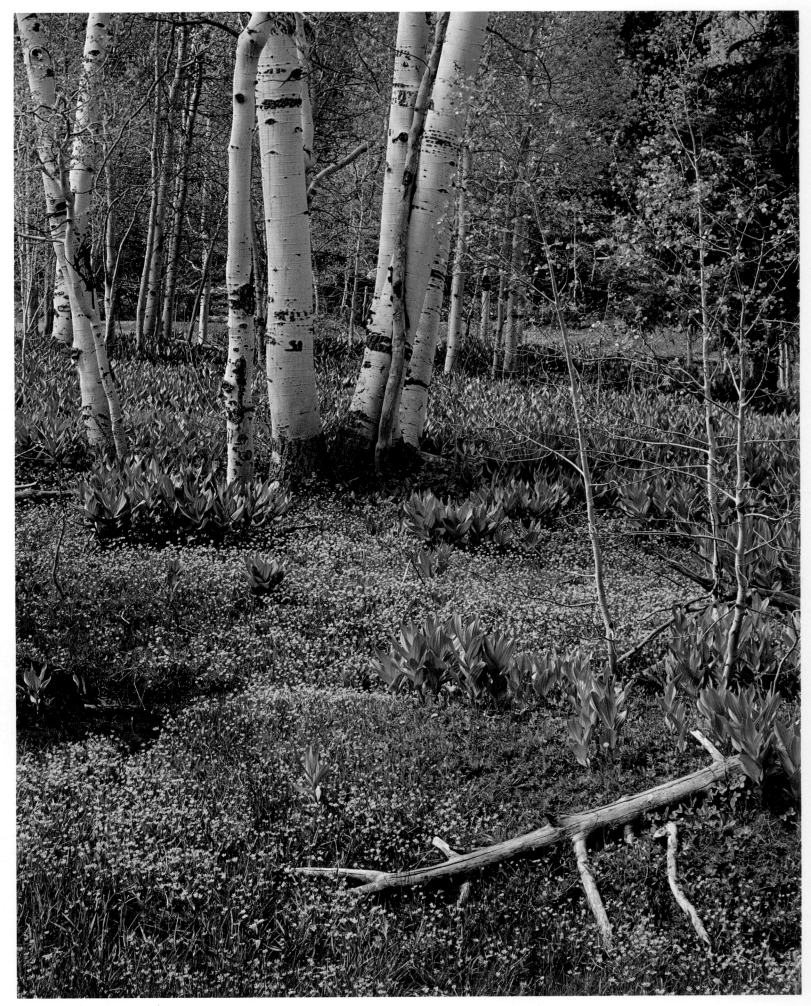

Aspen parkland is wet in springtime, and, as the leaves are produced on the trees, the forest floor blossoms with a profusion of buttercups. Uinta Mountains. *Right:* At Hole-in-the-Rock, Joseph S. Smith and his wife, Belle, walked to the top of the crevice on January 26, 1880, and described the road downward, "...10 feet of loose sand, then a rocky pitch as steep as the roof of a house and barely as wide as a wagon..." Glen Canyon National Recreation Area.

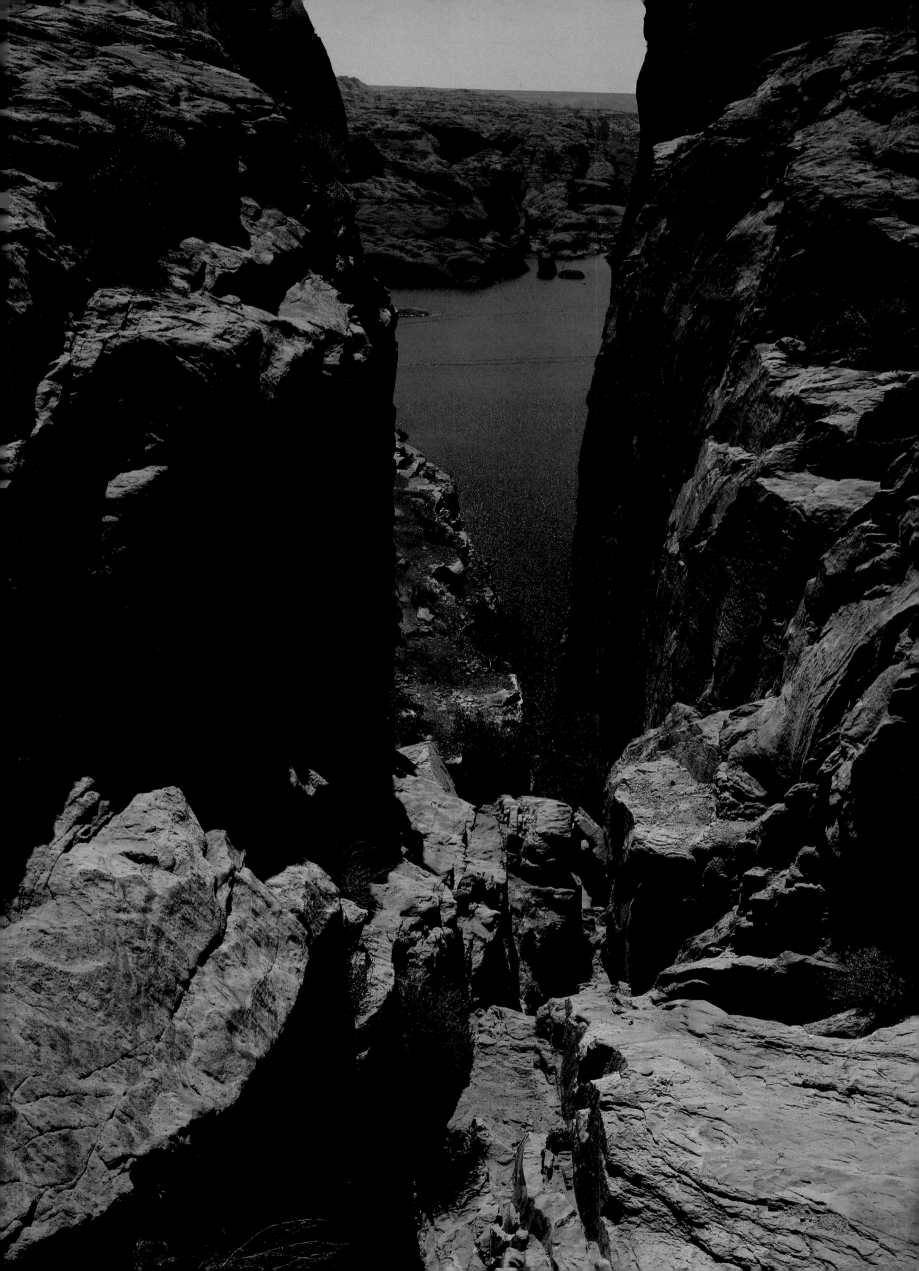

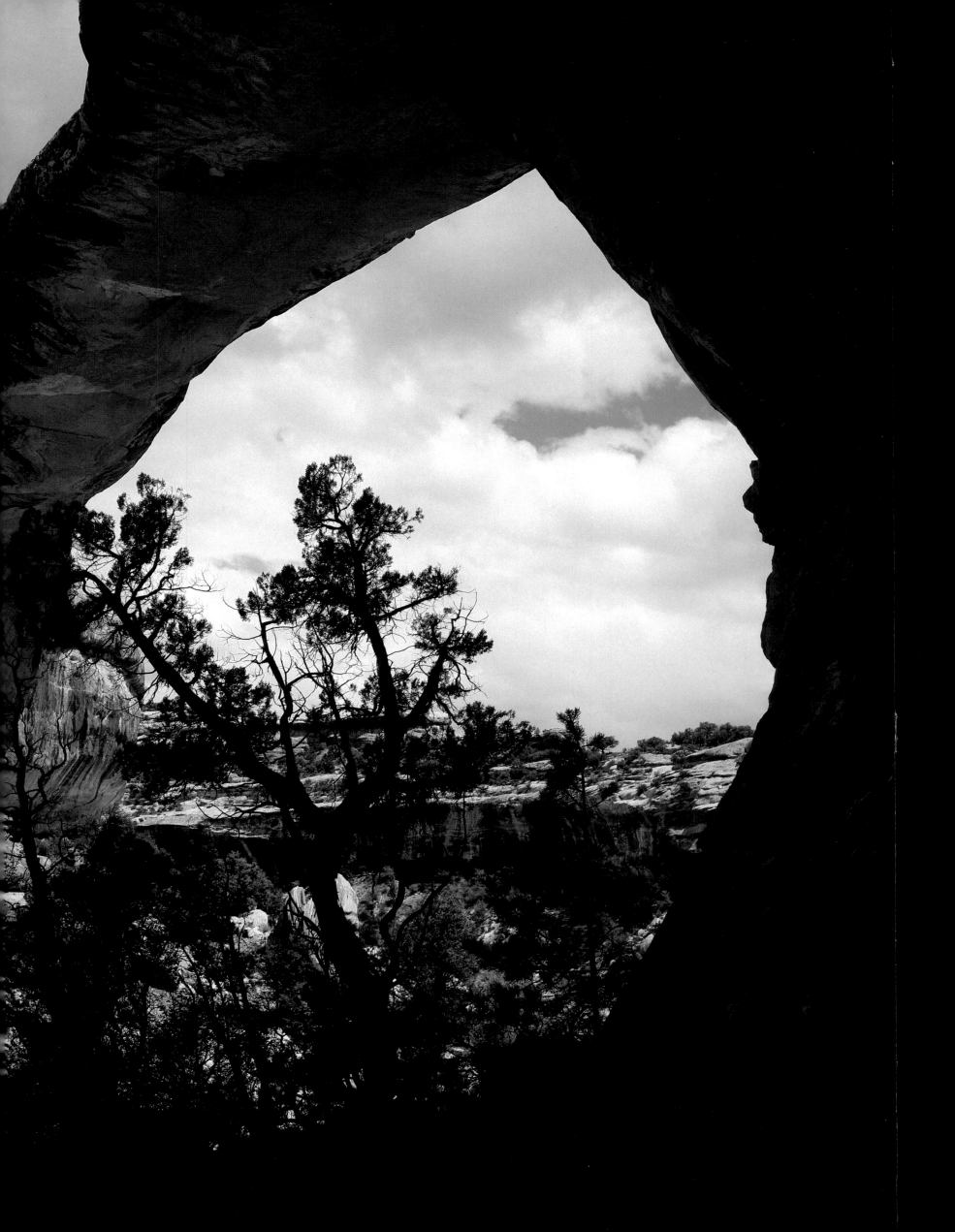

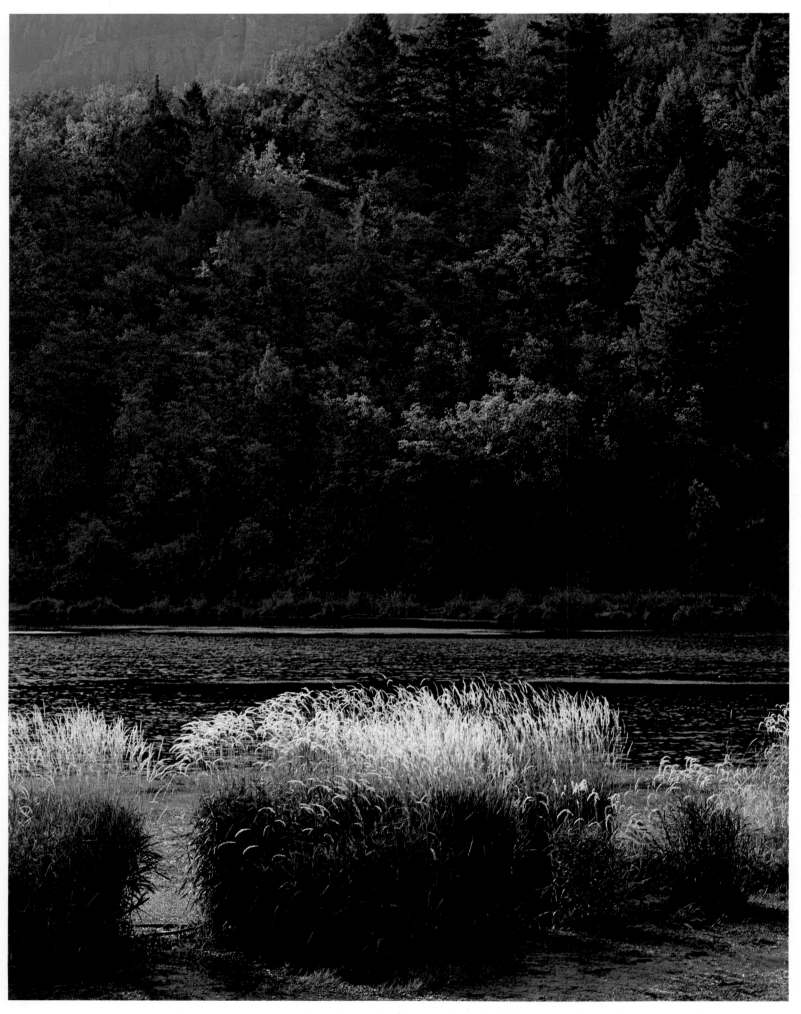

Grass, mature and laden with seed, presents their chaffy heads to the wind at seasons end. Logan Canyon. *Left:* Meandering streams entrench deeply into sandstone and wear away at the sides of meander bends. When they wear through, the result is a natural bridge. Owachomo Natural Bridge, Natural Bridges National Monument.

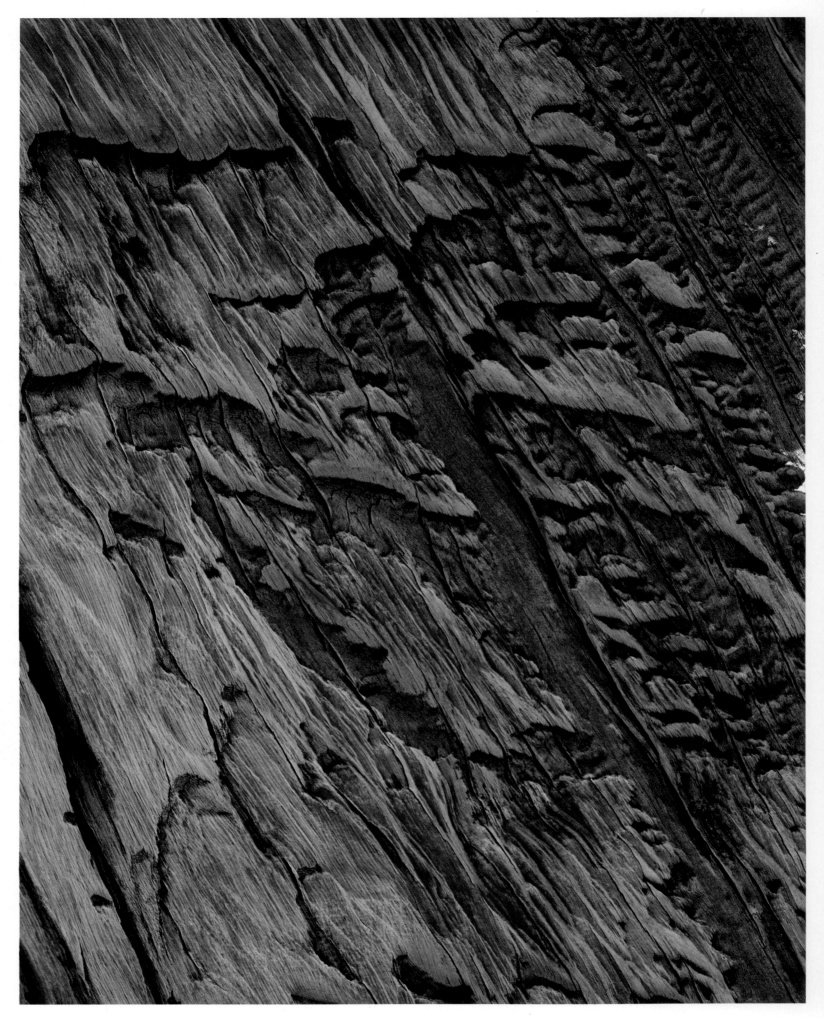

Galleries of bark beetles imbedded within the surface of an ancient bristle-
cone pine pattern exposed and weathered wood. Near Cedar Breaks. *Right:*
Pinyon pine, ecological counterpart of Utah juniper in pinyon-juniper
forests, replaces juniper in more moist sites. Canyonlands National Park.

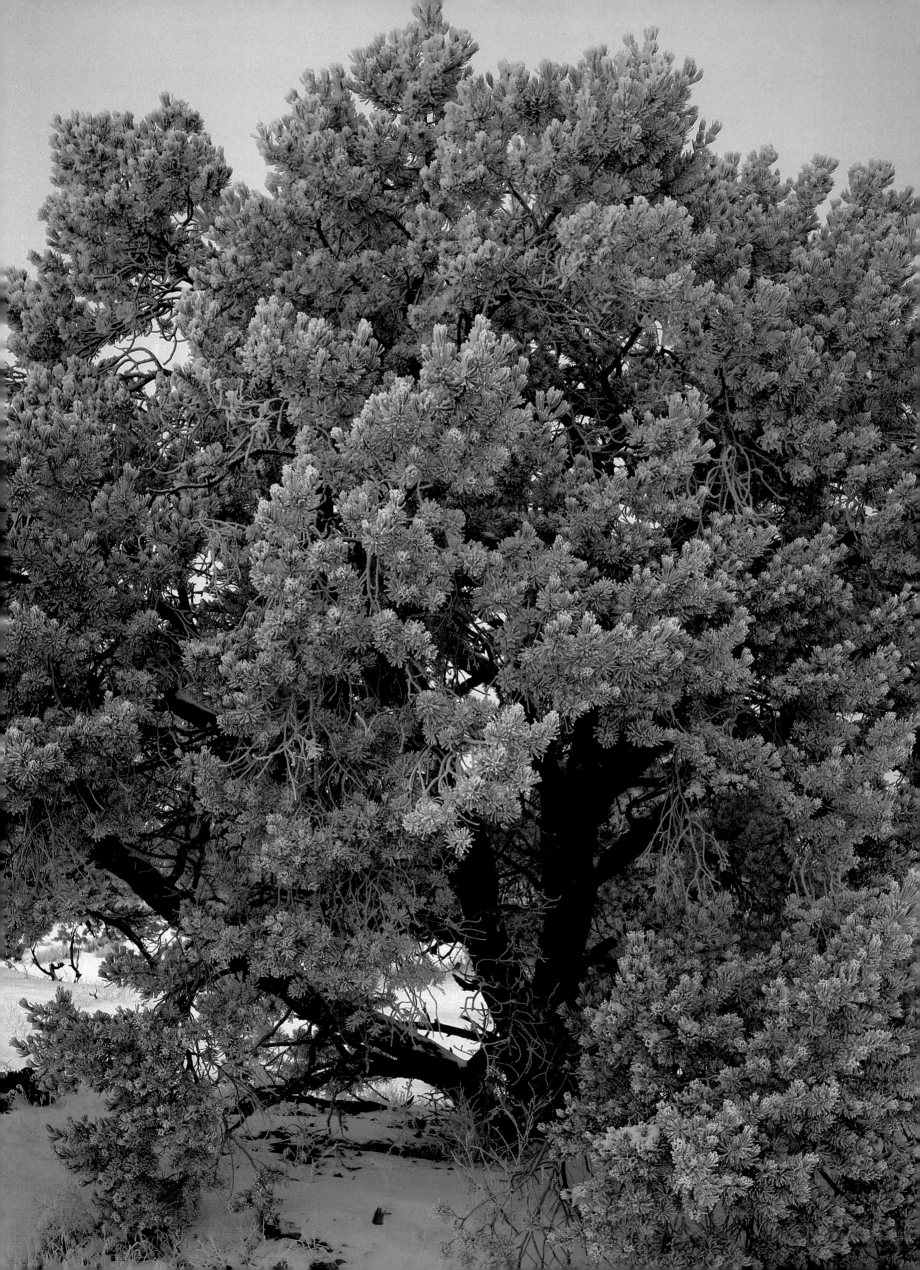

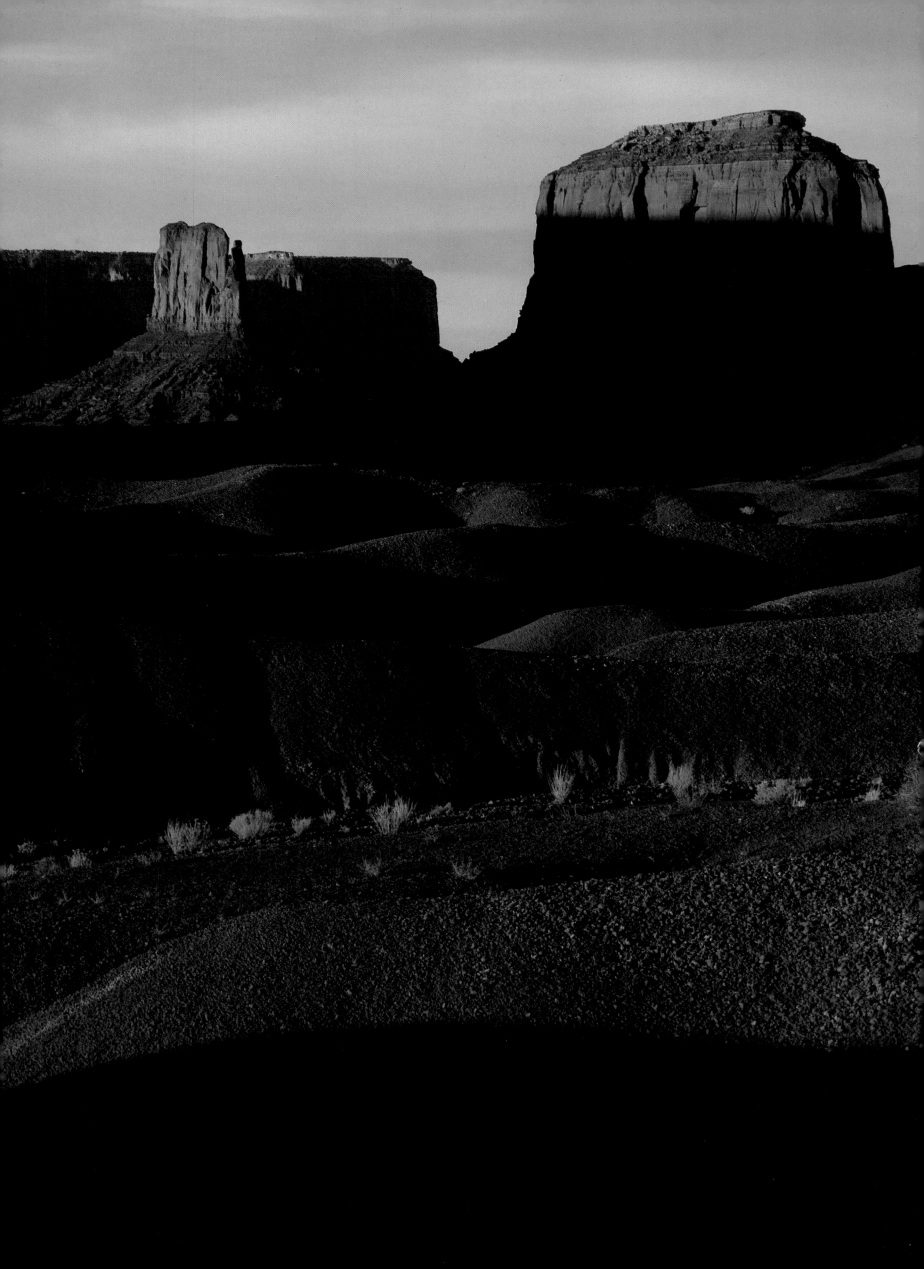

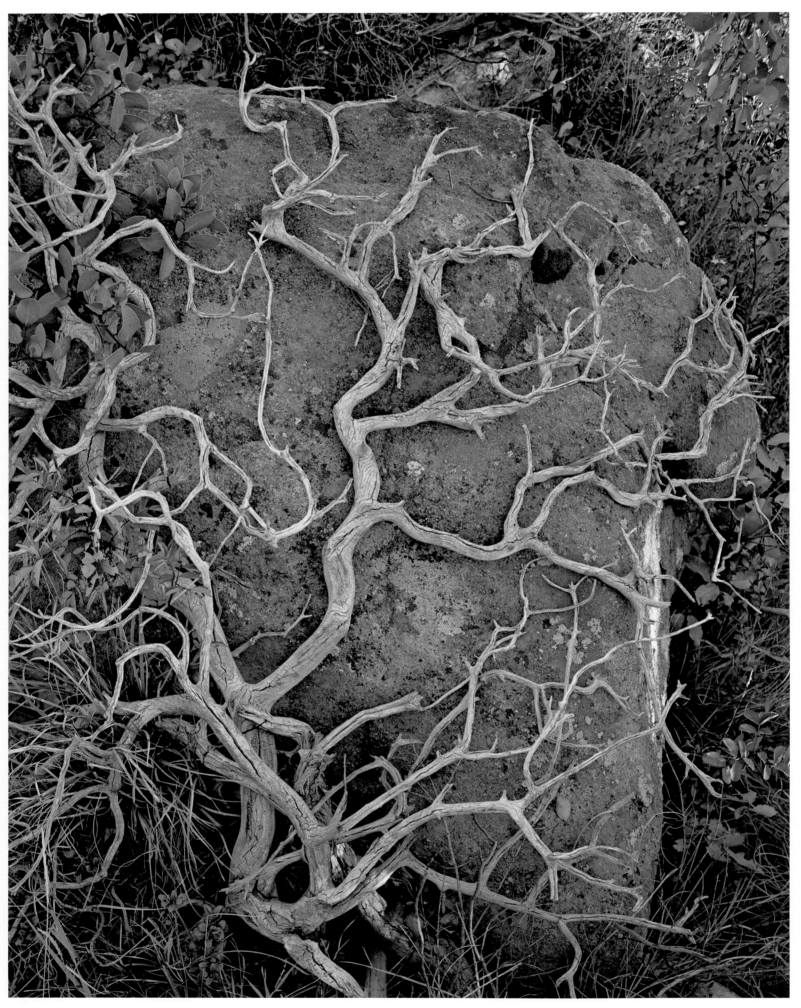

Clinging in death as it did in life, the skeleton-like branches of a manzanita
plant hug the surface of the boulder which supported it. Uinta Mountains.
Left: Red sand, red gravel, and red rock, all unobscured by vegetative cover,
give an overwhelming sense of space and time. Monument Valley.

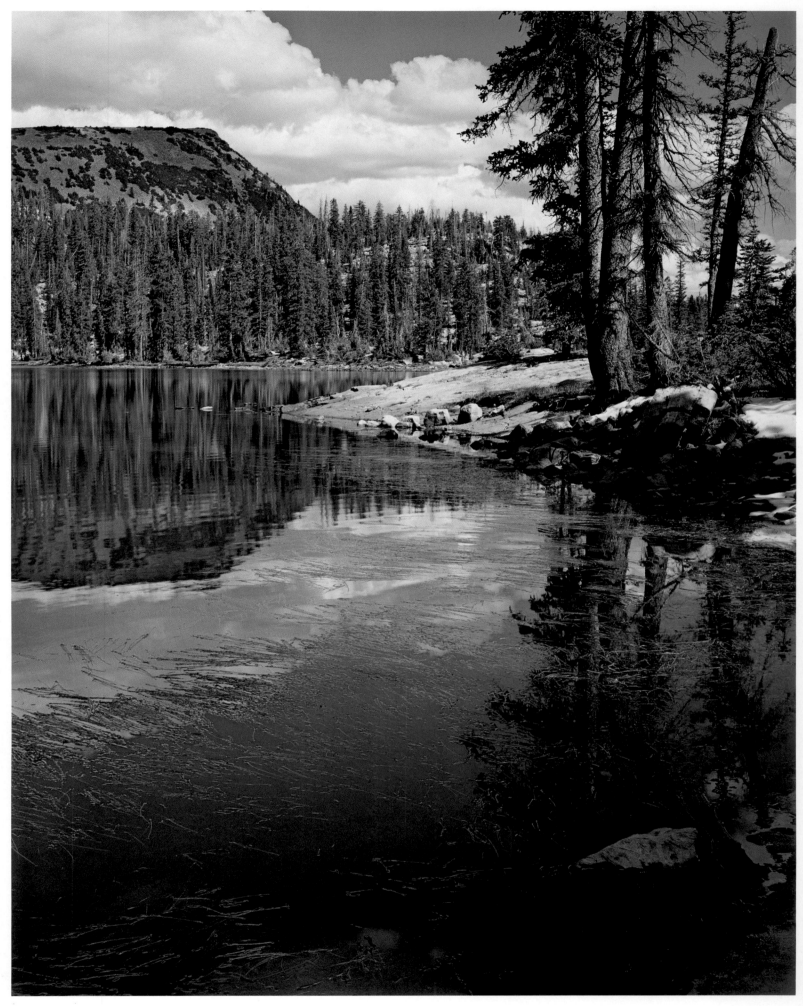

The mountains of Utah are richly endowed with lake basins formed by glaciers during the Ice Age. Island Lake, Uinta Mountains. *Right:* Water is gathered in underground chasms and then vents above ground as springs. Once in the light, the water becomes a habitat for aquatic plants and animals and quenches the thirst of wildlife and man. Ricks Spring, Logan Canyon. *Overleaf:* Salt Lake City, capital of the state and jewel of Utah, sparkles gem-like in the sea of night.

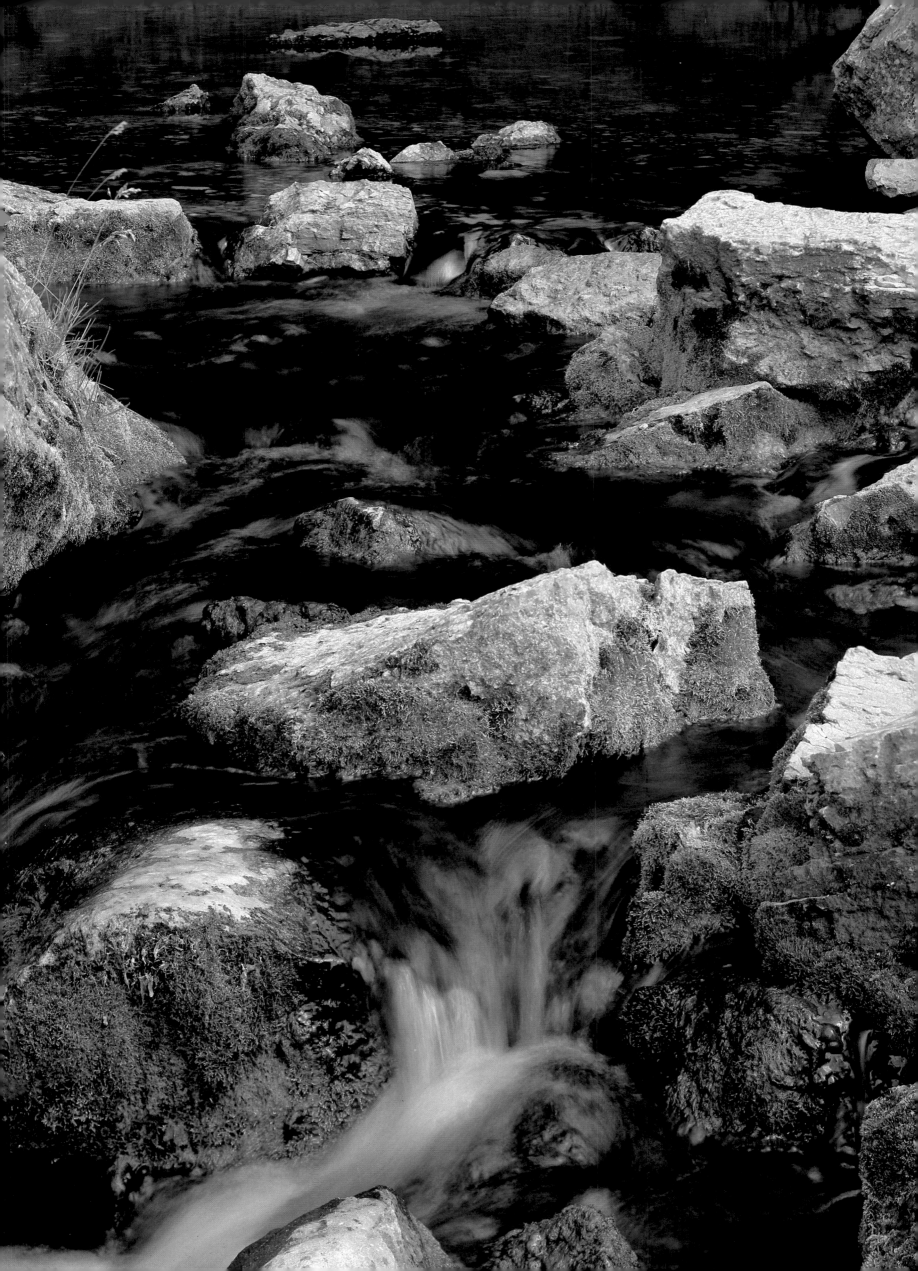

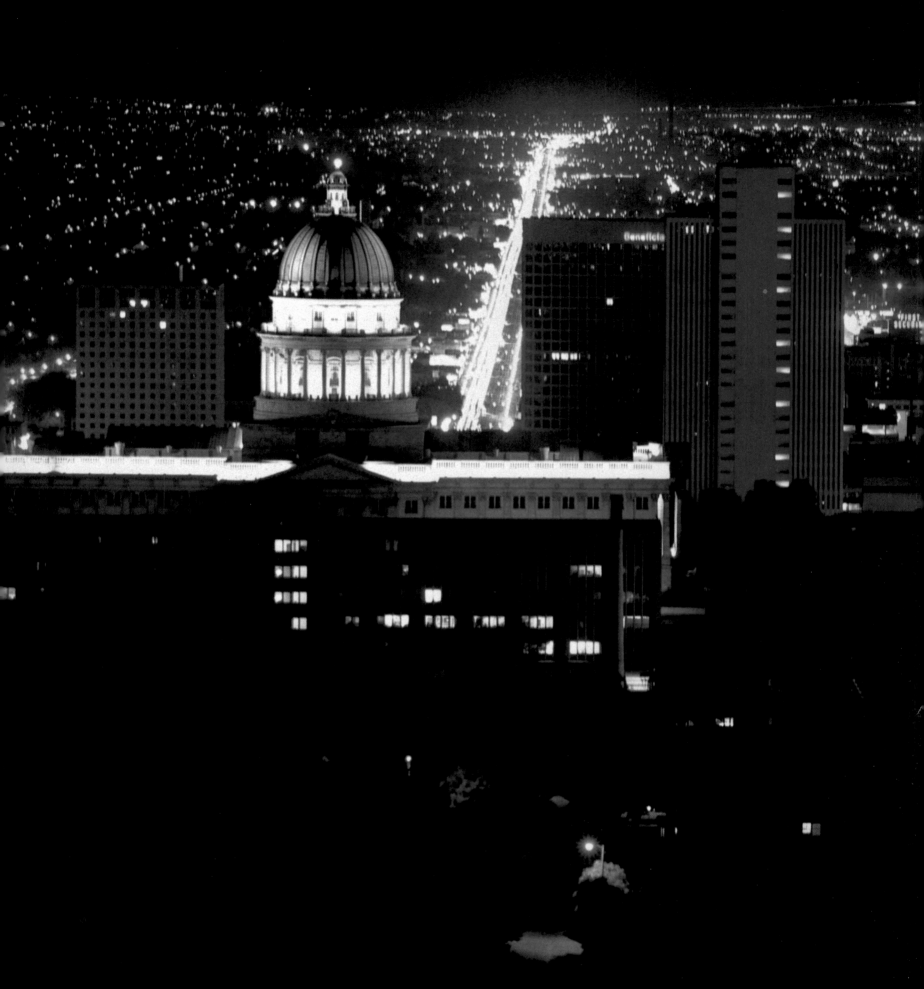

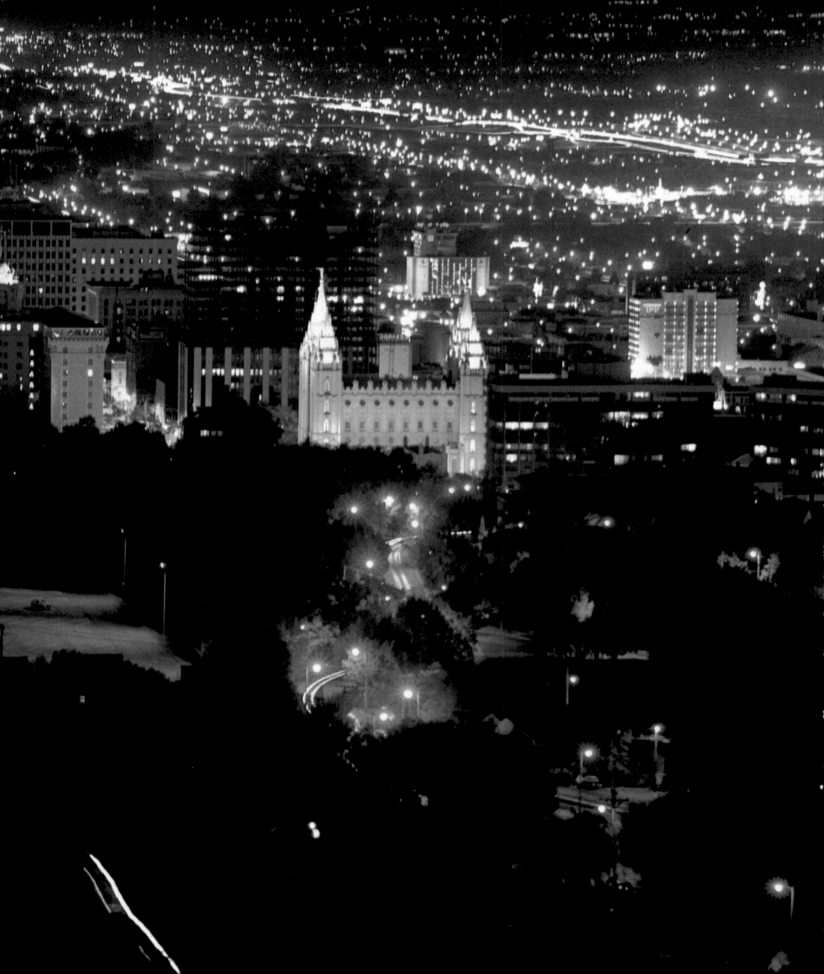

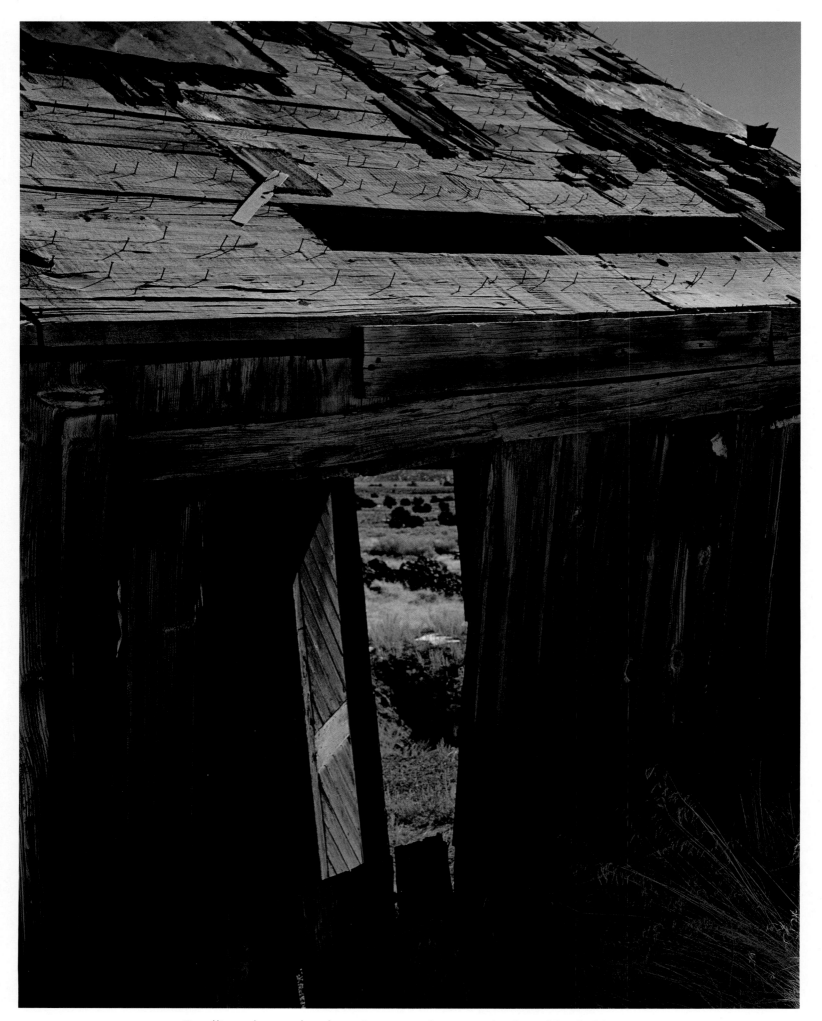

Dwellings, battered and sagging, occur in a now dessicated land. Frisco, "Ghost Town." Beaver County. *Left:* A dweller of hot dry deserts in southern Utah is the cholla cactus whose long sharp spines are sheathed in a scabbard-like covering. Beaver Dam Mountains. *Overleaf:* Cracked in parallel lines by forces within the earth, fingers of stone result from weathering of the weakened stone along the lines of fracture. Fin Canyon, Arches National Park.

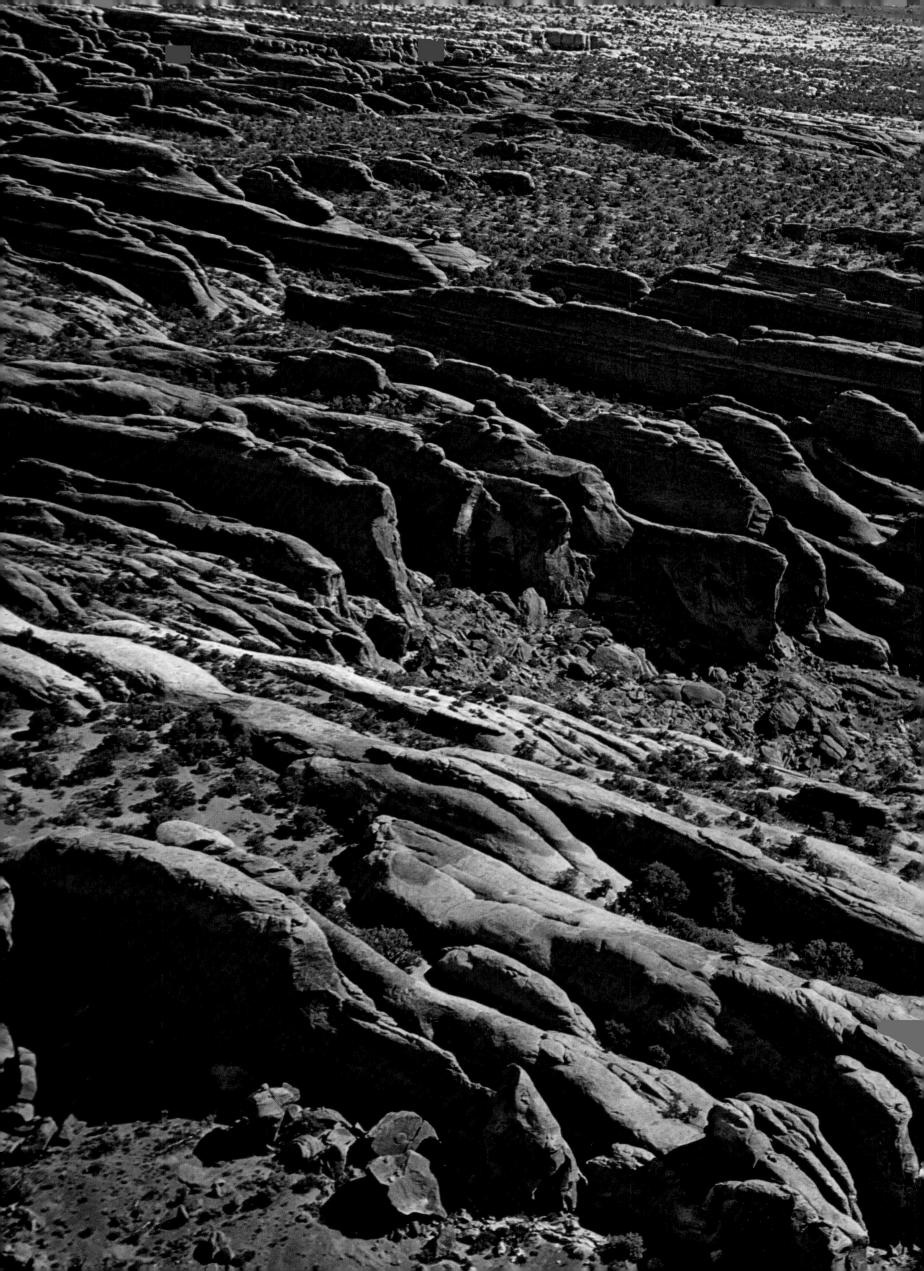

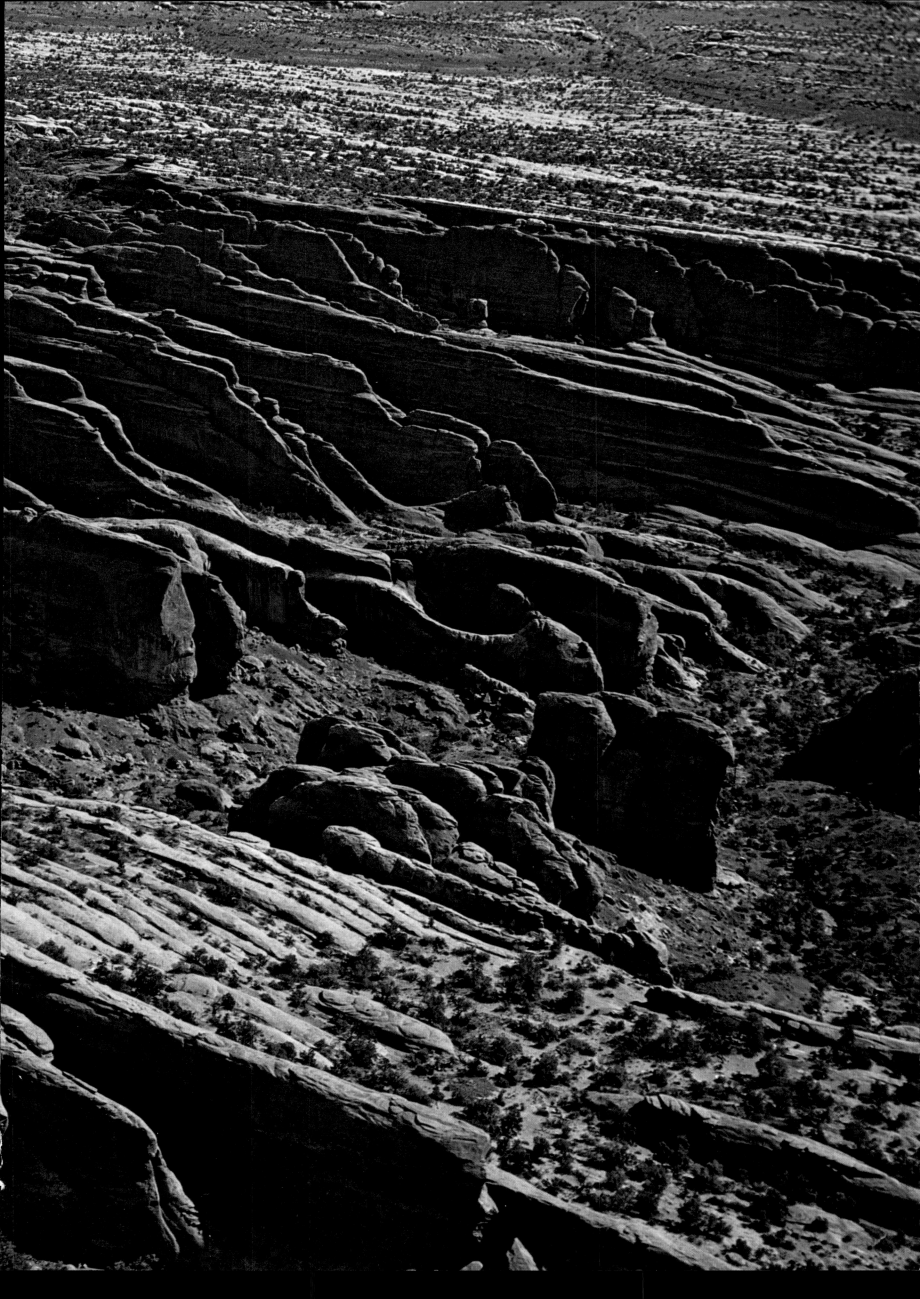

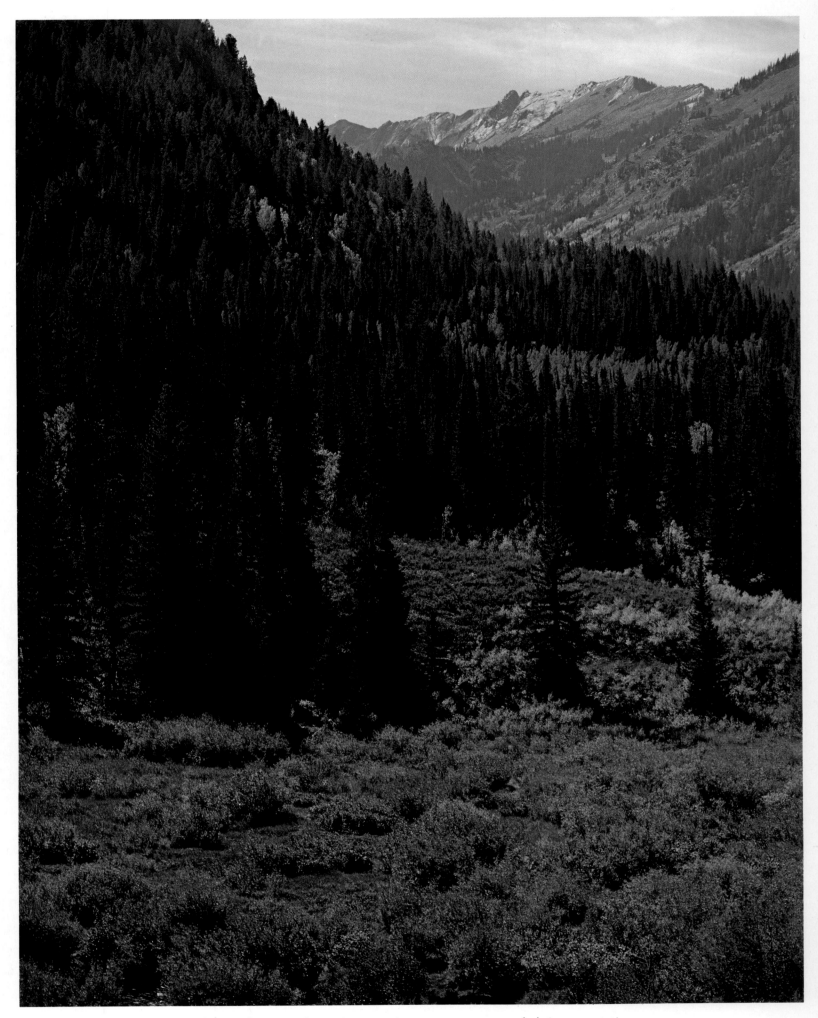

A forest of spruce, fir, and aspen gives way to a zone of alpine vegetation. Big Cottonwood Canyon, Wasatch Mountains. *Right:* Supported by a sandstone member of the Entrada Sandstone Formation, Grosvenor Arch is capped by Morrison Formation and stands high above park-like Butler Valley southeast of Cannonville.

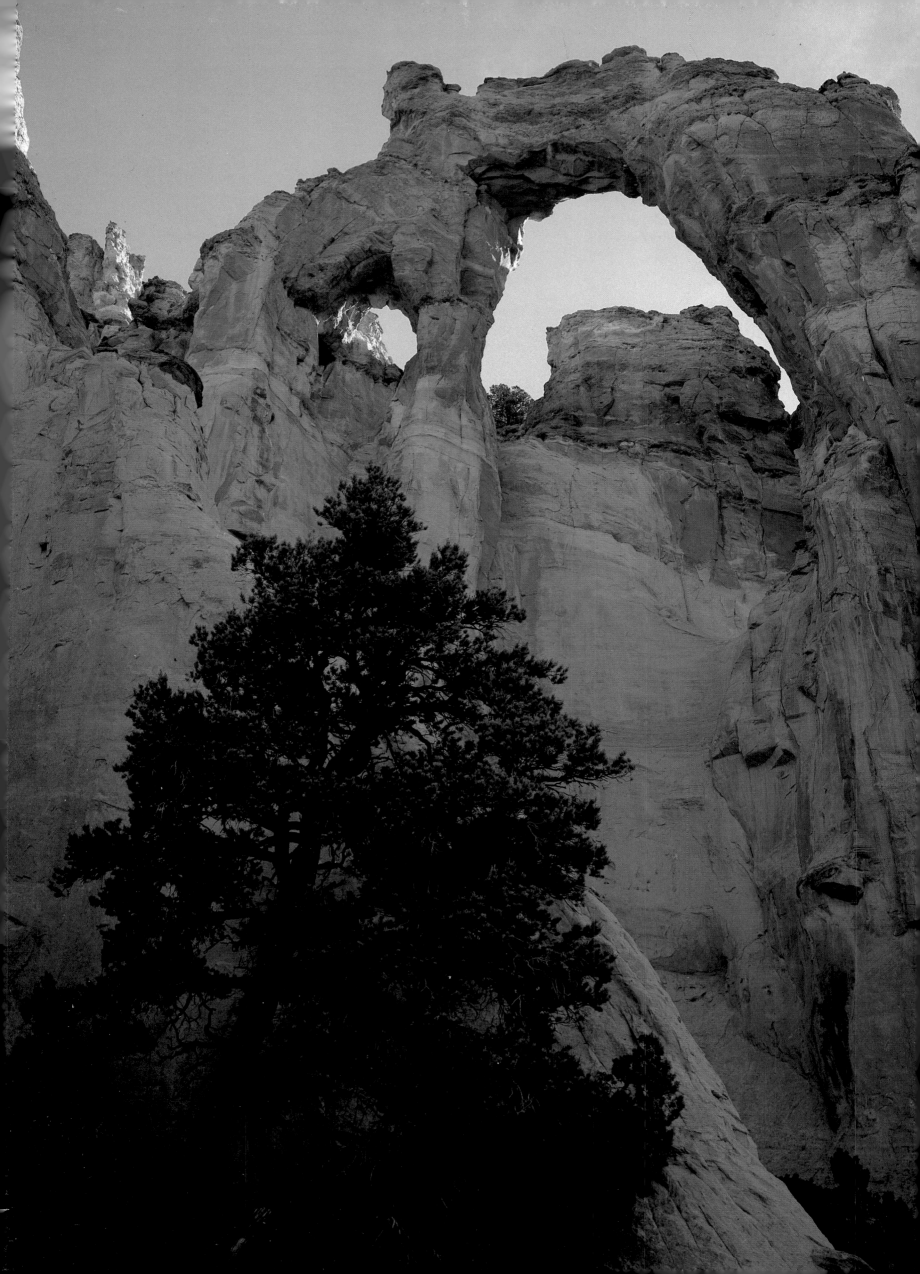